MW00462514

Lighthouses
Maine to Florida

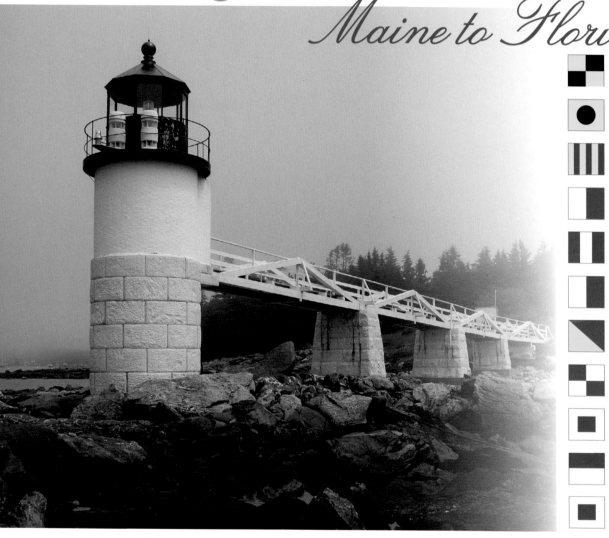

Text and Photography by David Biggy

4880 Lower Valley Road, Atglen, Pa 19310

Schiffer Books are available at special discounts for bulk purchases for sales promotions or premiums. Special editions, including personalized covers, corporate imprints, and excerpts can be created in large quantities for special needs. For more information contact the publisher:

Published by Schiffer Publishing Ltd.
4880 Lower Valley Road
Atglen, PA 19310
Phone: (610) 593-1777; Fax: (610) 593-2002
E-mail: Info@schifferbooks.com

For the largest selection of fine reference books on this and related subjects, please visit our web site at **www.schifferbooks. com**
We are always looking for people to write books on new and related subjects. If you have an idea for a book please contact us at the above address.

This book may be purchased from the publisher.
Include $5.00 for shipping.
Please try your bookstore first.
You may write for a free catalog.

In Europe, Schiffer books are distributed by
Bushwood Books
6 Marksbury Ave.
Kew Gardens
Surrey TW9 4JF England
Phone: 44 (0) 20 8392-8585; Fax: 44 (0) 20 8392-9876
E-mail: info@bushwoodbooks.co.uk
Website: www.bushwoodbooks.co.uk
Free postage in the U.K., Europe; air mail at cost.

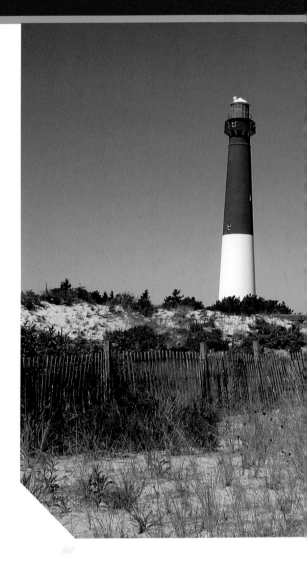

Copyright © 2009 by David Biggy
Library of Congress Control Number: 2008940959

Designed by
Type set in Lucia BT/Zurich BT

ISBN: 978-0-7643-3177-0
Printed in China

Dedication

To my wonderful wife, Melissa, because I wouldn't even have thought to do any of this if it weren't for you. It all started with you, and I thank you so much for your support and encouragement.

Contents

Acknowledgements

First and foremost, my thanks go to the team at Schiffer Publishing for providing the opportunity to further share my photography with the world. Second, gratitude must go to my family and friends who have supported my photography dreams the past several years: Melissa and Herb, Winnie and Warren Anderegg, Roger and Rita Biggy, as well as Mark and Cara. Also, I must mention two important people who have had parts in my personal success, even after their deaths: my grandmother, Stella Biggy, who through hard work and dedication taught me more than I probably realize; and Russell Kilpatrick, who willingly and patiently helped kick-start me into the world of photography by teaching me how to use a camera.

The following people deserve recognition for their help over the past few years: Gary Martin, Mike Hershberger, Ross Tracy, Barry Rosenberg and the rest of the lighthousing.net bunch; Bob Trapani Jr., Jeremy D'Entremont, Timothy Harrison, Jim Walker, Bill and Debbie Jenkins, Gary Richardson, Tony Ratliff, the entire Manahawkin Baptist Church family, Capt. Mike Richards of Chesapeake Lights Boat Tours, Capt. Bo Anderson of Barbour's Marina, Capt. Winston Shaw of SeaVenture Custom Tours, and the captains and crews of the Cape May Whale Watcher, Boston Harbor Cruises, Bay Queen Cruises, Sunbeam Fleet, Long Reach Cruises, the North Carolina ferry system, the Block Island Ferry, the Bald Head Island Ferry, the Isle of Shoals Steamship Company, and the Steamship Authority. Many organizations and their volunteers have given many hours to lighthouse preservation, protection, and restoration efforts. Those groups are listed at the back of this book, so please donate to their causes or, better yet, become a member and volunteer for their success.

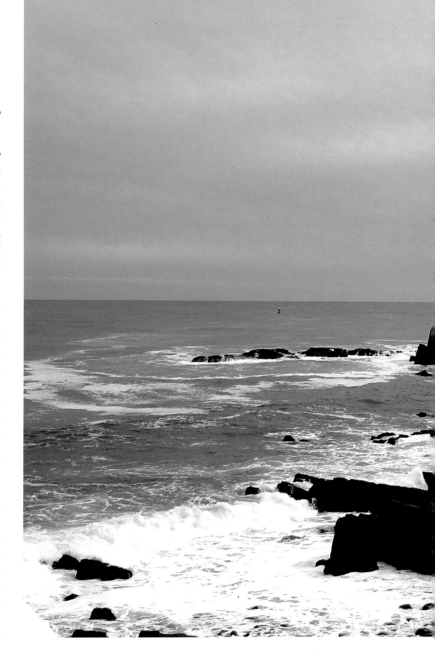

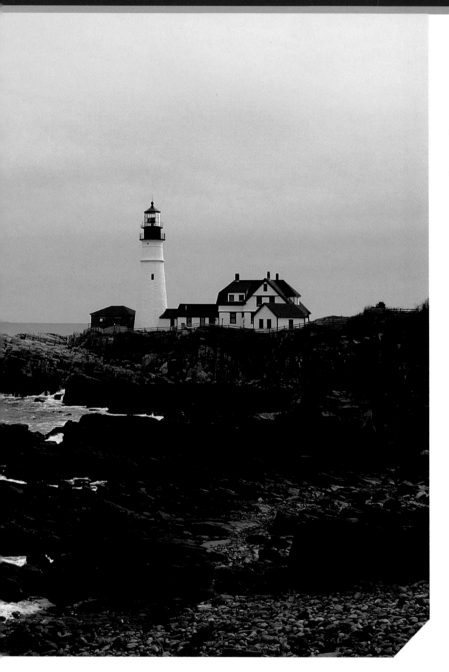

Foreword

Lighthouses are not simply photogenic. Their appearance and sense of place along great coastlines is captivatingly beautiful in a most profound and majestic manner.

It takes special effort to capture these enchanting sentinels amidst the countless moods of the sea and skies, all the while revealing through breathtaking imagery why lighthouses inspire us, give flight to our wildest imaginations, and stir the innermost emotions of those who admire their stately presence.

David Biggy is one such special talent, who not only possesses mastery for the art of photography, but also the rare visual insight and ability to convey the notions of romanticism, mystery, tranquility, strength, vigilence — and even the spiritual connotation of the "light against the darkness" through his riveting photos that are nothing less than works of art.

Is it possible to imagine lighthouses in one favorite scene? Probably not, for we love lighthouses against a plethora of backdrops — from sparkling oceans and sun-splashed skies to storm-lashed coastlines and nighttime mystery, when only the beams of light can be seen over a sea of darkness.

Thankfully, we do not have to choose a favorite scene, for they each share with the viewer the many alluring moods and charming settings, including their irreplaceable environments.

David Biggy doesn't stop with simply conveying the visual beauty of a lighthouse. He also focuses on a very important message throughout his photographic work, the need to preserve lighthouses; for despite the strong appearance of a lighthouse, many beacons are now in need of critical restoration to ensure their preservation for future generations.

So go ahead, sit back in your easy chair or along your favorite coastline and allow yourself to be absorbed by the beauty, colors, and mysteries of the lighthouse and its one-of-a-kind locale. It is an experience that promises to delight and inspire the viewer time and again, making this book a real "keeper."

Bob Trapani, Jr.

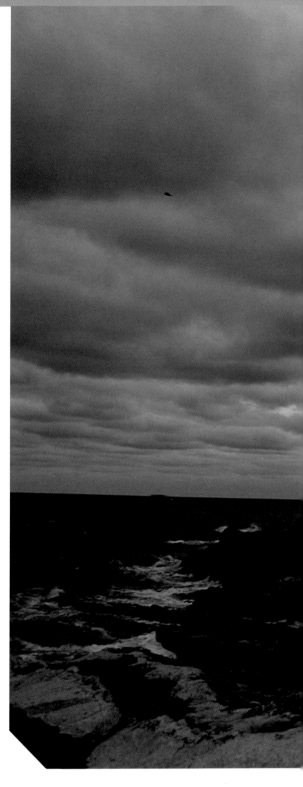

Introduction

Many lighthouses standing today have had their beacons extinguished for decades, while others continue to shine brightly as navigational aids. But whether or not today's lighthouses still cast a light over nearby waters, their history needs to be remembered and cherished, their towers need to be repaired or refurbished, and their existence needs to be preserved for future generations.

Every year, I visit dozens of lighthouses, to capture some of their moments in history as they continue to light the way for mariners, or to show, very simply, that they still exist and weather the tests of time and the fury of nature. For me, every time I visit a lighthouse I'm reminded that I'm telling part of its story through my photographs. And when I review those photos, I am reminded that somebody, somewhere, either once cared or still very much cares for that particular lighthouse.

Today, there are dozens of folks who give countless hours, sweat and blood to the effort of preserving, restoring and protecting lighthouses up and down the United States' East Coast keeping their histories alive. Dozens of organizations, some of which are listed in this book, exist for this sole purpose, and they too need our help, either through donations or those who have some time to volunteer to their efforts.

As you turn the pages of this book, I not only want you to see each lighthouse as a structure with a revered past, one of great service and nobility, but also as a sentinel marking the future, one that deserves all of our support. Each lighthouse in this book can mean something to somebody, and it's my hope to inspire you to act upon your desire to see whichever beacon you hold near and dear to your heart remain standing as a light for future generations.

The only reason a book like this exists is because these lighthouses are still around. These are *our* lighthouses. We need to do our best to keep them shining for decades, even centuries, to come. At the end of this photographic journey is a list of organizations which help keep many of these lighthouses standing, and keep their stories surging forward.

Most of these great beacons of hope are no longer saving lives, but each one can use your help.

Remember ... together, in many ways and by using our God-given gifts, we can keep these lights shining forever. My way of doing so just so happens to be resting within your hands right now. My photographs are not here to show off a talent God has blessed me with, but to give you a simple, realistic look at each lighthouse's personal story, and inspire you to action.

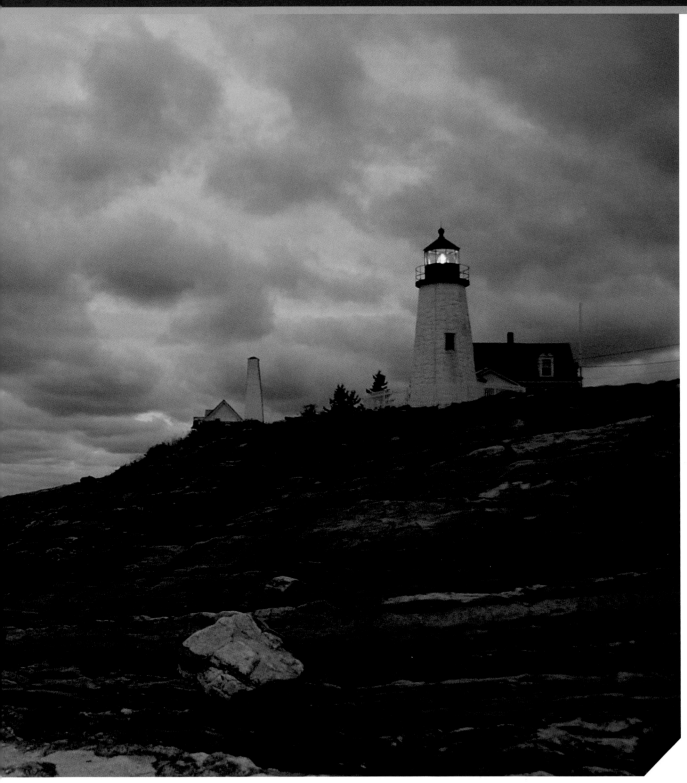

As you take my journey from Maine, through New England and into New Jersey and the Mid-Atlantic, down through the Outer Banks and then to Florida, please keep in mind that each lighthouse along the path I've put forth in front of you needs some help in order to keep its story shining brightly for generations to come. Please help however and whenever you can.

Maine

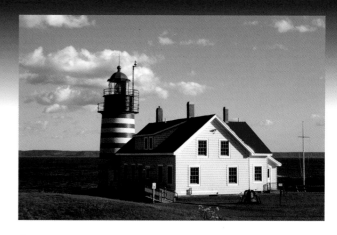

Since 1858, West Quoddy Head Lighthouse has stood at the eastern-most point in the United States and today is one of the most recognized lighthouses in Maine for its distinctive, striped daymark.

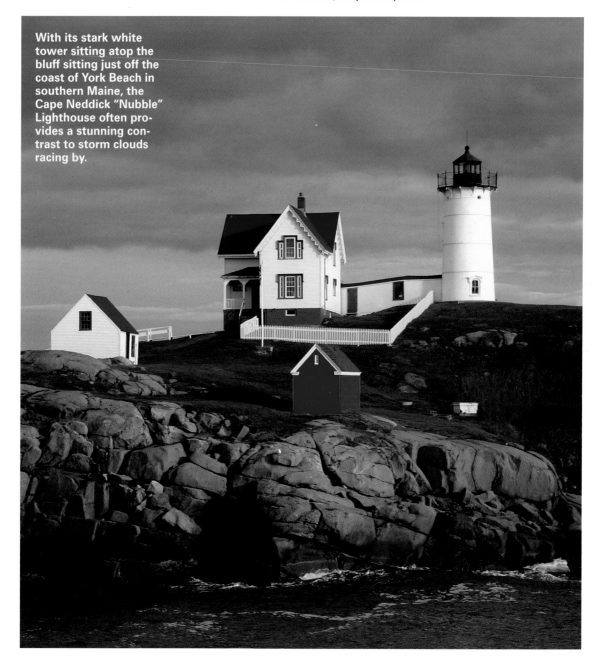

With its stark white tower sitting atop the bluff sitting just off the coast of York Beach in southern Maine, the Cape Neddick "Nubble" Lighthouse often provides a stunning contrast to storm clouds racing by.

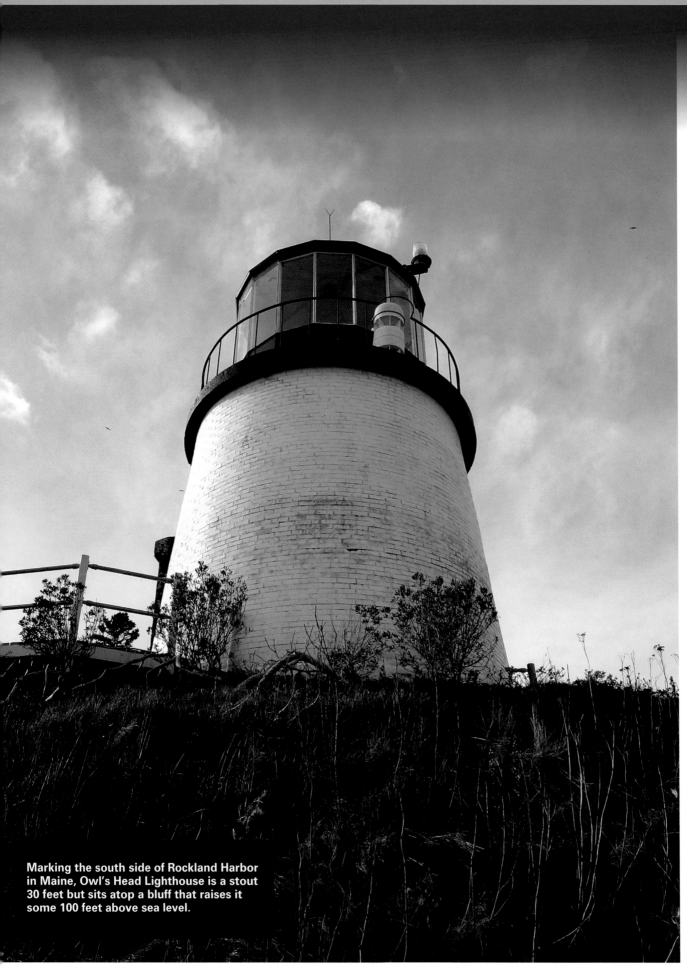

Marking the south side of Rockland Harbor in Maine, Owl's Head Lighthouse is a stout 30 feet but sits atop a bluff that raises it some 100 feet above sea level.

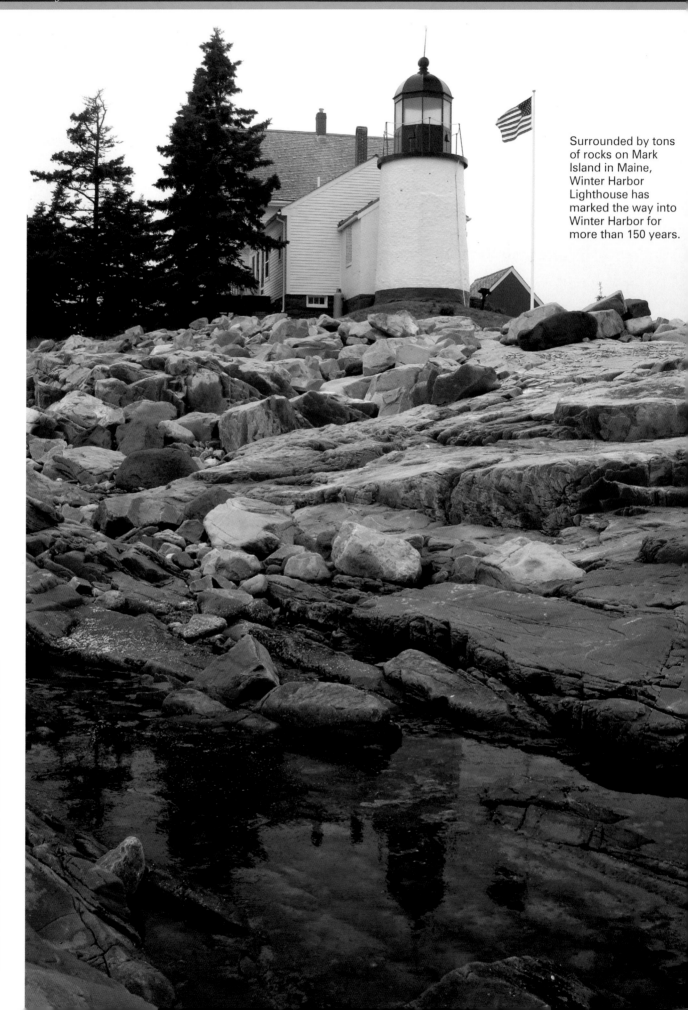

Surrounded by tons of rocks on Mark Island in Maine, Winter Harbor Lighthouse has marked the way into Winter Harbor for more than 150 years.

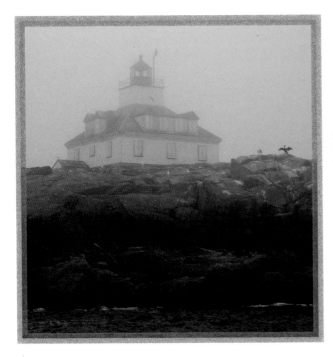

Located on a dangerous island near the entrance to Frenchman Bay in Maine, Egg Rock Lighthouse, built in 1875, often encounters foggy days and nights.

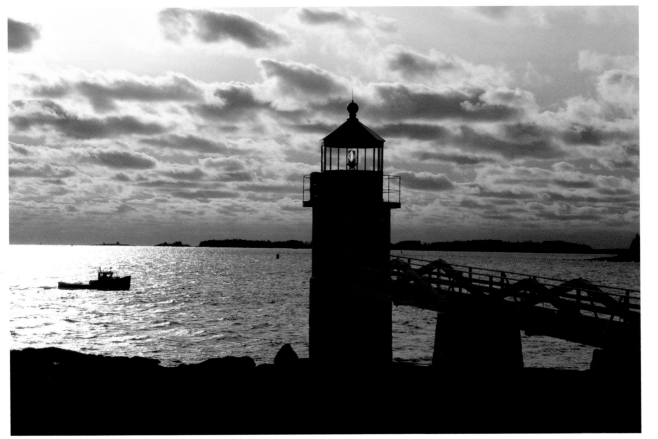

Built in 1857 at a height of 31 feet, Marshall Point is another such lighthouse with a foot-bridge that connects the tower to land.

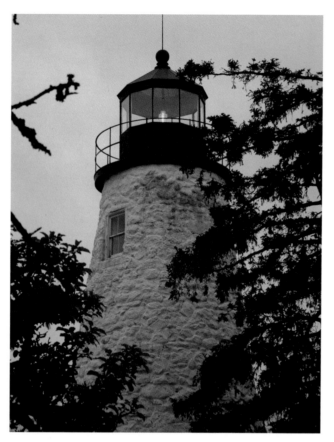

Left:
Built in 1829, Dice Head Lighthouse marks the eastern entrance to the Penobscot River and sits atop a 100-foot bluff.

Opposite Page:
Located atop a cliff at the southern tip of Mount Desert Island within Acadia National Park in Maine, Bass Harbor Head Lighthouse was built in 1858 and still has its red Fresnel lens.

Below:
If you ever wanted to get a look at why Bass Harbor Head Lighthouse was built to mark the southeast entrance of Blue Hill Bay, just go there at sunset.

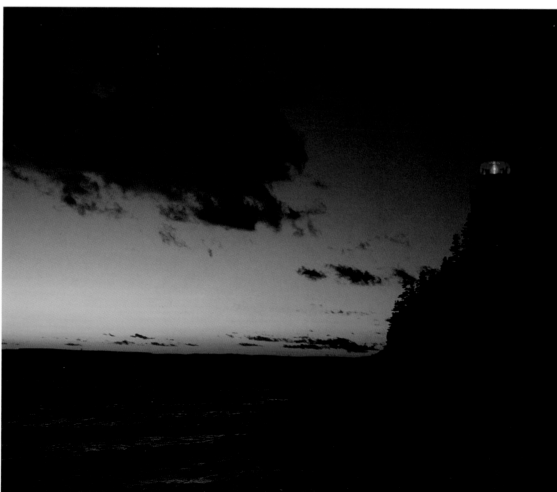

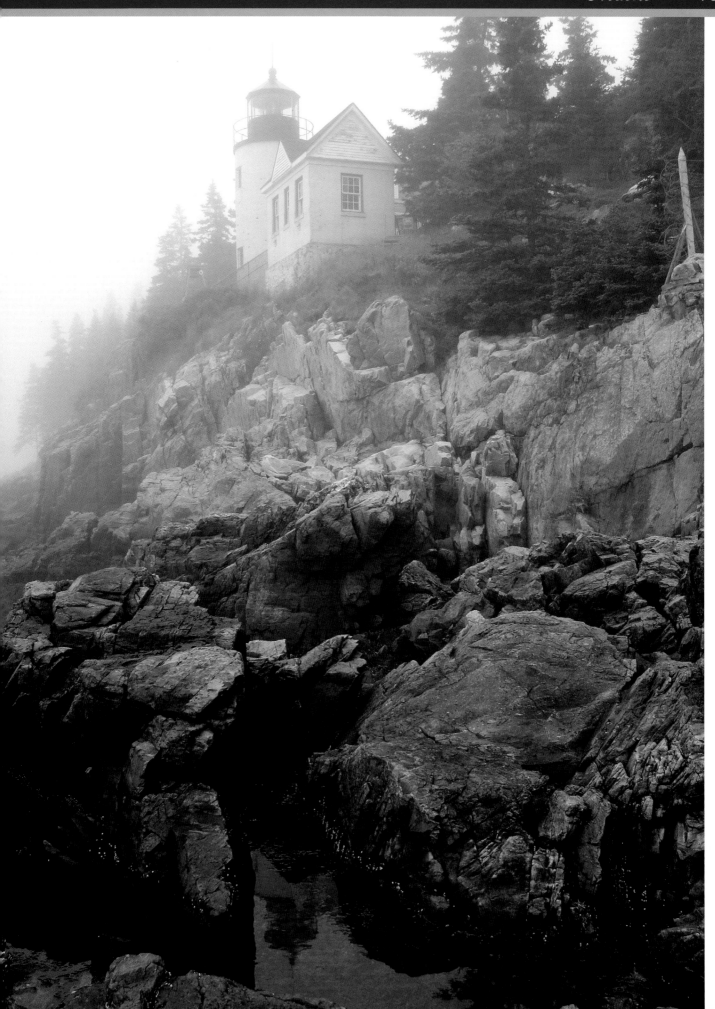

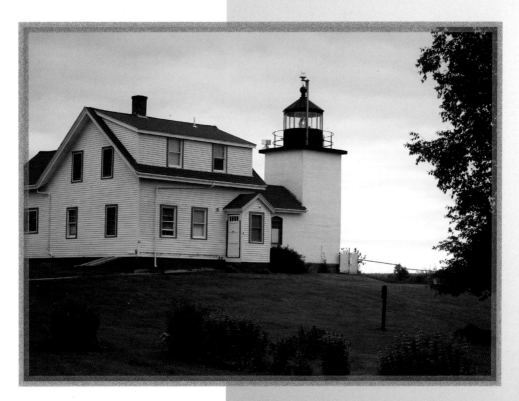

The grounds surrounding Fort Point Lighthouse, which marks the western side of the mouth of the Penobscot River in Maine, offer plenty of viewing angles and spots to relax.

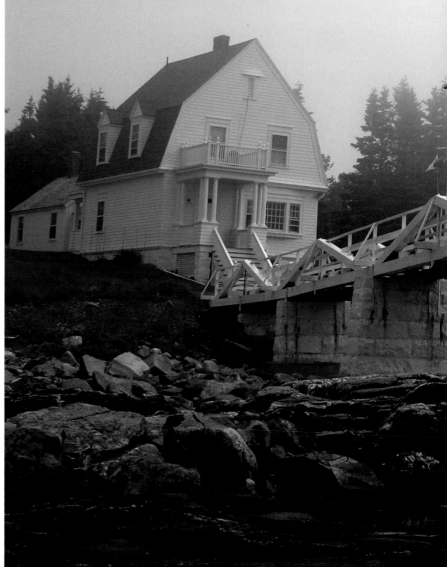

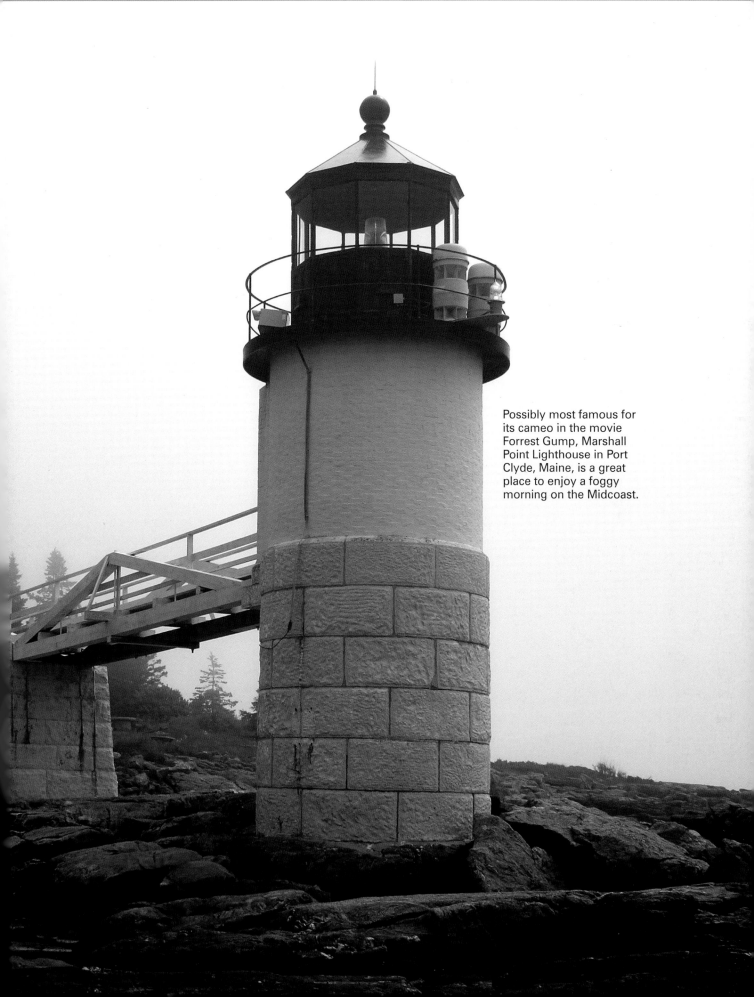

Possibly most famous for its cameo in the movie Forrest Gump, Marshall Point Lighthouse in Port Clyde, Maine, is a great place to enjoy a foggy morning on the Midcoast.

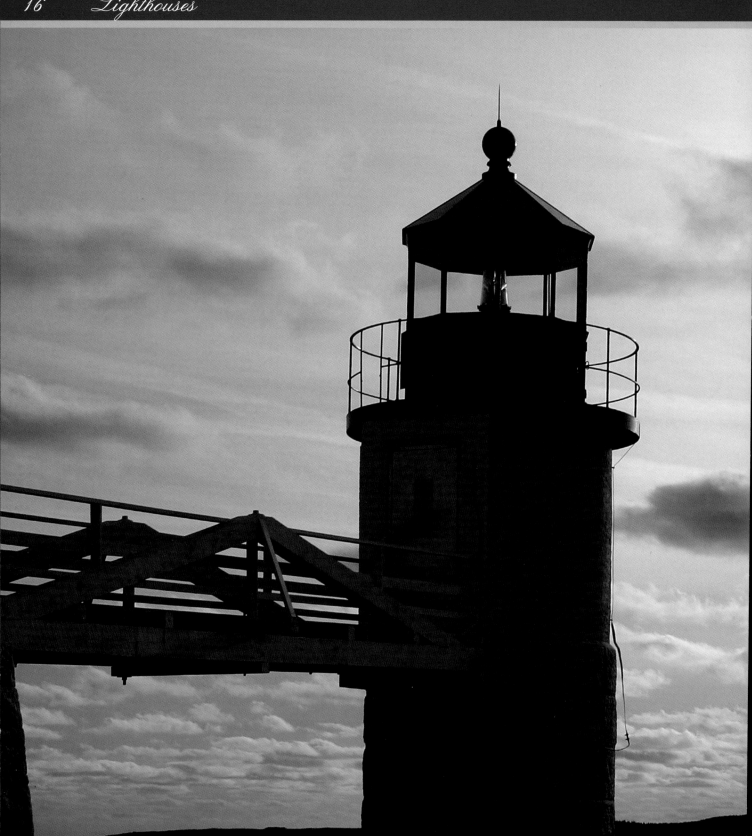

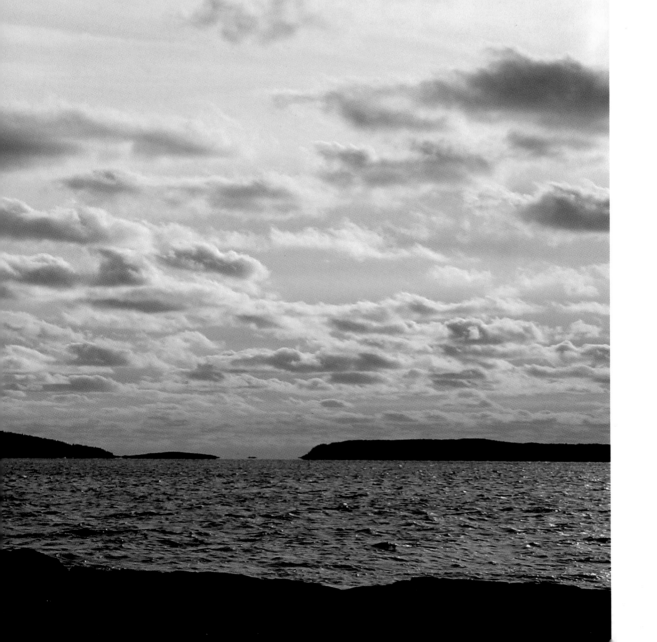

Depending on
the time of year,
the skies over
Marshall Point
Lighthouse in
Maine can yield
many different
colors and reflect
all kinds of moods.

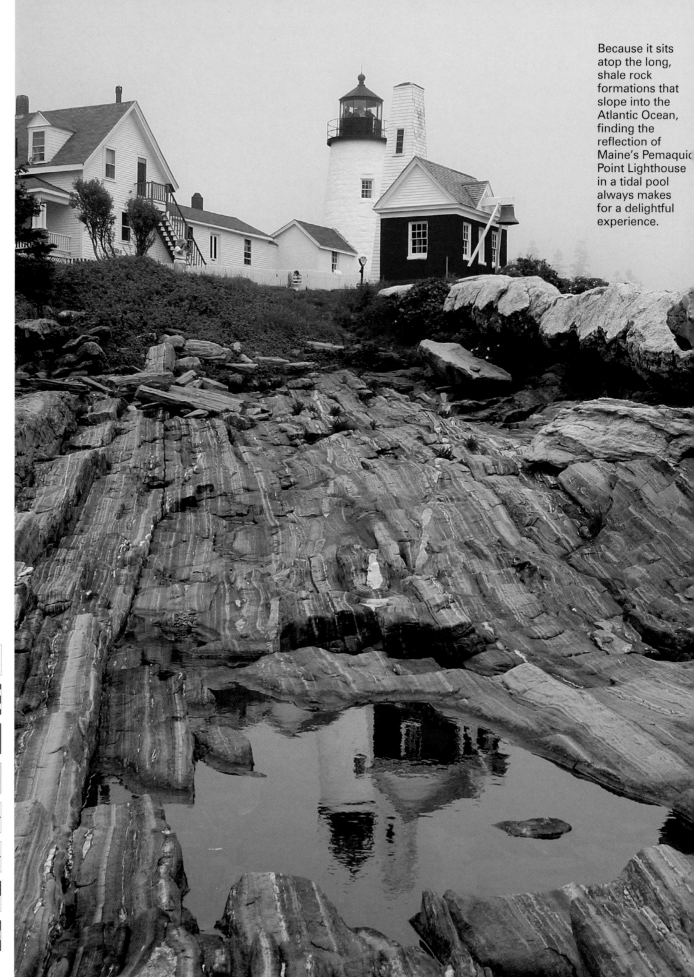

Because it sits atop the long, shale rock formations that slope into the Atlantic Ocean, finding the reflection of Maine's Pemaquid Point Lighthouse in a tidal pool always makes for a delightful experience.

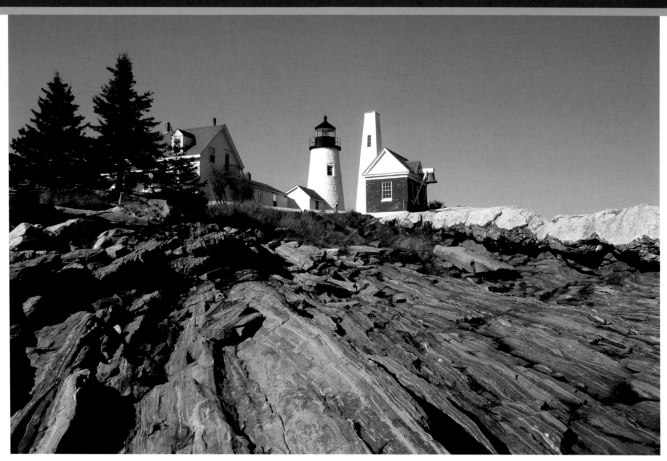

Whether it's a clear day in May or a foggy morning in June, Pemaquid Point Lighthouse in South Bristol, Maine, stands as one of the most photographed lights on the East Coast.

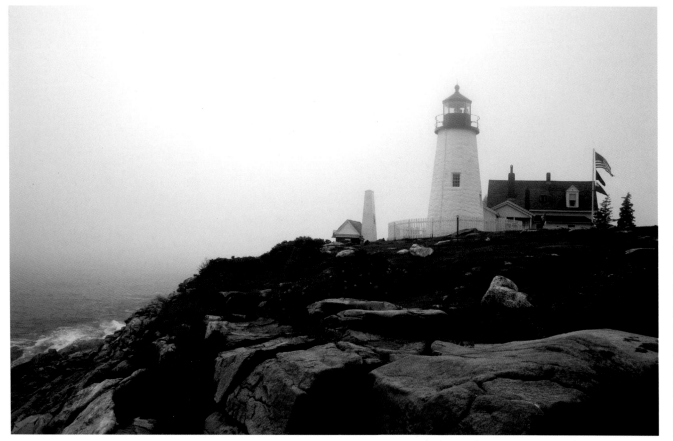

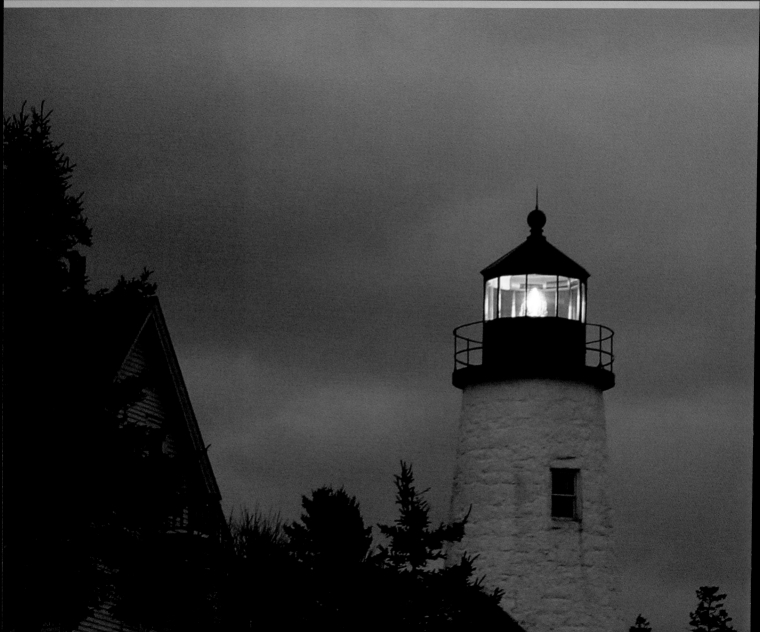

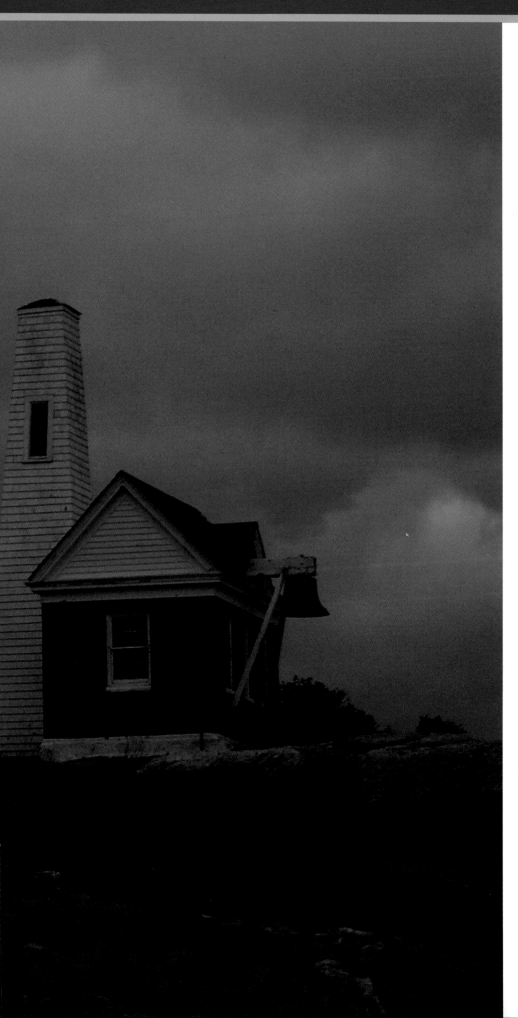

Stormy clouds right after the sun sets provides an interesting mood as the bright light of Pemaquid Point Lighthouse shines brightly atop its rocky, and treacherous, spot along the Atlantic Ocean.

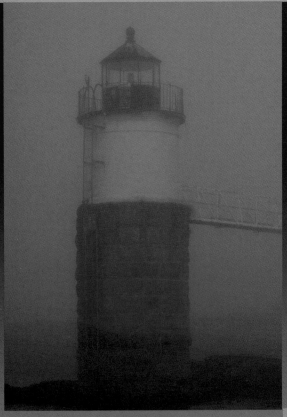

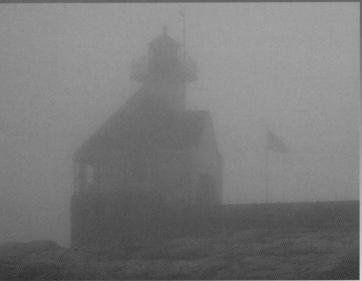

Sitting atop an island located near the western entrance to Boothbay Harbor in Maine, Burnt Island Lighthouse often stands amid foggy conditions.

One of several lighthouses near the entrance of Boothbay Harbor in Maine, Ram Island's fog signal blasts every 30 seconds.

Many times throughout the year, The Cuckolds Lighthouse in Maine is completely engulfed by fog, which is why its fog signal continues to blast every 15 seconds after more than 100 years in service.

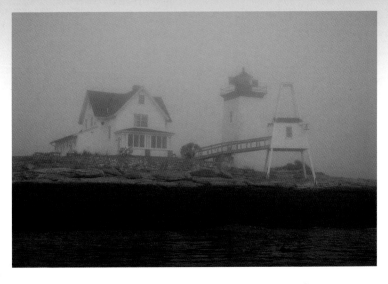

Like many of the lighthouses in the Boothbay region, the 39-foot-tall Hendricks Head Lighthouse frequently stands engulfed by fog.

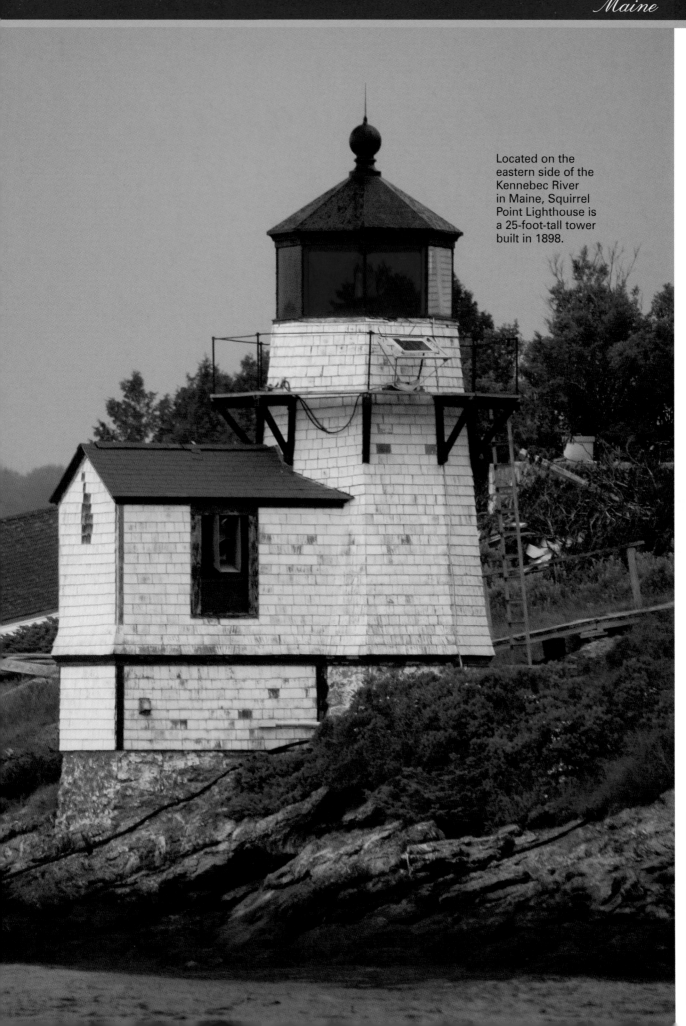

Located on the eastern side of the Kennebec River in Maine, Squirrel Point Lighthouse is a 25-foot-tall tower built in 1898.

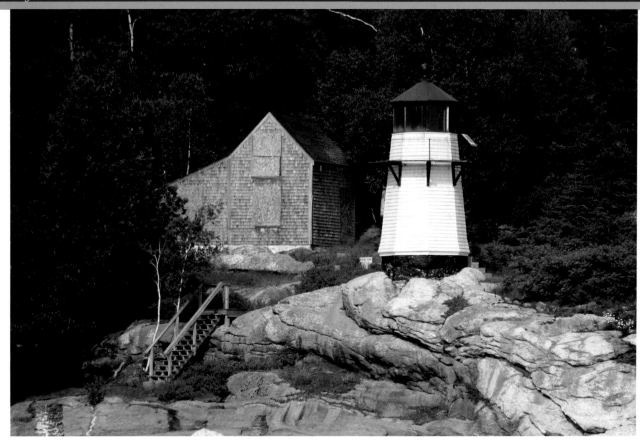

Above:
Standing just 23 feet tall, Perkins Island Lighthouse marks a dangerous area near the mouth of the Kennebec River along Maine's rugged Midcoast.

Below:
Built in 1898 on the eastern side of the Kennebec River, the 23-foot tower that is Doubling Point Lighthouse has a footbridge that seems fairly common among Maine lighthouses.

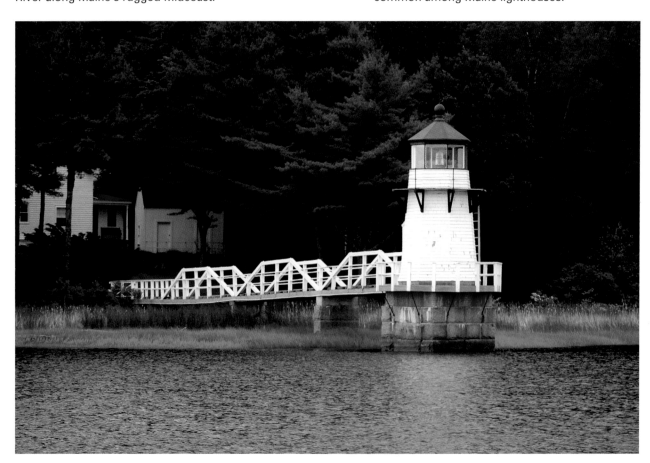

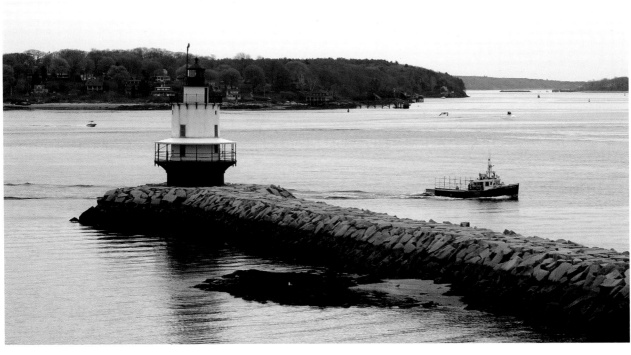

Above:
Spring Point Ledge Lighthouse has an important function as one of several markers into Maine's Portland Harbor, guiding the way for many boats at all times of the day and night.

Below:
One of the markers at the entrance to Portland Harbor, the Portland Breakwater Lighthouse is a diminutive 26 feet and has a unique Grecian design.

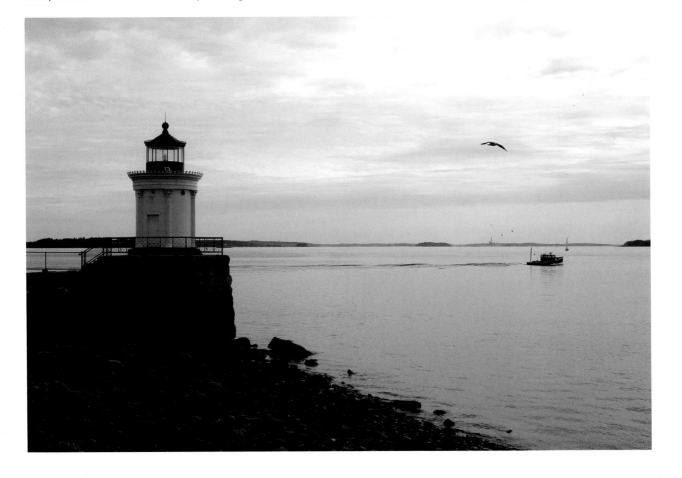

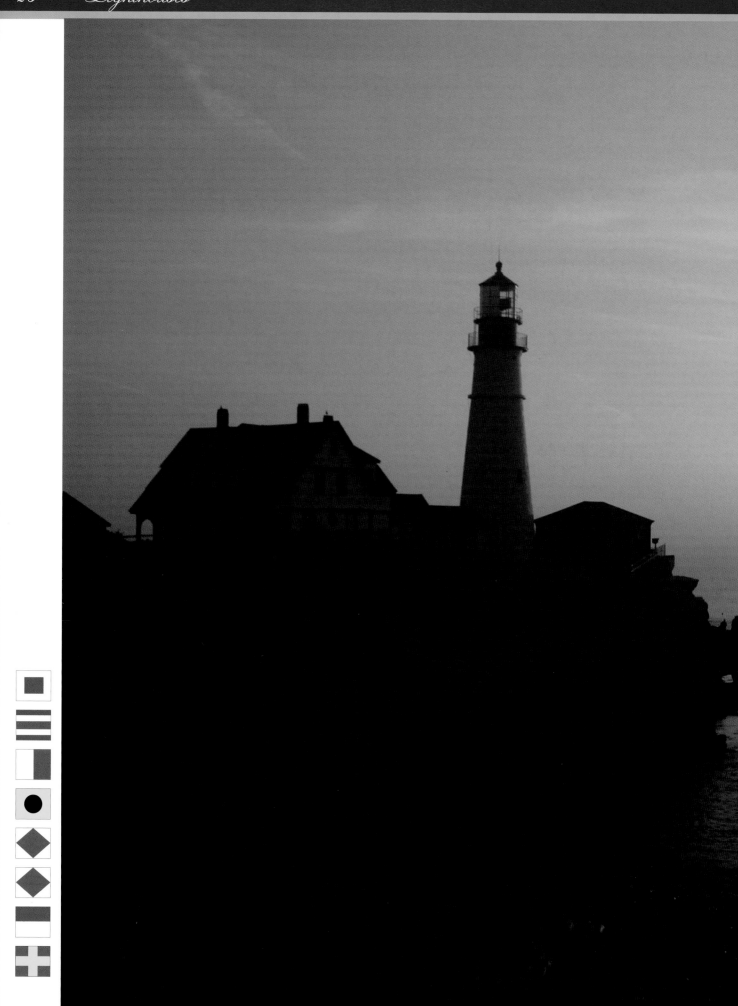

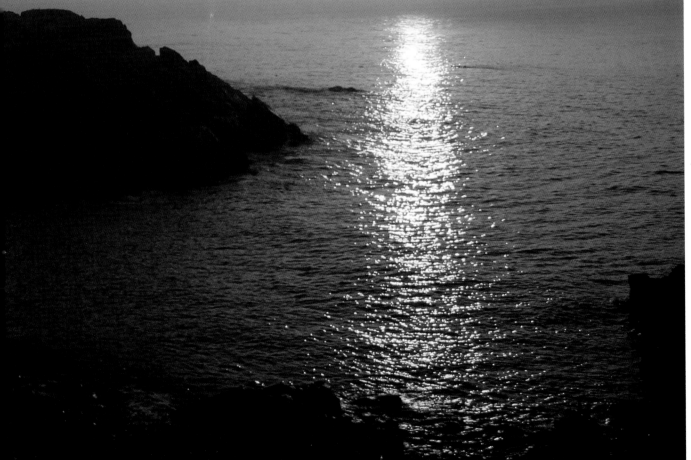

Even without roaring waves crashing on the nearby rocks, the scenery that surrounds Portland Head Lighthouse in Maine is spectacular.

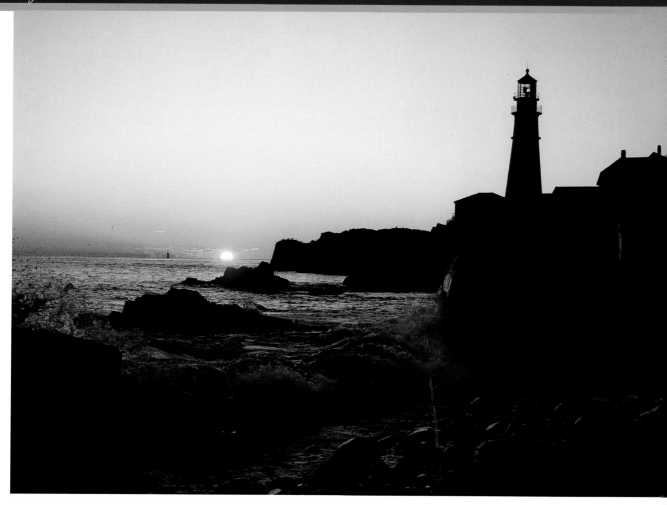

Whether it's sunrise or later on in the day, Portland Head Lighthouse, which was built in 1791, is one of the most picturesque lighthouses in the entire country.

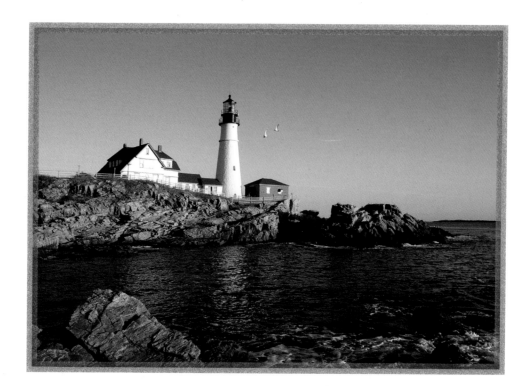

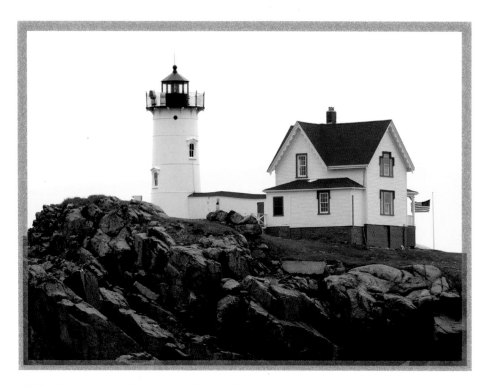

While the western side of the bluff on which Cape Neddick "Nubble" Lighthouse stands is easily viewed, many people rarely get the opportunity to see the side of "the nubble" that for many years was the most dangerous for mariners.

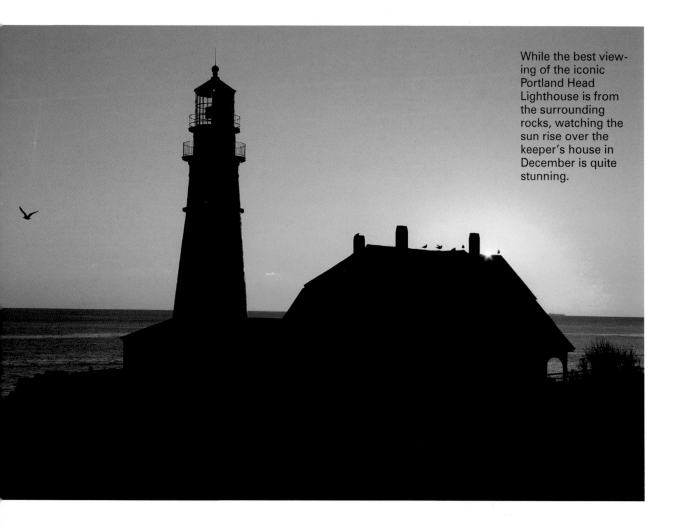

While the best viewing of the iconic Portland Head Lighthouse is from the surrounding rocks, watching the sun rise over the keeper's house in December is quite stunning.

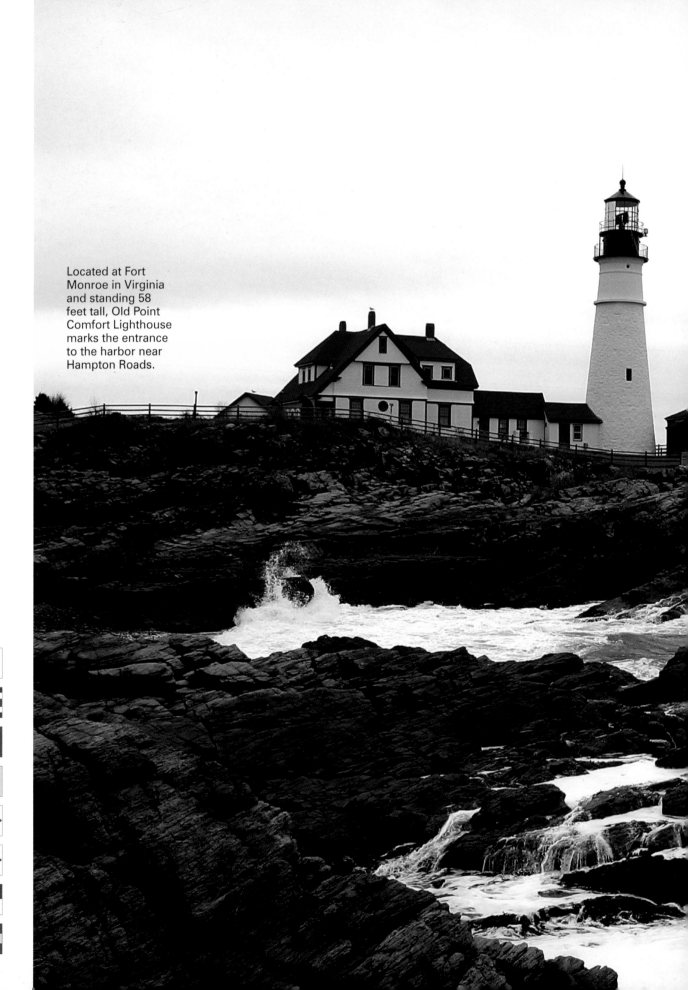

Located at Fort Monroe in Virginia and standing 58 feet tall, Old Point Comfort Lighthouse marks the entrance to the harbor near Hampton Roads.

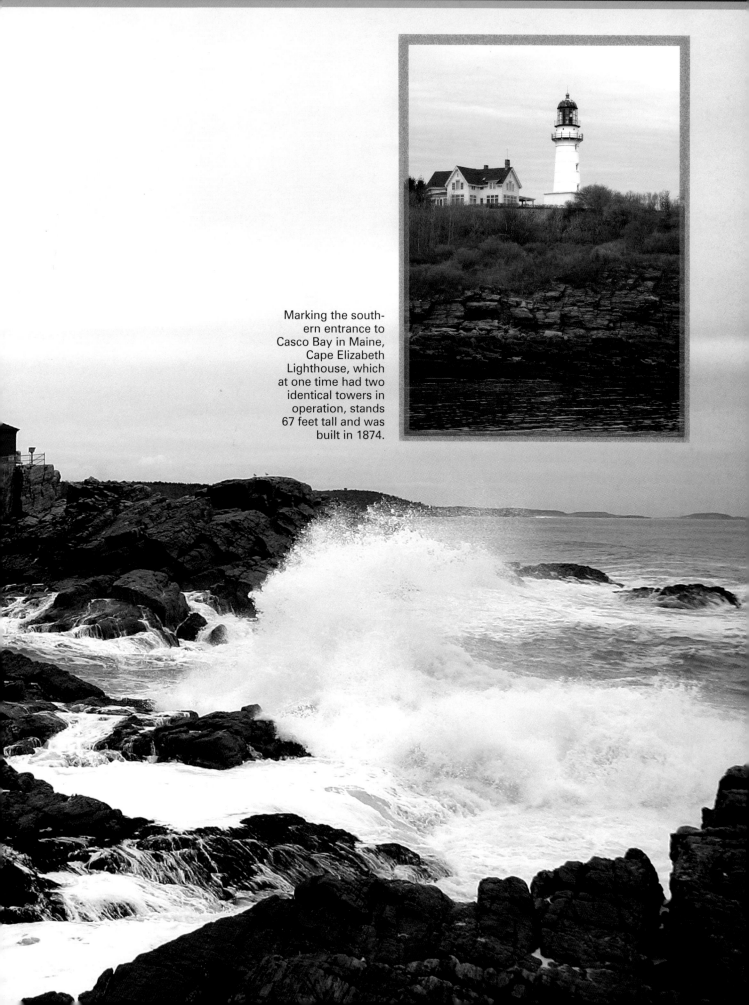

Marking the southern entrance to Casco Bay in Maine, Cape Elizabeth Lighthouse, which at one time had two identical towers in operation, stands 67 feet tall and was built in 1874.

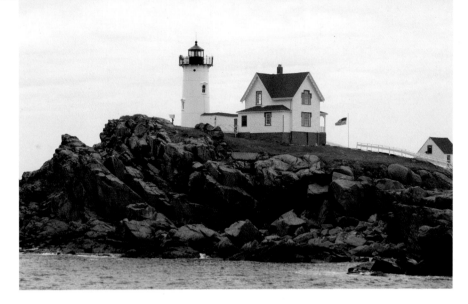

At any time of the year, the view of Cape Neddick from the Atlantic Ocean is even more astonishing, with the weather-beaten rocks of "the nubble" revealing the clear signs of danger at this spot on Maine's rugged coastline.

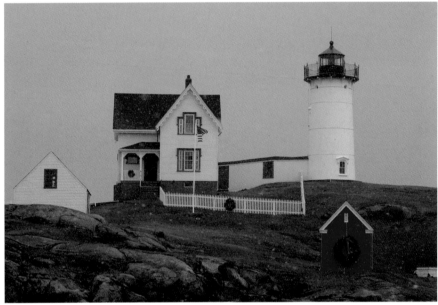

During the Christmas season in Maine, York Beach residents and visitors get to see Cape Neddick "Nubble" Lighthouse all decked out for the holiday, which also includes a nightly lights display.

Located near the entrance to the Piscataqua River, Whaleback Lighthouse is Maine's southern-most lighthouse and it too has received its share of rough weather.

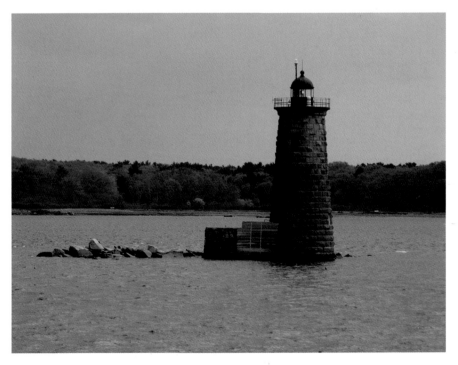

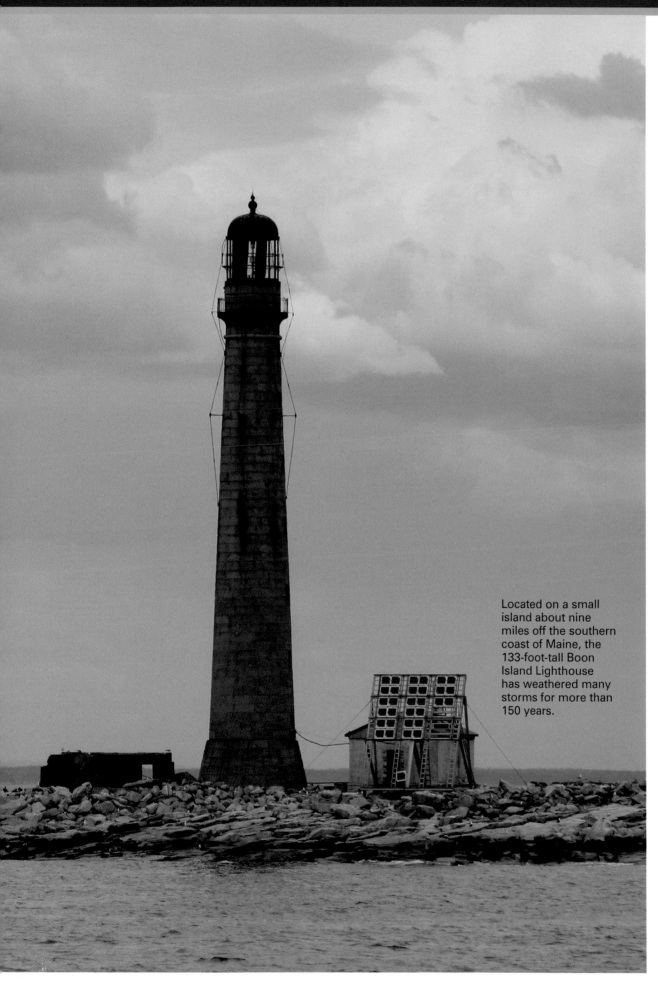

Located on a small island about nine miles off the southern coast of Maine, the 133-foot-tall Boon Island Lighthouse has weathered many storms for more than 150 years.

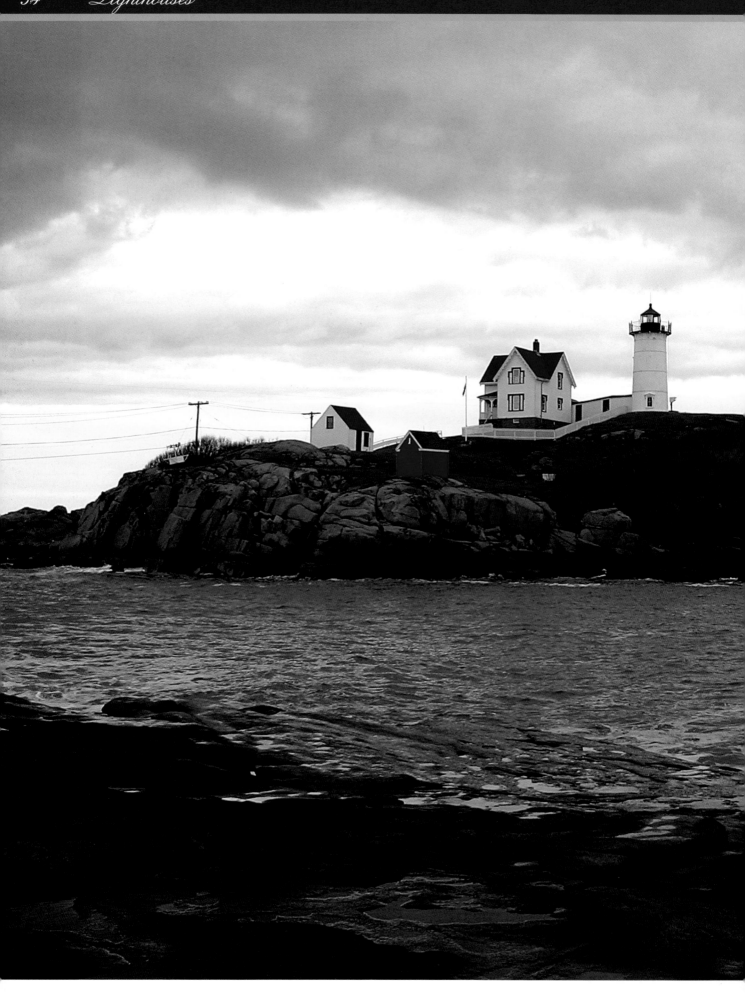

Cape Neddick "Nubble" Lighthouse always offers a picturesque scene no matter what time of year, and no matter what type of weather.

New Hampshire

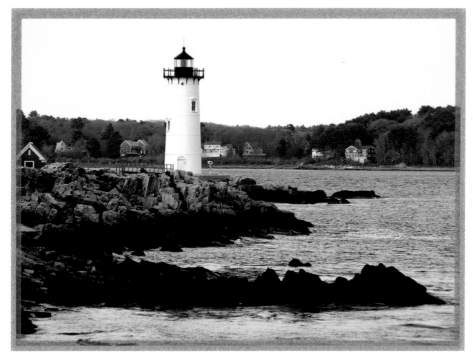

Not only is Portsmouth Harbor Lighthouse the only land-based Atlantic Coast light in New Hampshire, it's in a very scenic spot near the entrance to the Piscataqua River.

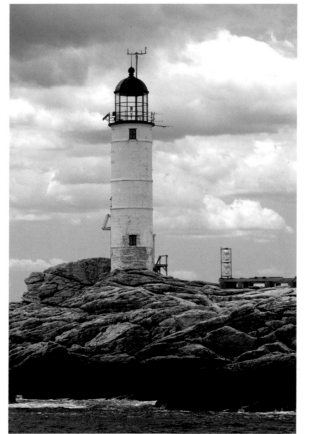

After having its covered walkway from the keeper's house to the light destroyed by a storm in 2007, White Island Lighthouse's tower stands as a testimony to the dangerous waters surrounding the Isle of Shoals about six miles off the coast of New Hampshire.

Opposite page:
Built in 1878, Portsmouth Harbor Lighthouse is one of just two lights in New Hampshire located near the Atlantic Ocean.

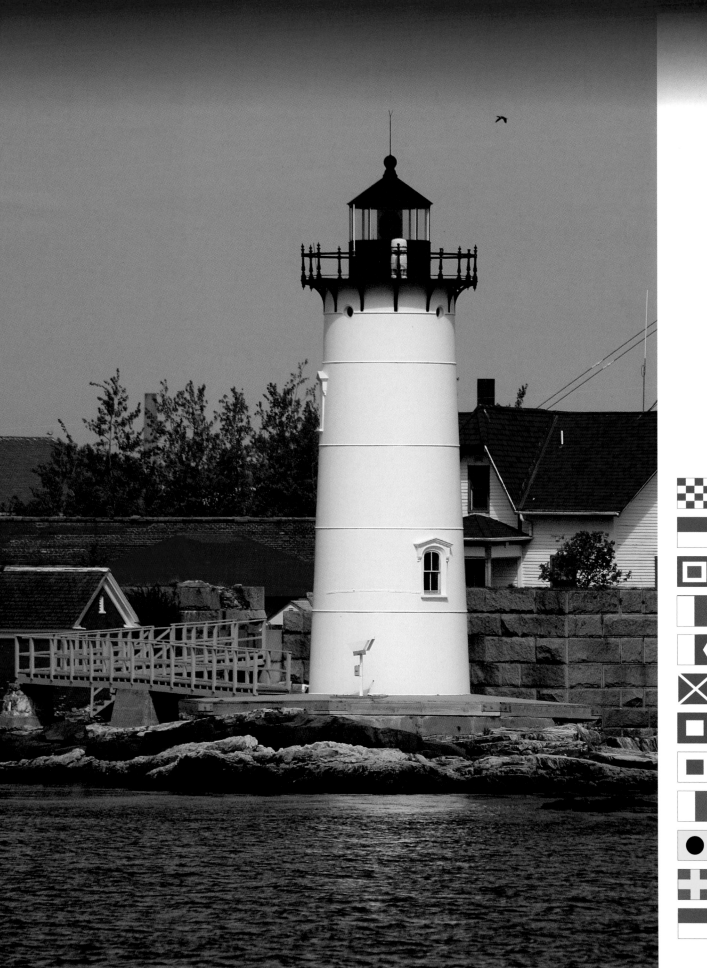

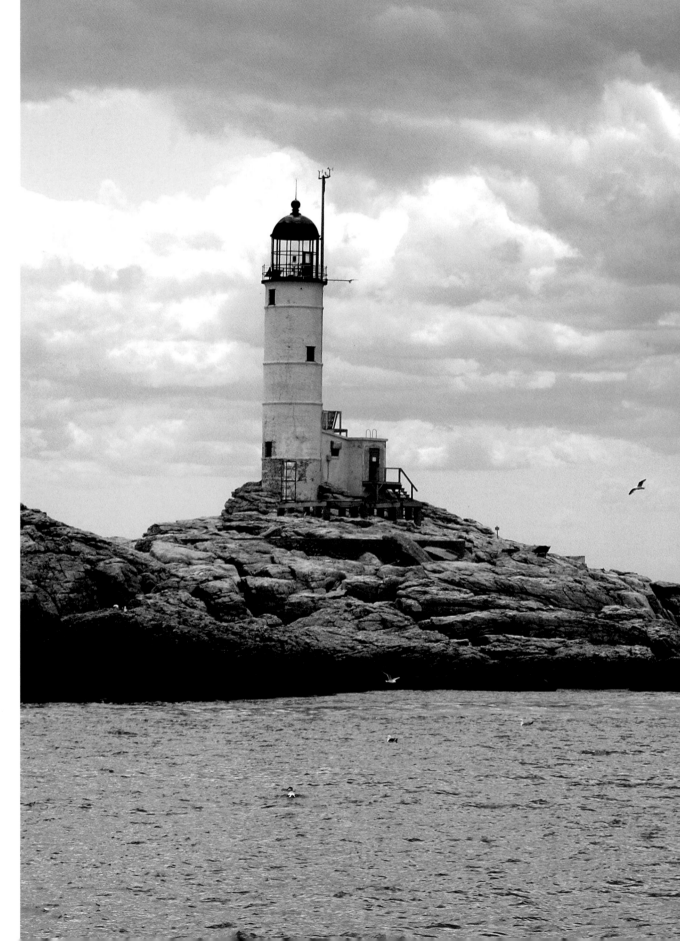

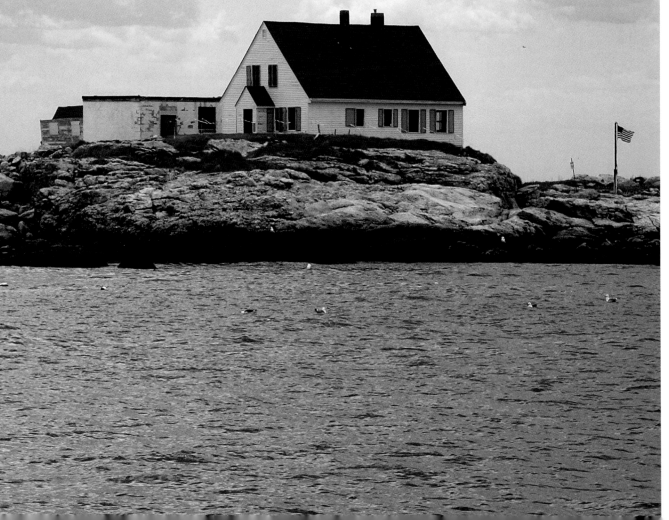

One of only
two lighthouses
along the
Atlantic Coast in
New Hampshire,
White Island
Lighthouse sits
atop a bluff amid
the Isle of Shoals
about six miles
off the coast.

Massachusetts

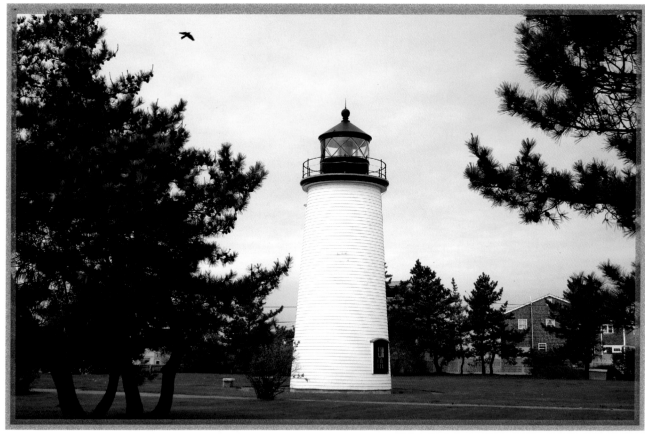

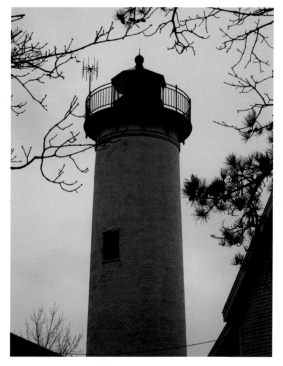

Above:
Located on a nine-mile-long barrier island off the northern coast of Massachusetts, Plum Island Lighthouse stands as a marker to the entrance of the Merrimack River.

Left:
Still an active light, West Chop Lighthouse, built in 1891, marks the western side of the entrance to Vineyard Haven Harbor on Martha's Vineyard.

Opposite Page:
The only exo-skeletal light on the coast of Massachusetts, Marblehead Lighthouse was built in 1896 and stands 105 feet tall at the entrance to Marblehead Harbor.

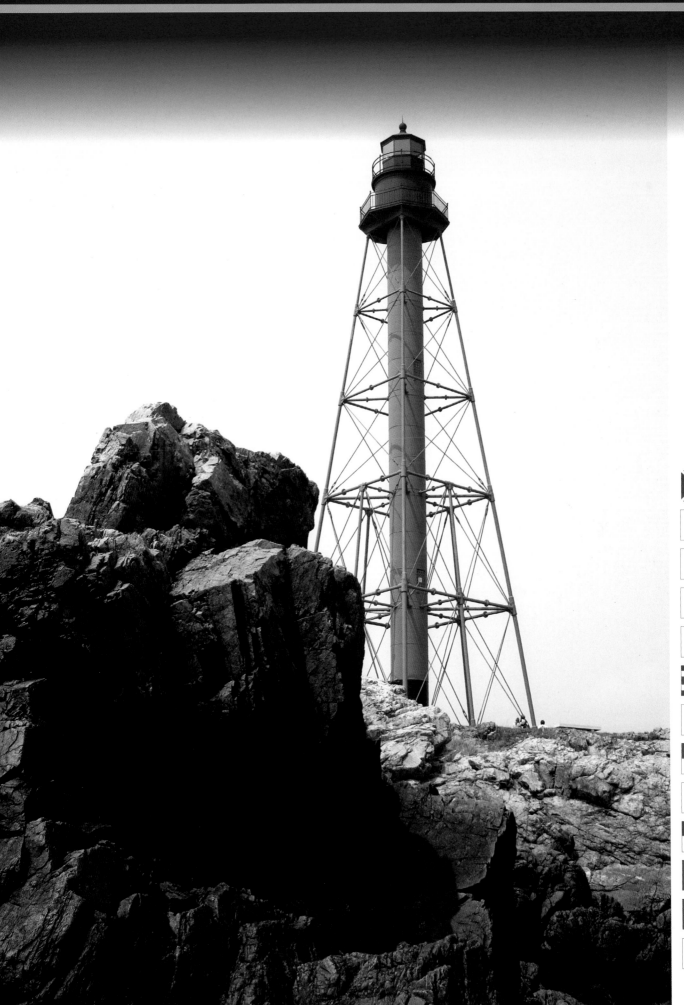

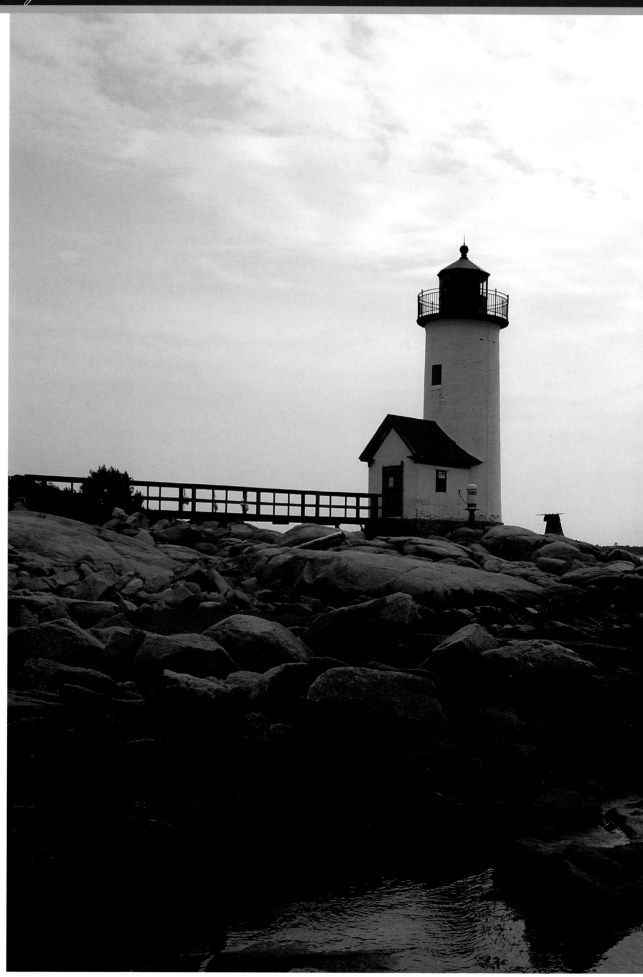

Located at the
eastern side
of the north
entrance to the
Annisquam River
in Massachusetts,
Annisquam
Lighthouse stands
41 feet tall and
was built in 1897.

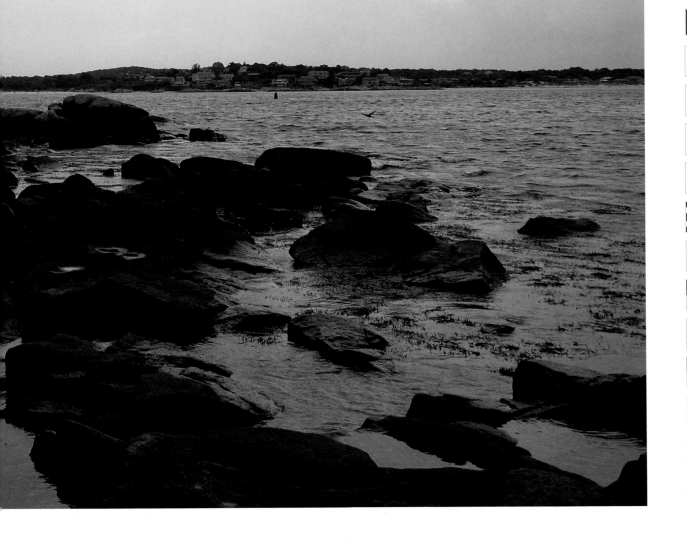

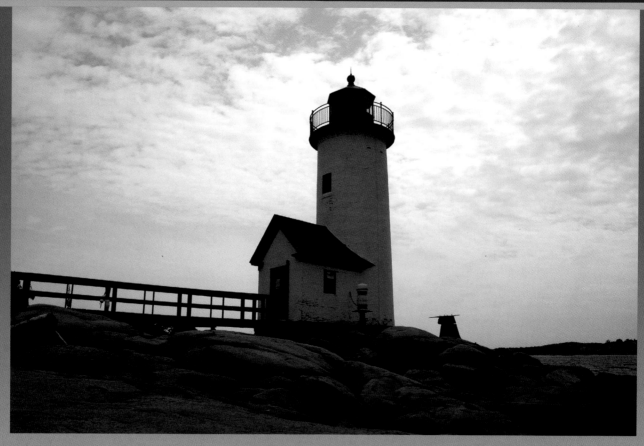

Above:
On a relatively stormy day, the backdrop for Annisquam Lighthouse at the northeast side of Cape Ann in Massachusetts can become an ominous one.

Below:
The short, square Derby Wharf Lighthouse has been lighting a path for boats traveling into Salem Harbor for more than 135 years.

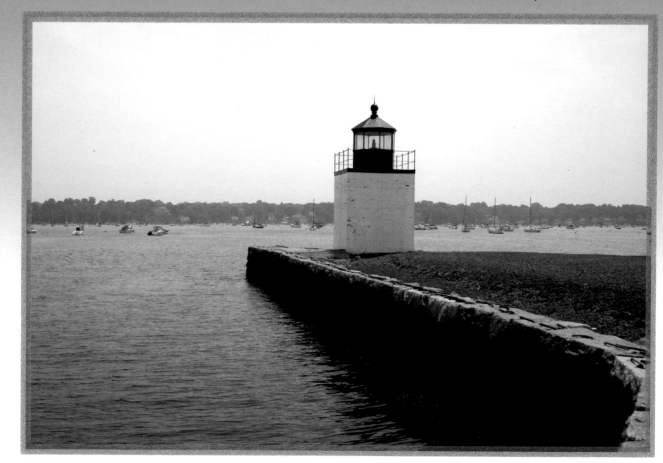

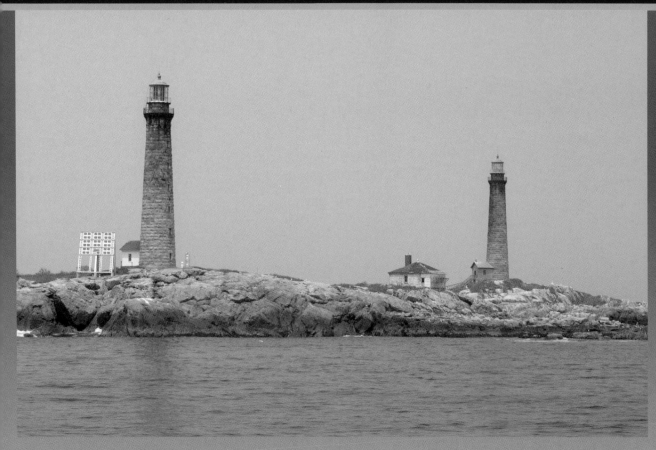

Above:
At 124 feet tall, the Thacher Island Twin Lights have been stalwarts of strength since 1861 and remain today as the country's only operational pair of twin lights.

Below:
Located on the eastern side of the entrance to Gloucester Harbor in Massachusetts, Eastern Point Lighthouse was built in 1890 and remains active.

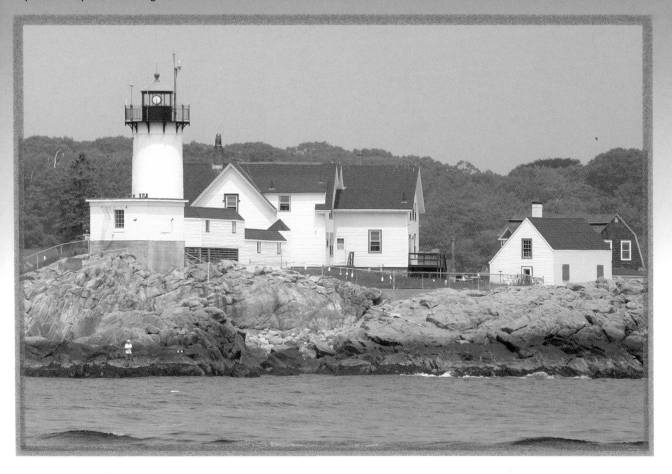

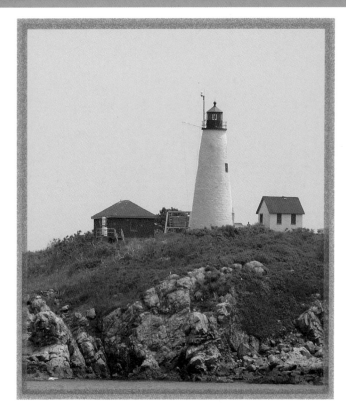

Built in 1820 and standing on an island near the approach to Salem Harbor in Massachusetts, Baker's Island Lighthouse also remains active.

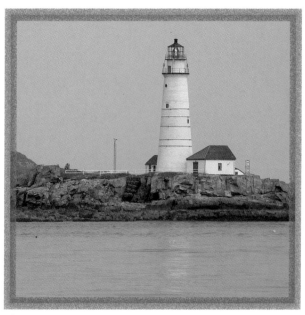

Marking the entrance to one of the most famous bodies of water in American history, Boston Harbor Lighthouse stills stands today as the only lighthouse in the country with a light keeper.

Even in the fog, Minot's Ledge Lighthouse stands out, and has been doing so since the current tower was built in 1860.

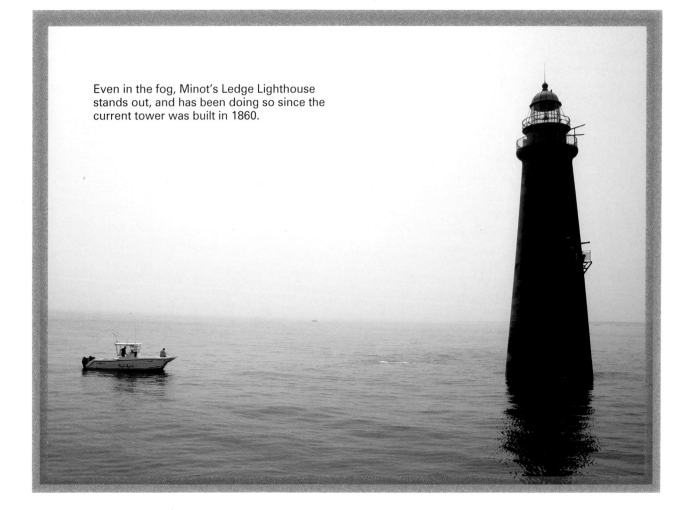

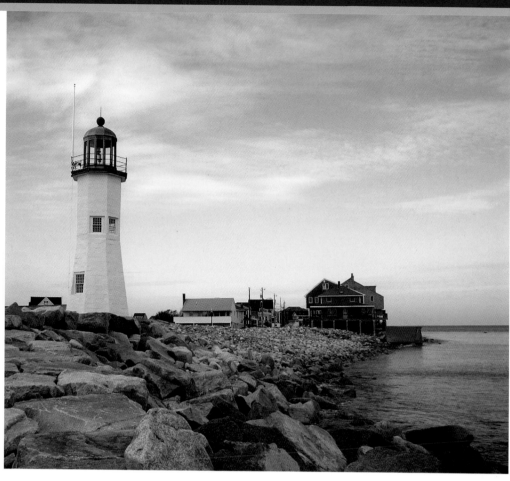

Tons of rocks that form a jetty stretch to the southeast of Scituate Lighthouse, making the spot a good one for local fishermen as well as visiting sightseers.

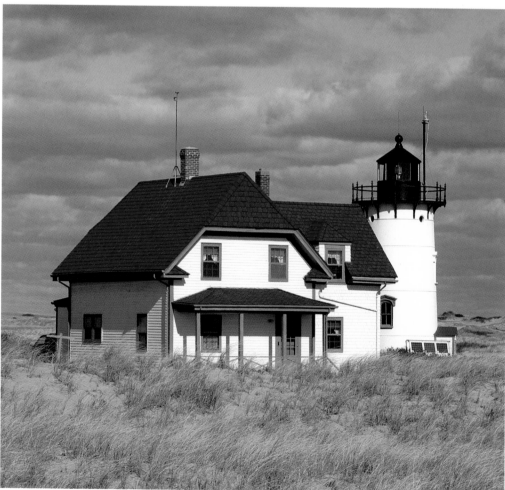

The northern end of Cape Cod, where Race Point Lighthouse and its keeper's house stand, can get quite blustery in November.

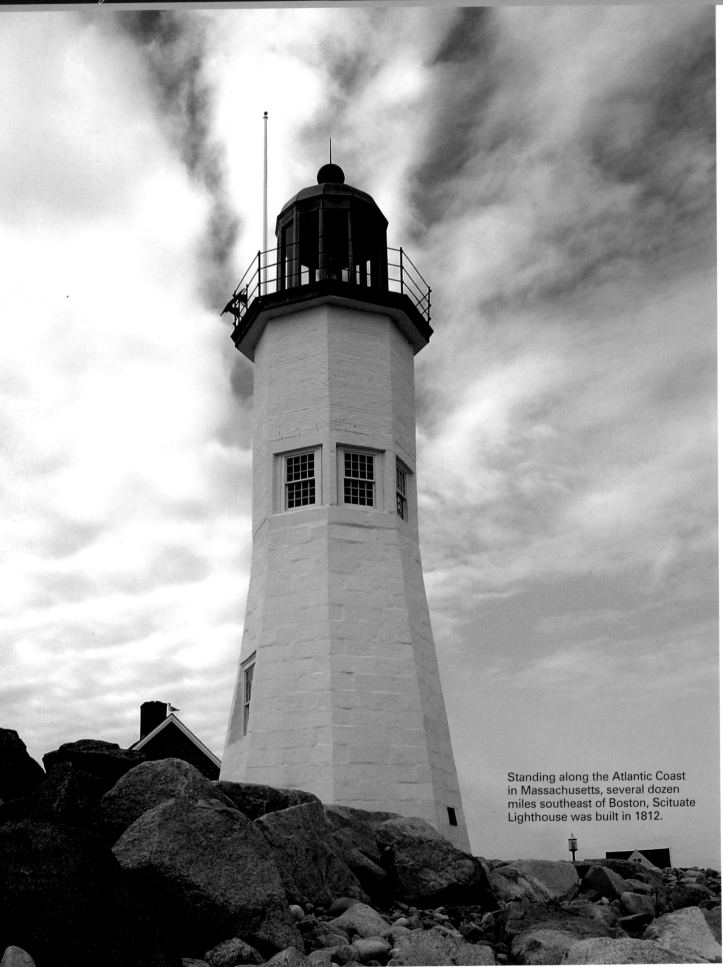

Standing along the Atlantic Coast in Massachusetts, several dozen miles southeast of Boston, Scituate Lighthouse was built in 1812.

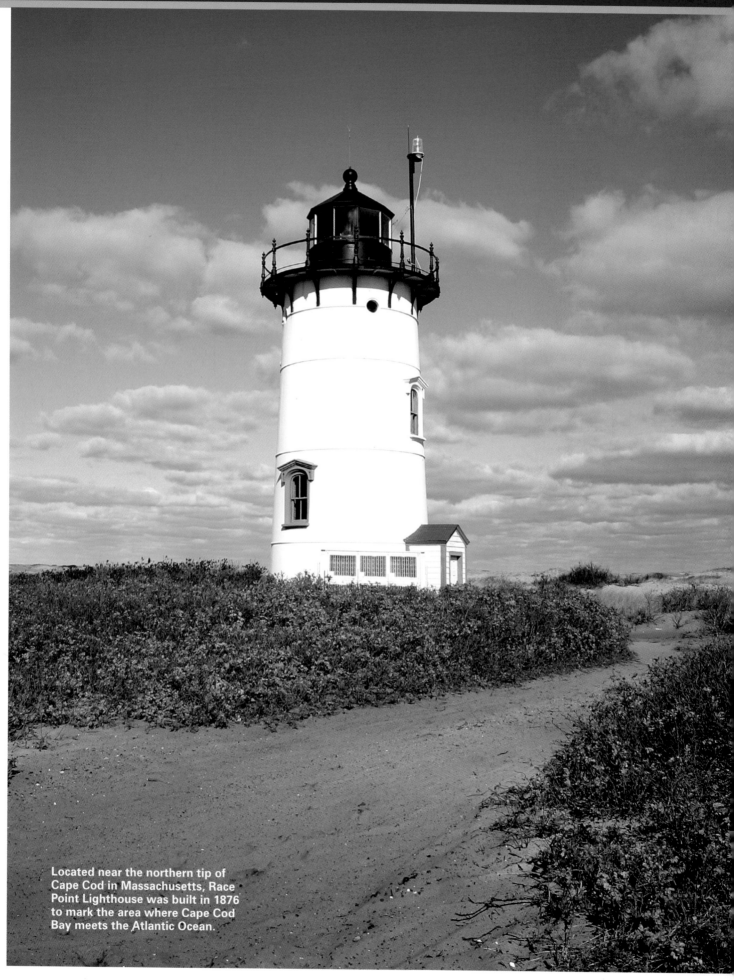

Located near the northern tip of Cape Cod in Massachusetts, Race Point Lighthouse was built in 1876 to mark the area where Cape Cod Bay meets the Atlantic Ocean.

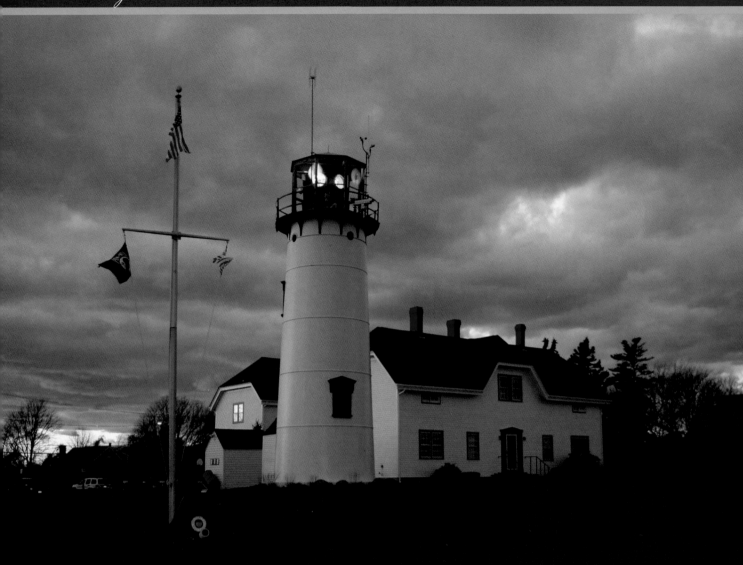

Once home to a pair of identical lighthouses, Chatham Lighthouse continues to light the way for ships passing the eastern side of Cape Cod in Massachusetts.

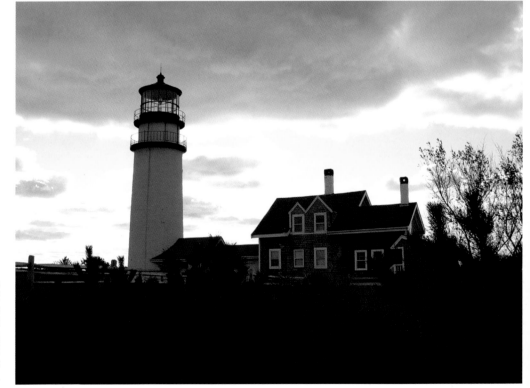

Located on the northeast side of Cape Cod's Atlantic Coast, Highland Lighthouse was built in 1857 and has weathered its share of storms.

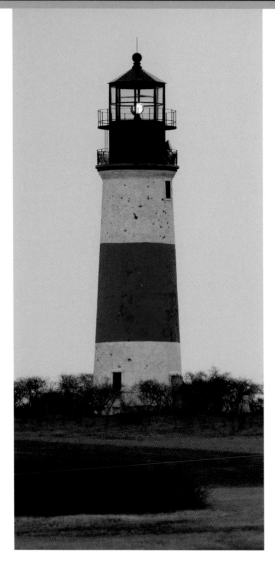

Located on the eastern shore of Nantucket island, some 30 miles off the southern coast of Massachusetts, Sankaty Head Lighthouse stands 70 feet tall and was built in 1850.

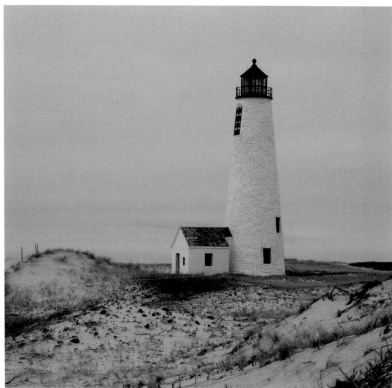

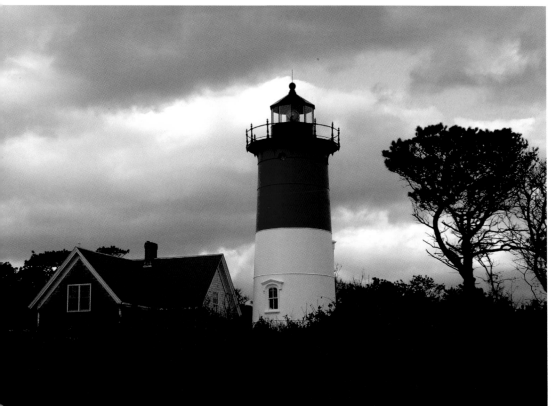

The 60-foot-tall Great Point Lighthouse stands at the northern-most tip of Nantucket island, rebuilt in 1986 after a storm destroyed the previous tower that had stood since 1818.

After the north tower in Chatham was moved to Eastham, Mass., the upper half was painted red and thus gave way to the daymark that now signifies Nauset Beach Lighthouse.

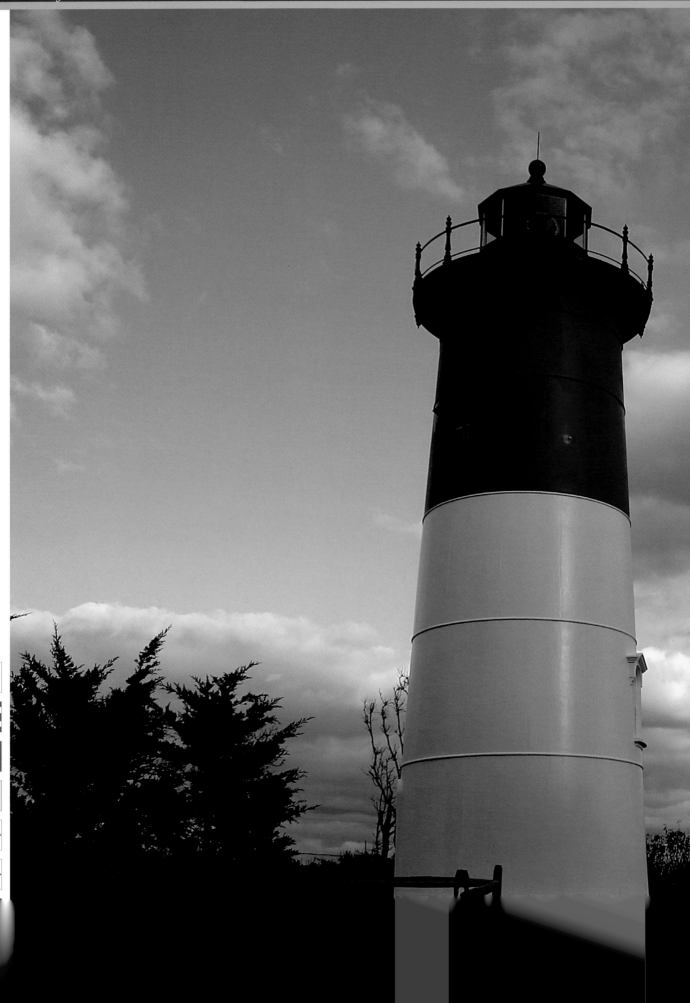

After more than 130 years in service at its current location, Nauset Beach Lighthouse in Massachusetts now doubles as an icon for Cape Cod Potato Chips.

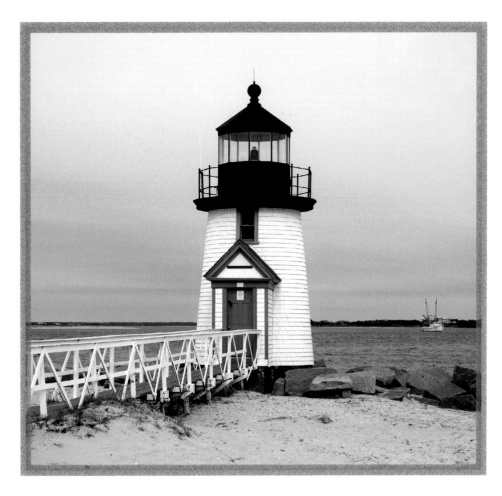

Marking the western entrance to Nantucket Harbor, the 26-foot-tall Brant Point Lighthouse was built in 1901.

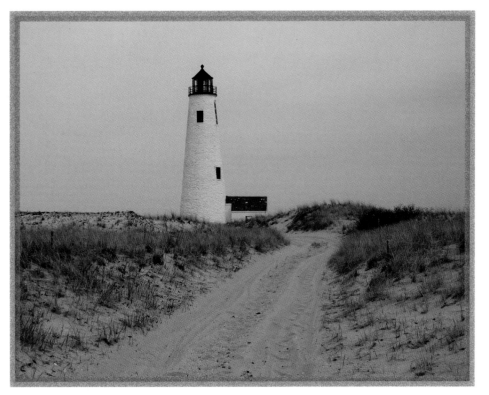

With its tower relatively new compared to most lighthouses along the East Coast, Great Point Lighthouse at the north end of Nantucket in Massachusetts may have many years of "life" left.

Opposite page: At any time of day, Nobska Point Lighthouse, which stands at the southwestern corner of Cape Cod in Massachusetts, is an attractive sight to both mariners and visitors to the area.

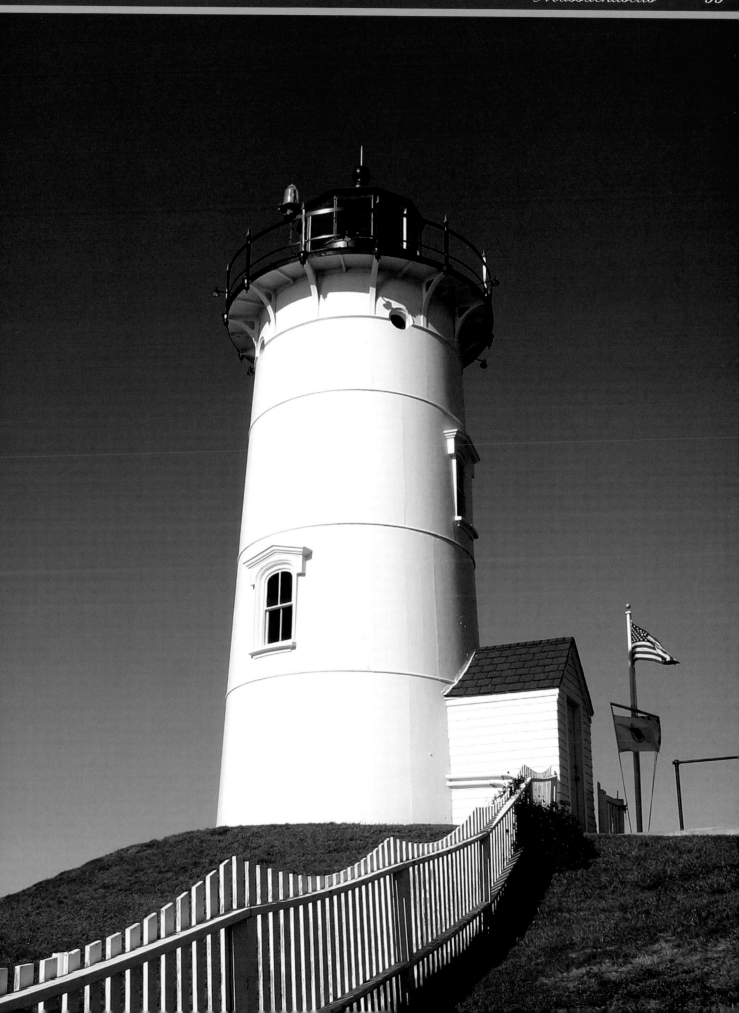

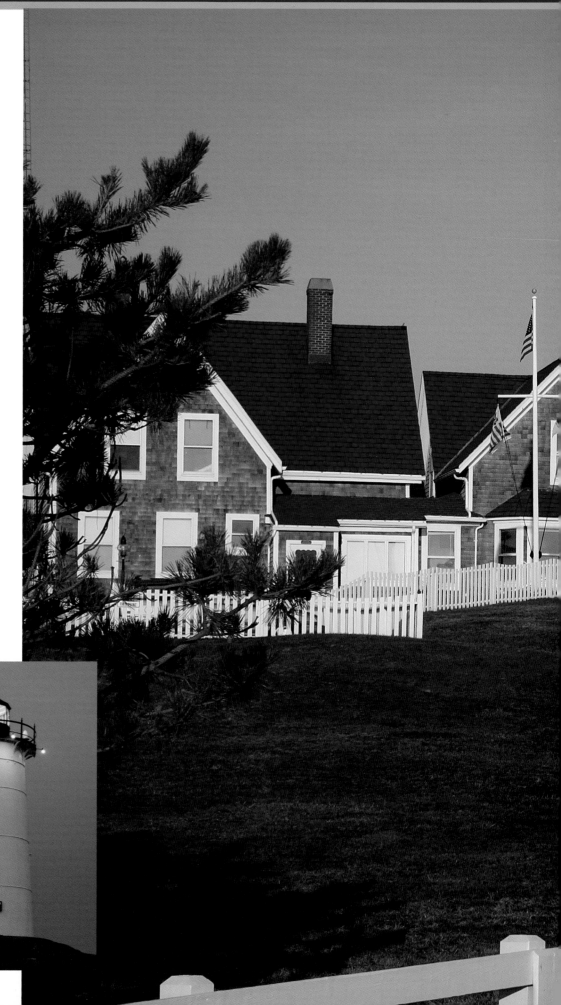

Like many of
its cast-iron
cousins along the
Massachusetts
coast, Nobska
Point Lighthouse
lights up the sky
in the evening.

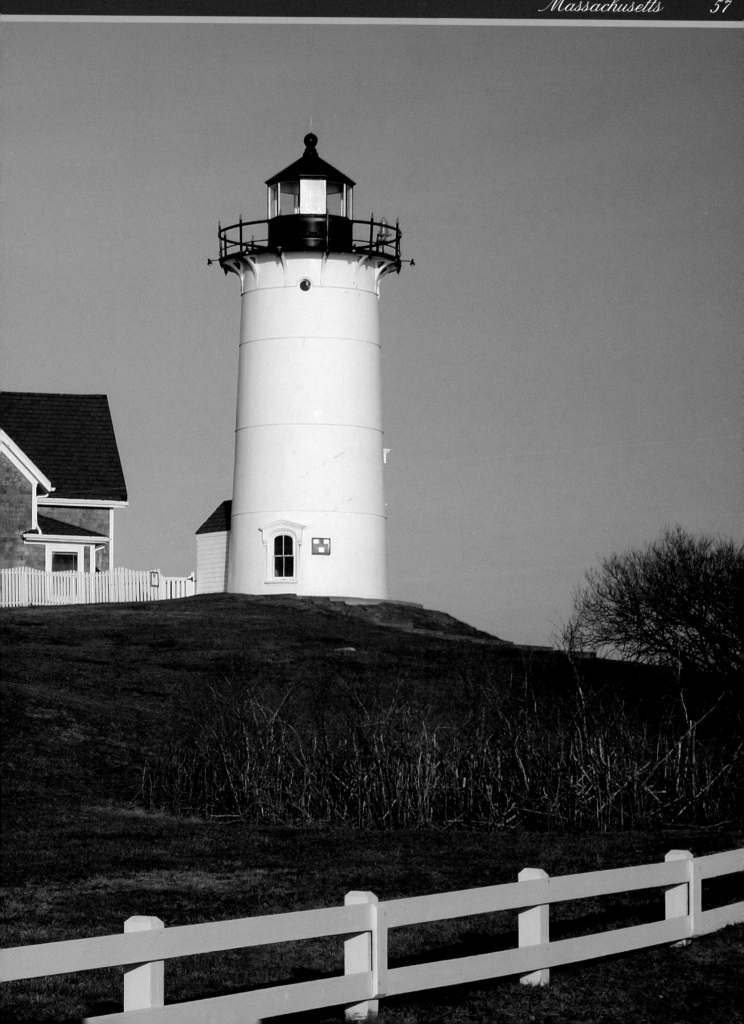

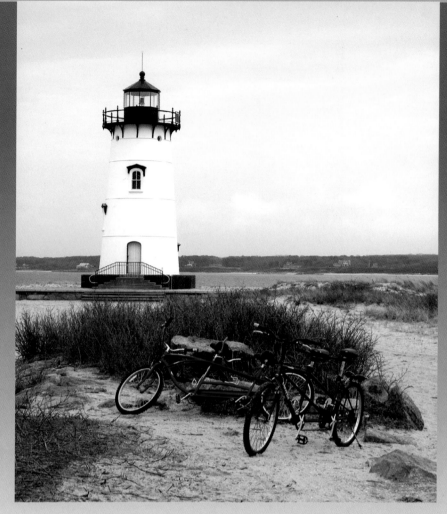

Marking the eastern side of Edgartown Harbor on Martha's Vineyard, Edgartown Lighthouse is a popular spot to park a bike and take a walk by the water.

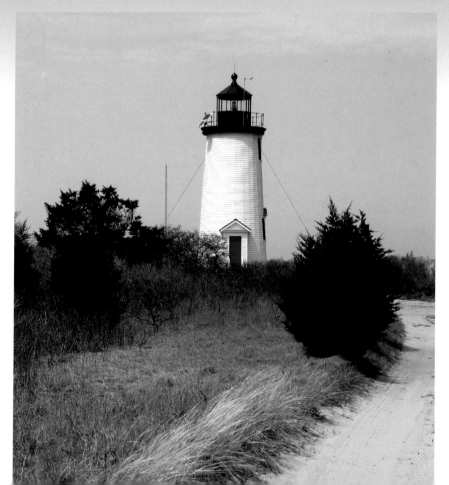

Cape Poge Lighthouse stands at the northern tip of Chappaquiddick Island at the entrance of Edgartown Harbor on Martha's Vineyard.

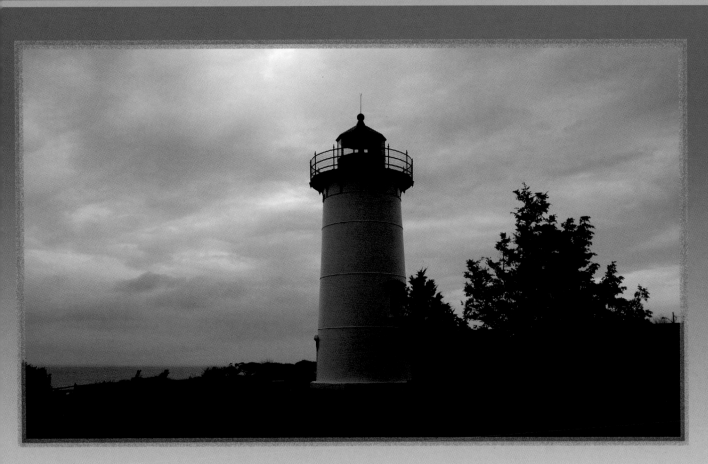

Standing high on a bluff overlooking the eastern side of the entrance to Vineyard Haven Harbor on Martha's Vineyard in Massachusetts, East Chop Lighthouse was built in 1878 and remains active.

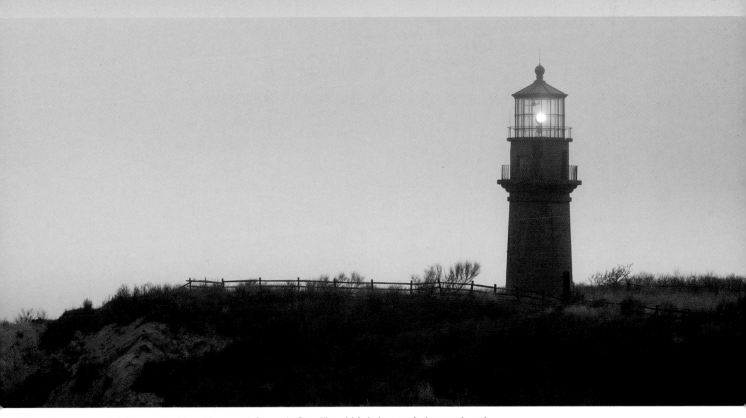

Standing atop a bluff overlooking Vineyard Sound, Gay Head Lighthouse is located at the western-most point of Martha's Vineyard off the southern coast of Massachusetts.

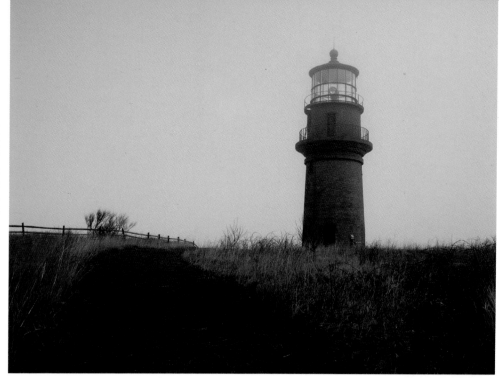

It's not a tall tower, but Gay Head Lighthouse's beacon shines amid the fog on many mornings at the western end of Martha's Vineyard.

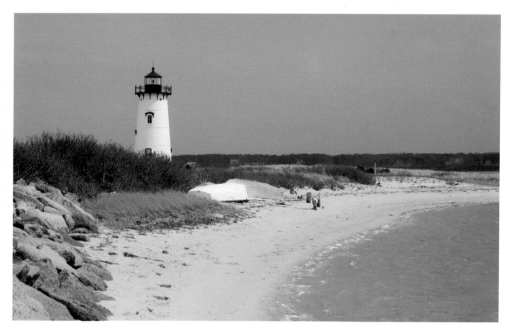

Built in 1881 and standing 45 feet tall, Edgartown Lighthouse on Martha's Vineyard is a peaceful spot when the tourist season isn't in full swing.

Standing at 35 feet tall on the north point of Martha's Vineyard in Massachusetts, Cape Poge, built in 1893, appears to be in good shape and remains active.

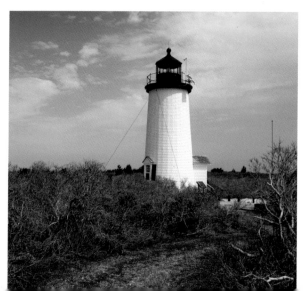

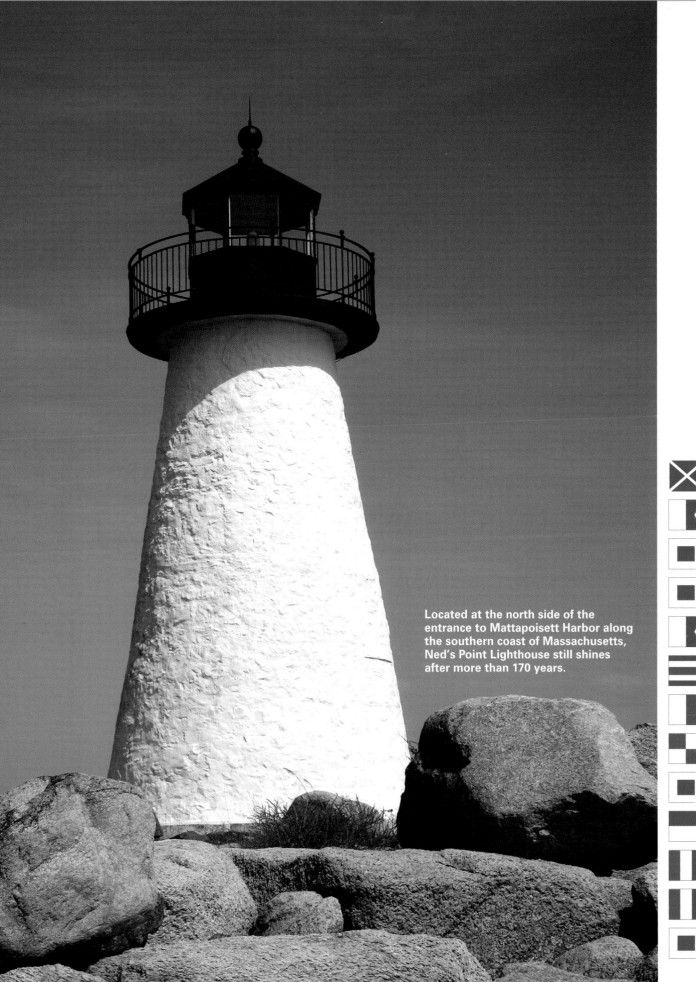

Located at the north side of the entrance to Mattapoisett Harbor along the southern coast of Massachusetts, Ned's Point Lighthouse still shines after more than 170 years.

Rhode Island

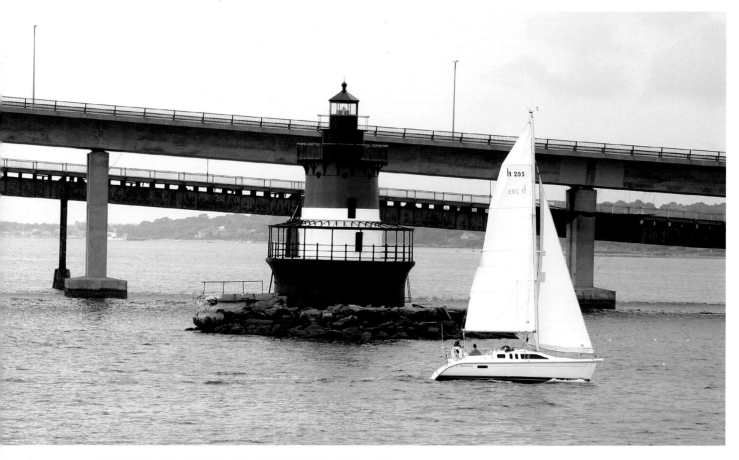

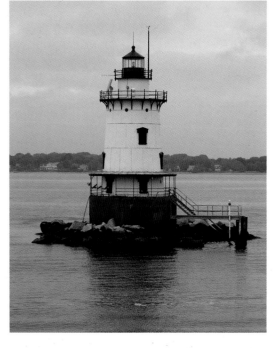

Above:
Located in the west passage of Rhode Island's Narragansett Bay, Plum Beach Lighthouse was built in 1899 and sits just north of the Jamestown-Verrazano Bridge.

Left:
One of several sparkplug-style lights on Narragansett Bay in Rhode Island, Conimicut Lighthouse was built in 1883 to mark the entrance of the Providence River.

Opposite page:
With its original Fresnel lens still flashing from the lantern room, the 51-foot-tall Point Judith Lighthouse that marks the western-side entrance of Narragansett Bay in Rhode Island shows off some rich color as the sun sets.

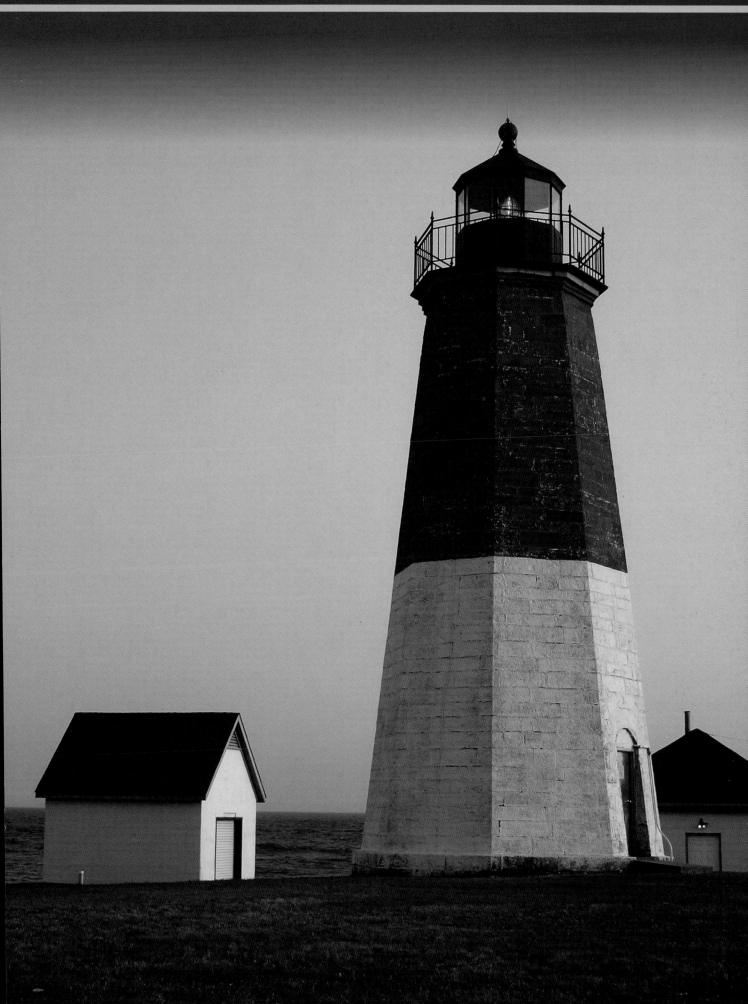

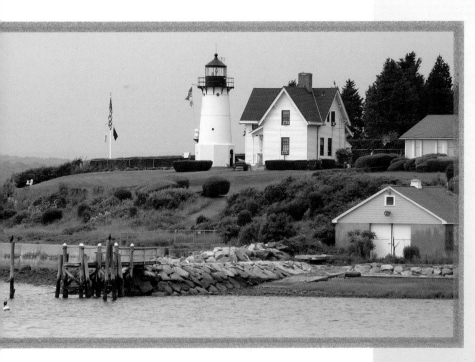

Located along the west passage of Narragansett Bay in Rhode Island, Warwick Lighthouse still stands as an aid to navigation.

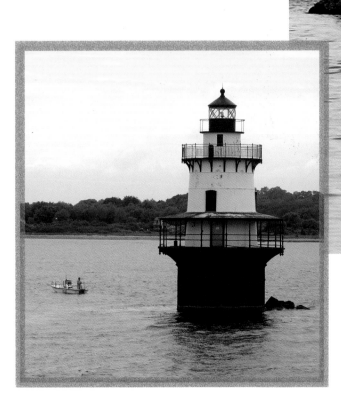

Built in 1901 and standing 60 feet tall, Hog Island Shoal Lighthouse is yet another sparkplug-style light located on the east side of Narragansett Bay in Rhode Island.

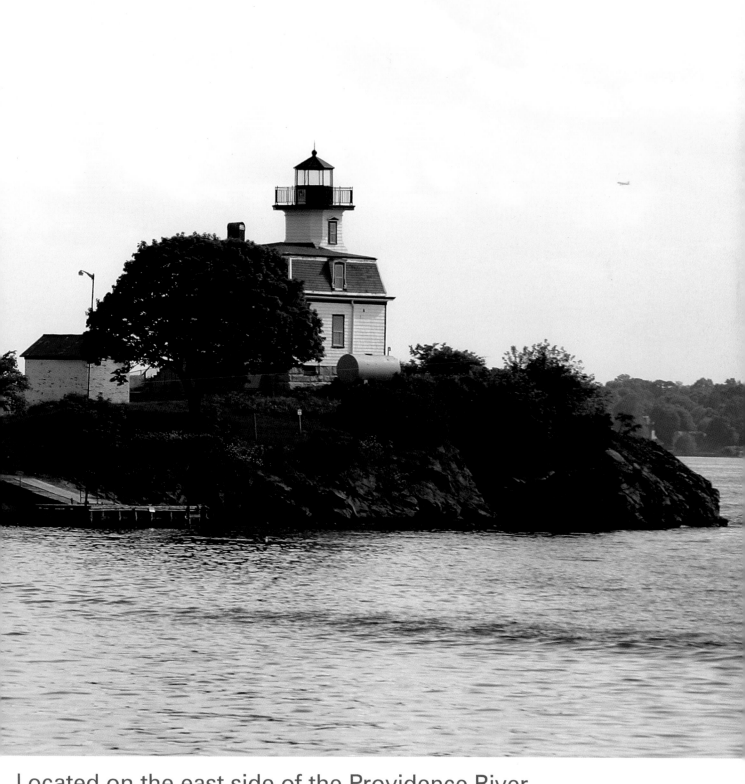

Located on the east side of the Providence River, Pomham Rocks Lighthouse has been lighting the way toward Providence, R.I., for more than 135 years.

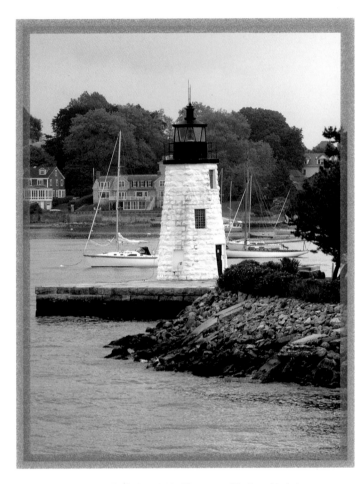

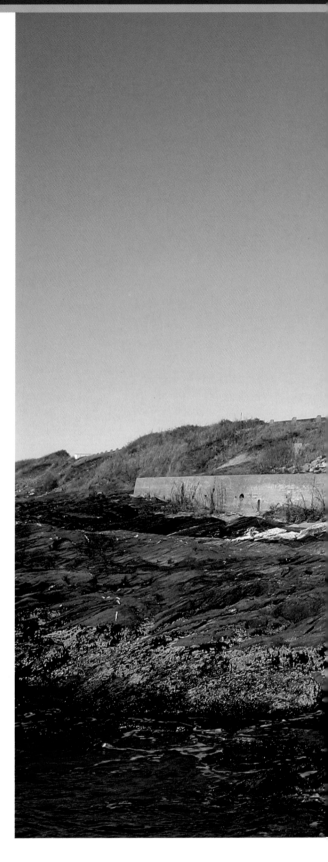

Built in 1842, Newport Harbor Lighthouse
stands at the northern tip of Goat Island in
Rhode Island's Narragansett Bay.

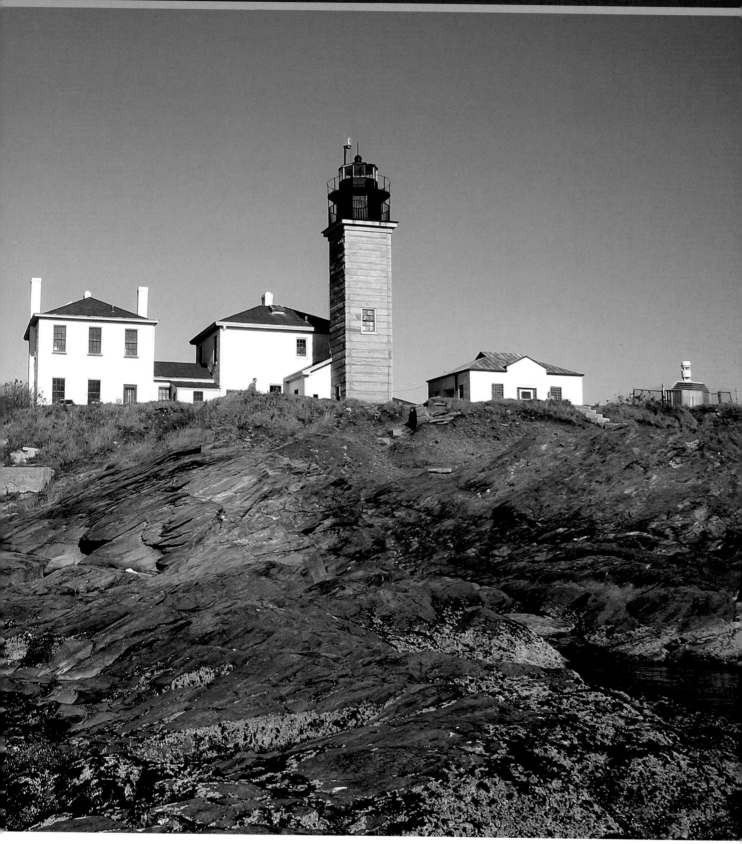

Located at the southern tip of Conanicut Island in Rhode Island's Narragansett Bay, Beavertail Lighthouse is a popular location for residents and visitors.

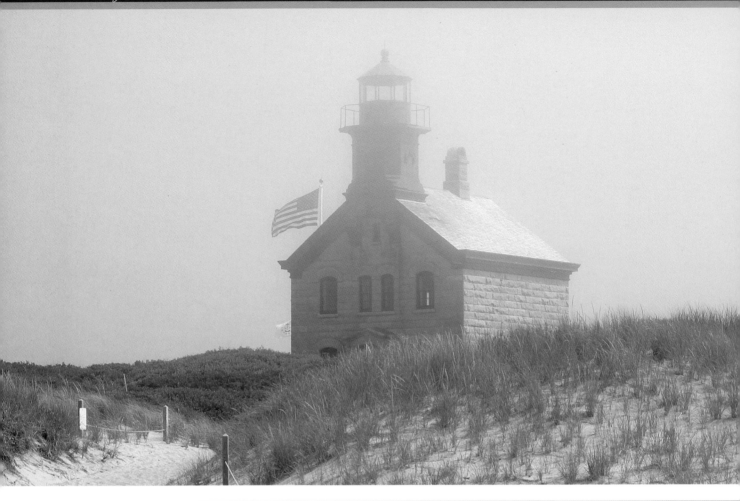

With its red lantern atop a granite keeper's house, the Block Island North Lighthouse (top) stands at one end of Block Island in Rhode Island, while the 52-foot, brick Block Island Southeast Lighthouse (bottom) stands atop a huge bluff on the southern side of the 10-square-mile island. Since 1858, when the North light was built, and 1865, when the Southeast light was constructed, the two lights have worked in tandem to mark dangerous shoals around the island.

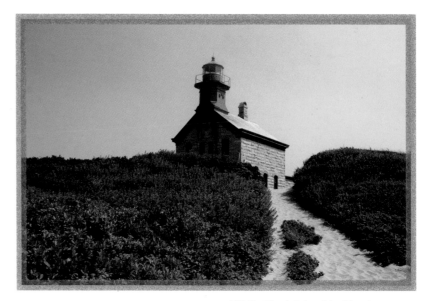

While Block Island in Rhode Island is a popular tourist destination, sometimes the grounds around the Block Island North Lighthouse are free of visitors.

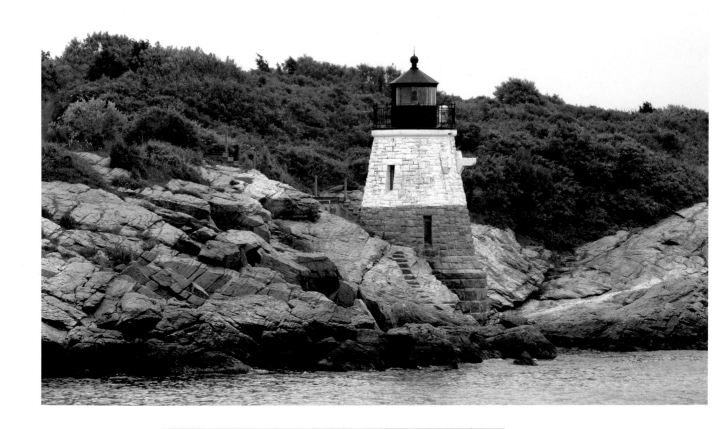

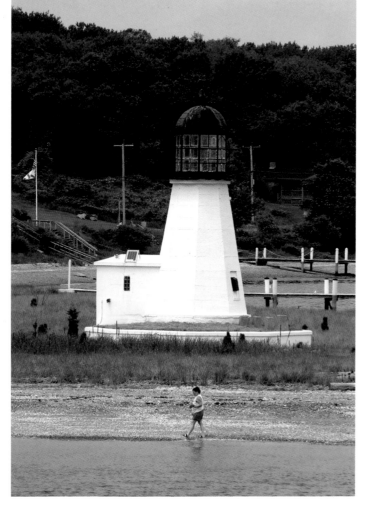

Above;
Located at the east side of the entrance to Narragansett Bay in Rhode Island, Castle Hill Lighthouse was built in 1890 and stands just 34 feet tall.

Left;
Standing at 28 feet and sporting a 19th-century, "birdcage" lantern, Prudence Island Lighthouse marks the east passage of Narragansett Bay from the east side of Prudence Island.

Opposite page;
Rhode Island's southern-most, mainland-based lighthouse overlooking Block Island Sound, Watch Hill Lighthouse stands 45 feet tall.

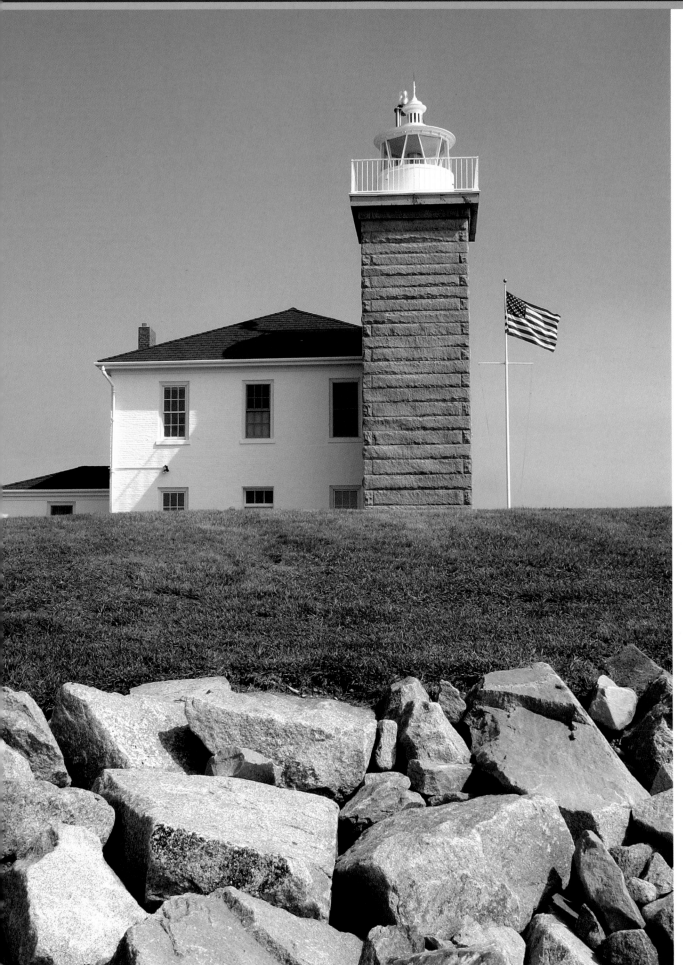

Connecticut

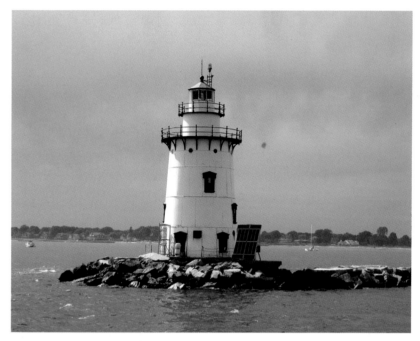

Left:
Marking the entrance to the Connecticut River, Saybrook Breakwater Lighthouse, which was constructed in 1886, is one of many sparkplug-style lights along Connecticut's coastline.

Opposite page:
Located on the western side of the entrance to the Connecticut River, the 65-foot-tall Lynde Point Lighthouse was built in 1838 and still has its Fresnel lens.

Bellow:
Located at the western side of the Thames River on Connecticut's coast, New London Harbor Lighthouse stands 89 feet tall and was built in 1801.

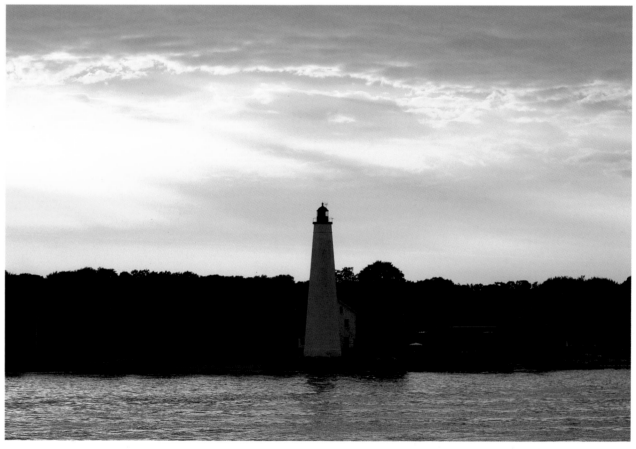

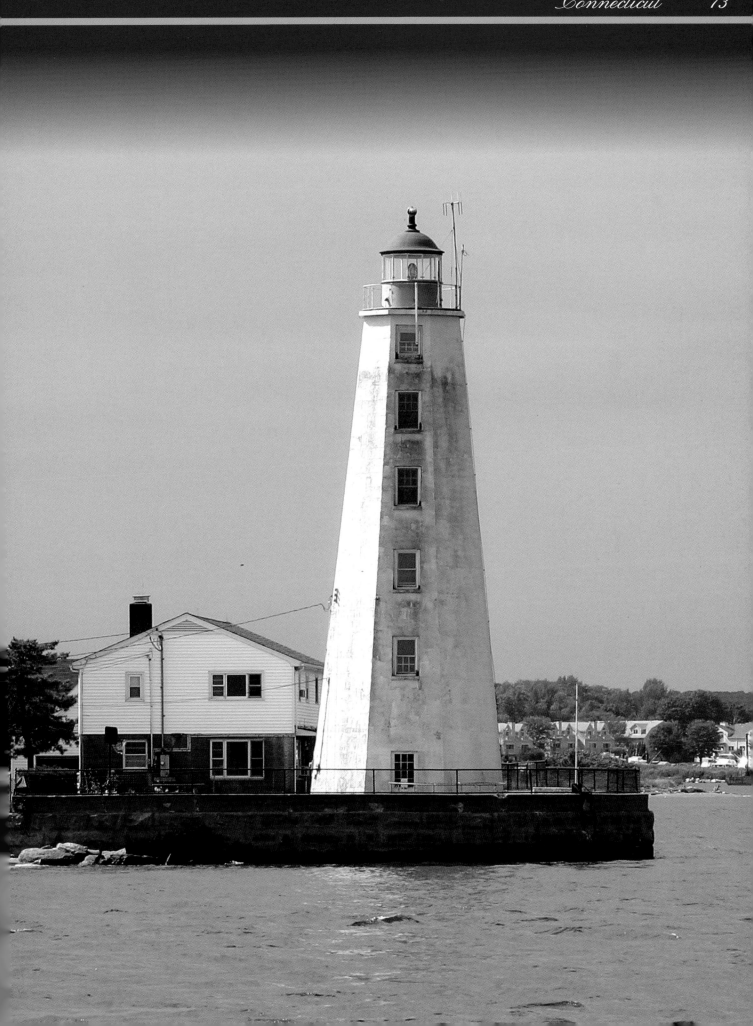

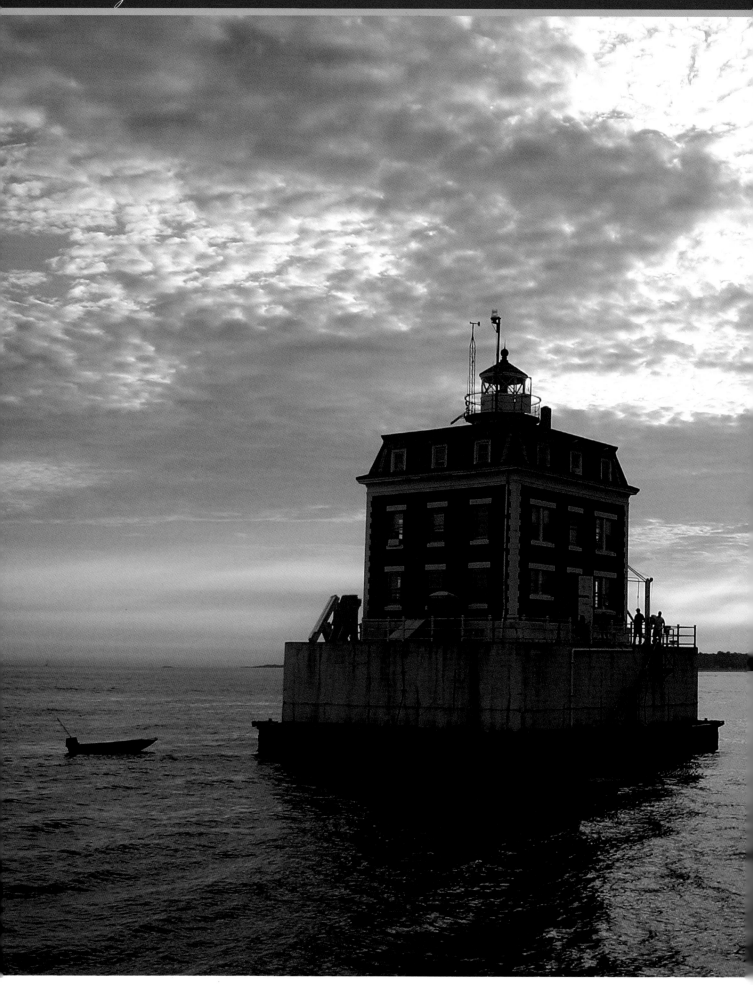

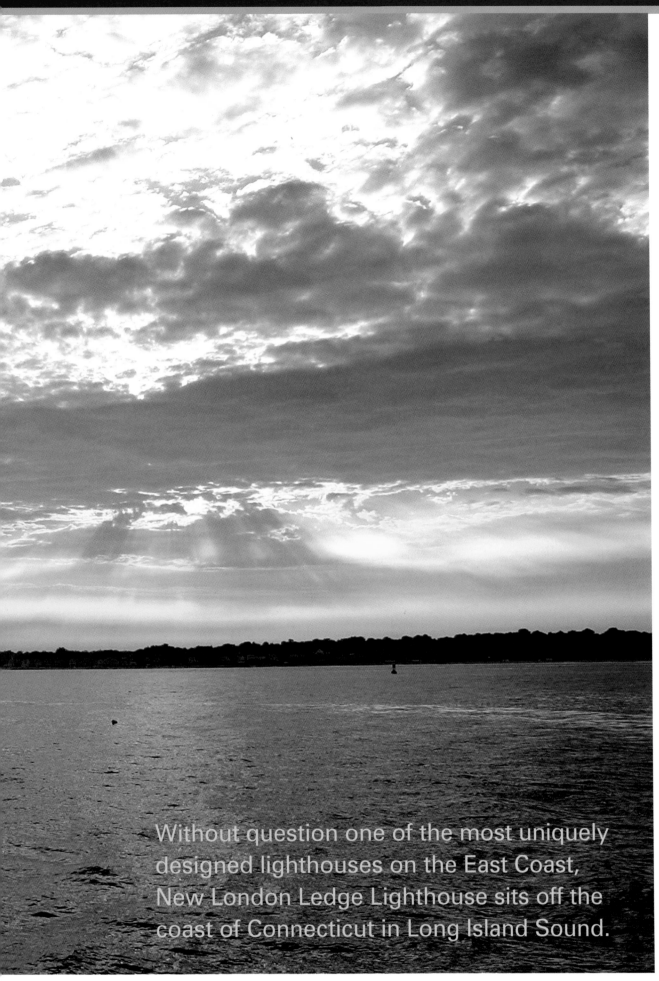

Without question one of the most uniquely
designed lighthouses on the East Coast,
New London Ledge Lighthouse sits off the
coast of Connecticut in Long Island Sound.

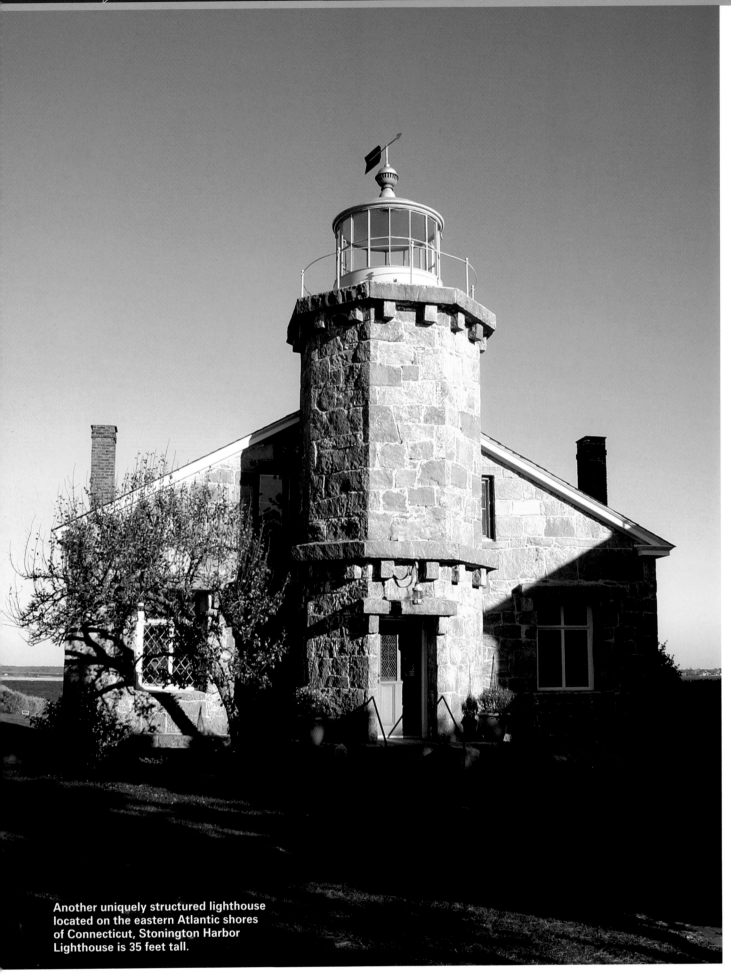

Another uniquely structured lighthouse
located on the eastern Atlantic shores
of Connecticut, Stonington Harbor
Lighthouse is 35 feet tall.

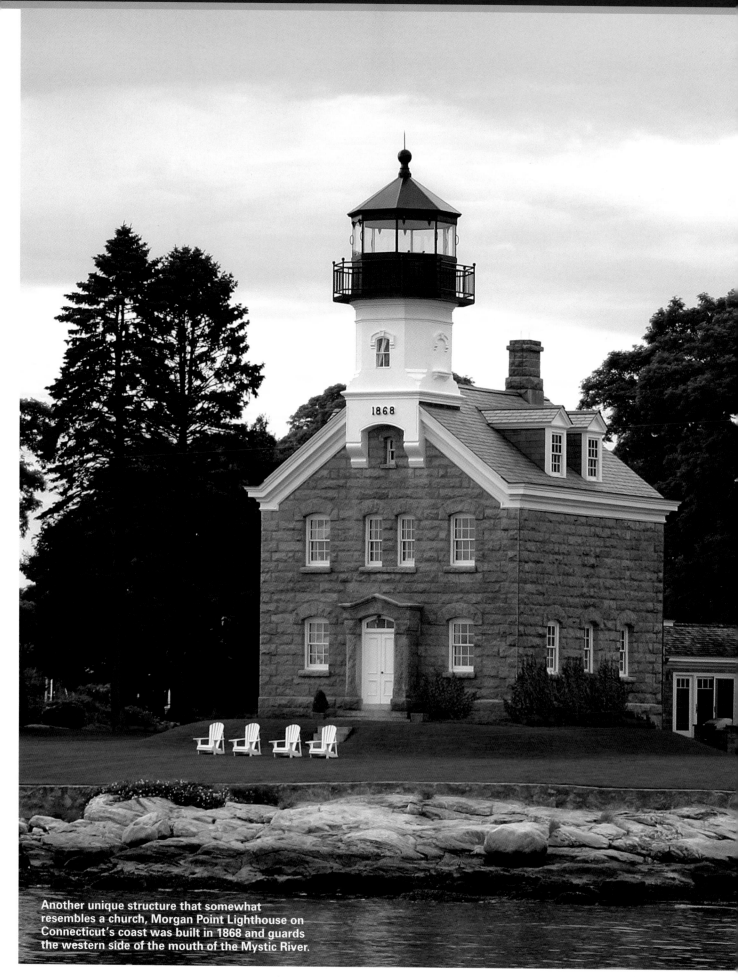

Another unique structure that somewhat resembles a church, Morgan Point Lighthouse on Connecticut's coast was built in 1868 and guards the western side of the mouth of the Mystic River.

New York

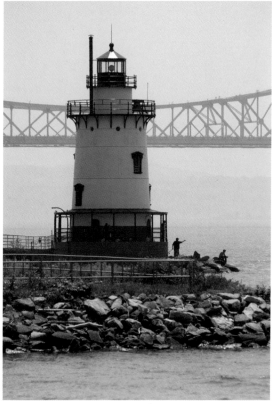

Left:
Built in 1883, Sleepy Hollow Lighthouse, or Tarrytown light, once marked an area of the Hudson River's eastern shore that was dangerous to mariners, until the Tappan Zee Bridge (background) was constructed.

Opposite page:
Still an active aid to navigation, Montauk Point Lighthouse at the eastern-most point on Long Island in New York is an easily recognizable icon to visitors of the area.

Below:
Built in 1869 to help guide ships up and down the Hudson River, Saugerties Lighthouse now stands as a popular place for visitors enjoying time in the Hudson River Valley.

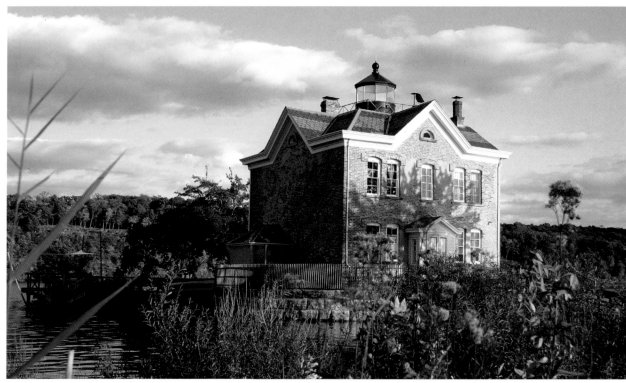

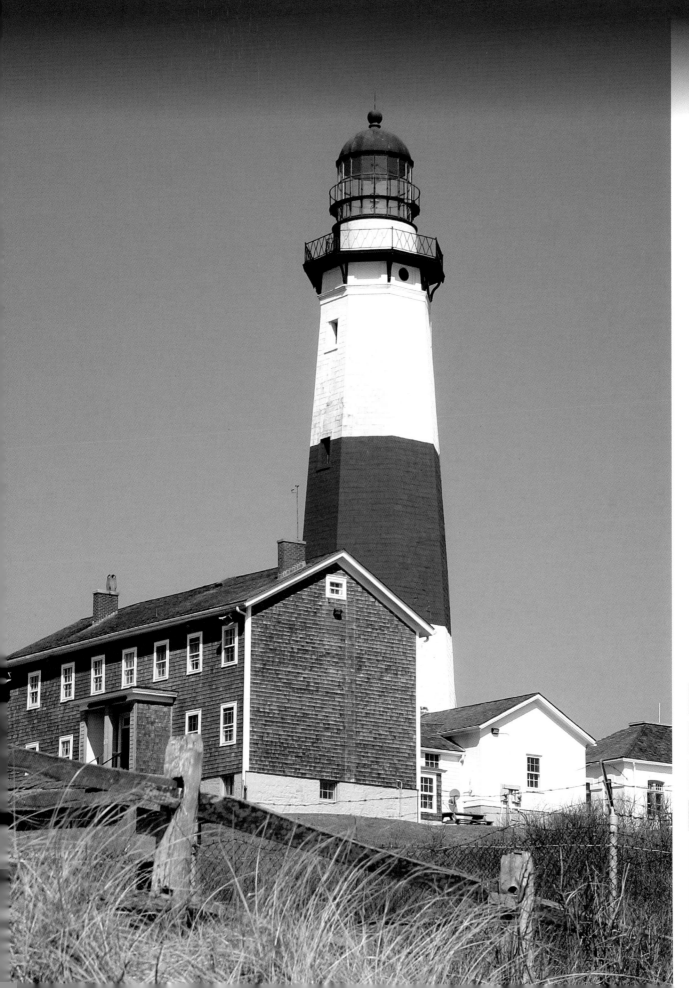

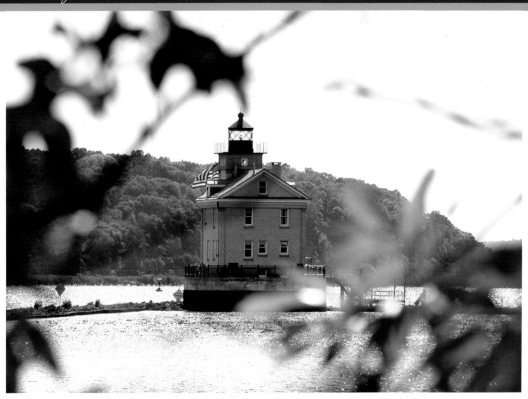

Located near the entrance to Rondout Creek in Kingston, N.Y., the current Rondout Lighthouse was built in 1915 and stands 48 feet tall.

Set right in the middle of the Hudson River halfway between Hudson and Athens, New York's Hudson-Athens Lighthouse marks some dangerous water near the Middle Ground Flats.

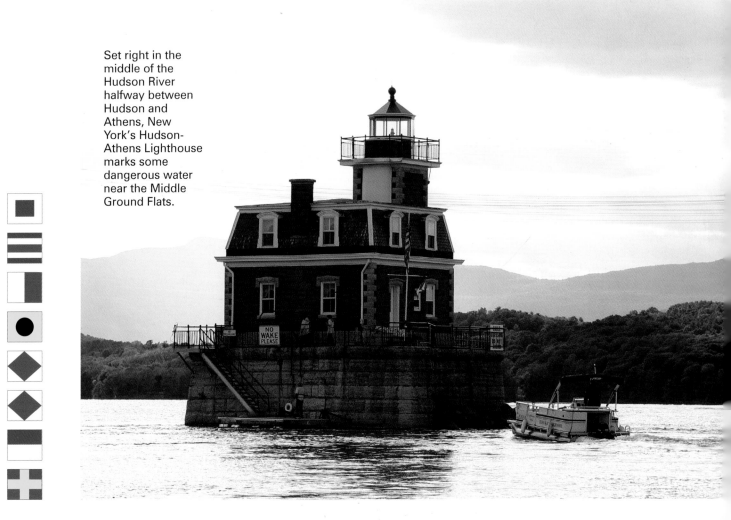

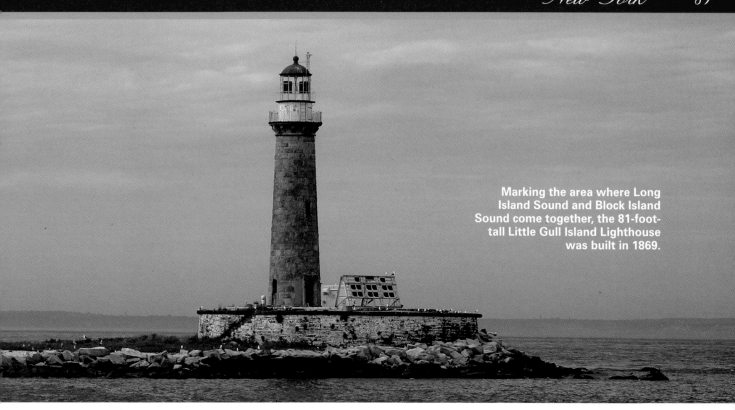

Marking the area where Long Island Sound and Block Island Sound come together, the 81-foot-tall Little Gull Island Lighthouse was built in 1869.

Esopus Meadows Lighthouse is no longer an operational lighthouse, but its 52-foot tower still has plenty of boat traffic passing by it every day on the Hudson River in New York.

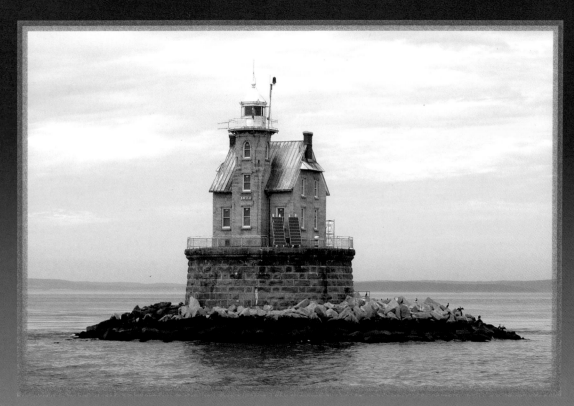

Quite unique in structure, the 67-foot-tall Race Rock Lighthouse remains as an active aid to navigation after more than 130 years of service in New York's Long Island Sound.

Standing 31 feet on North Dumpling Island in New York's Long Island Sound, North Dumpling Lighthouse was built in 1849.

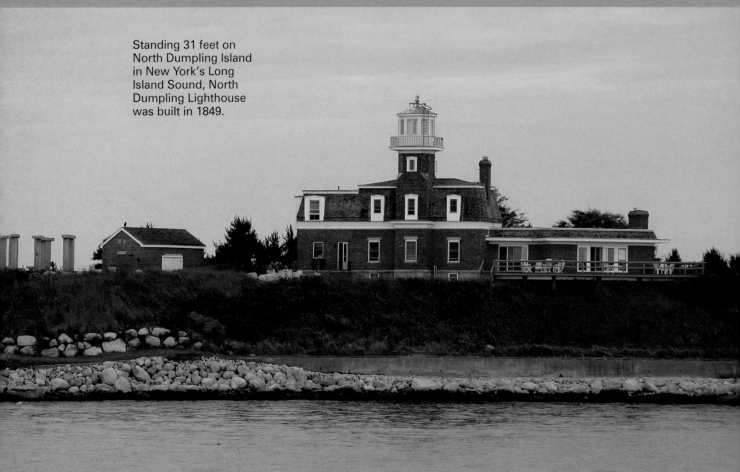

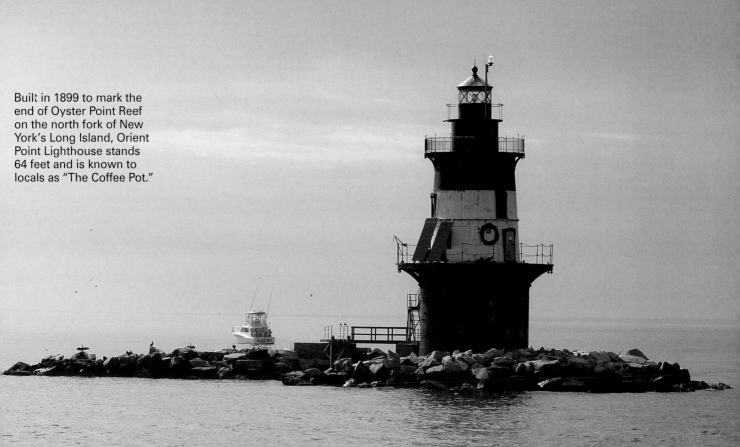

Built in 1899 to mark the end of Oyster Point Reef on the north fork of New York's Long Island, Orient Point Lighthouse stands 64 feet and is known to locals as "The Coffee Pot."

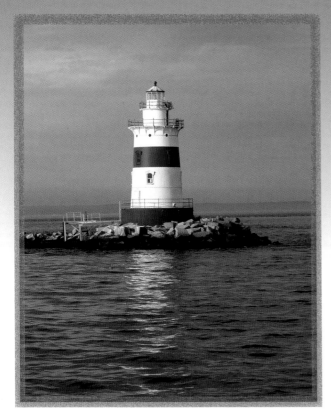

Still an active aid to navigation, the uniquely painted Latimer Reef Lighthouse stands 49 feet tall and is located in New York's Long Island Sound, just to the north of Fishers Island.

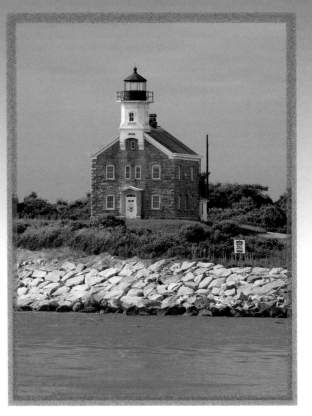

Built in 1869 and standing 34 feet tall, Plum Island Lighthouse along the north fork of Long Island looks similar to Block Island's North light.

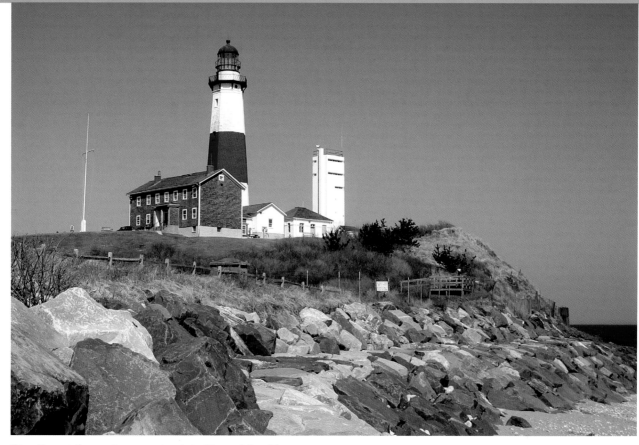

Standing at the eastern-most point of Long Island in New York since 1797, Montauk Point Lighthouse marks a dangerous area where Long Island Sound and the Atlantic Ocean come together.

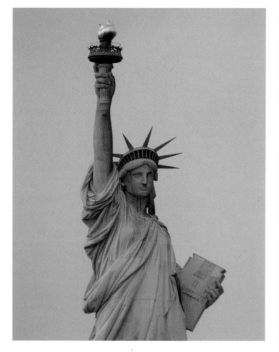

Once the tallest commissioned lighthouse in America at 305 feet tall, the Statue of Liberty still stands as the greatest symbol of freedom, strength and courage along the East Coast, and marks the entrance to New York's inner harbor.

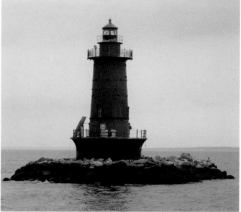

Marking the lower Ambrose Channel in New York Harbor, West Bank Lighthouse was first lighted in 1901.

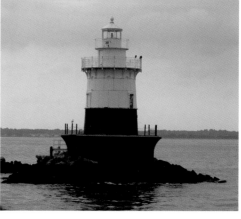

Built in 1893, Old Orchard Lighthouse marks the Gedney Channel in New York Harbor.

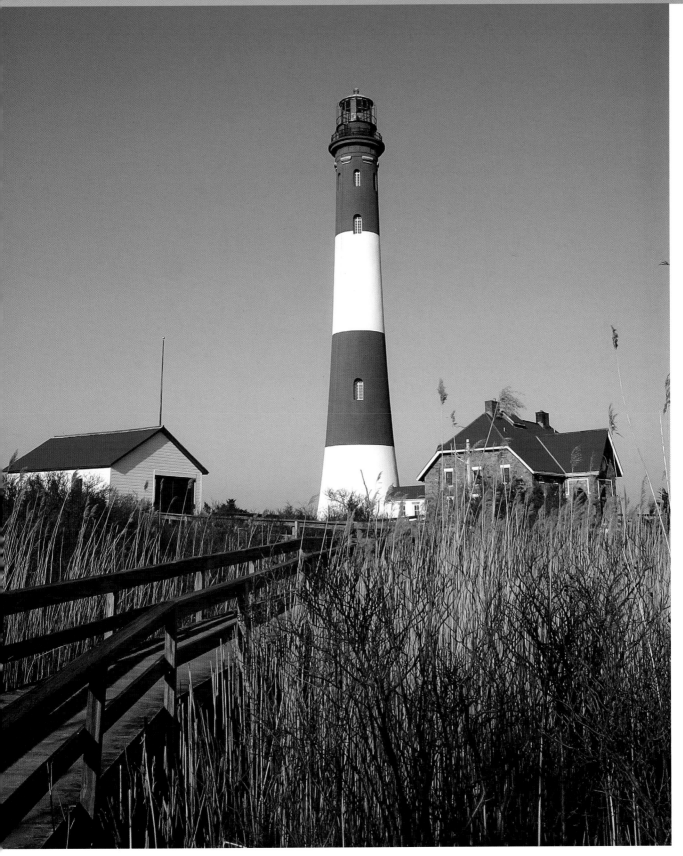

With the many trails and tons of beach of Fire Island National Seashore all around it, Fire Island Lighthouse stands out on the southern side of Long Island in New York.

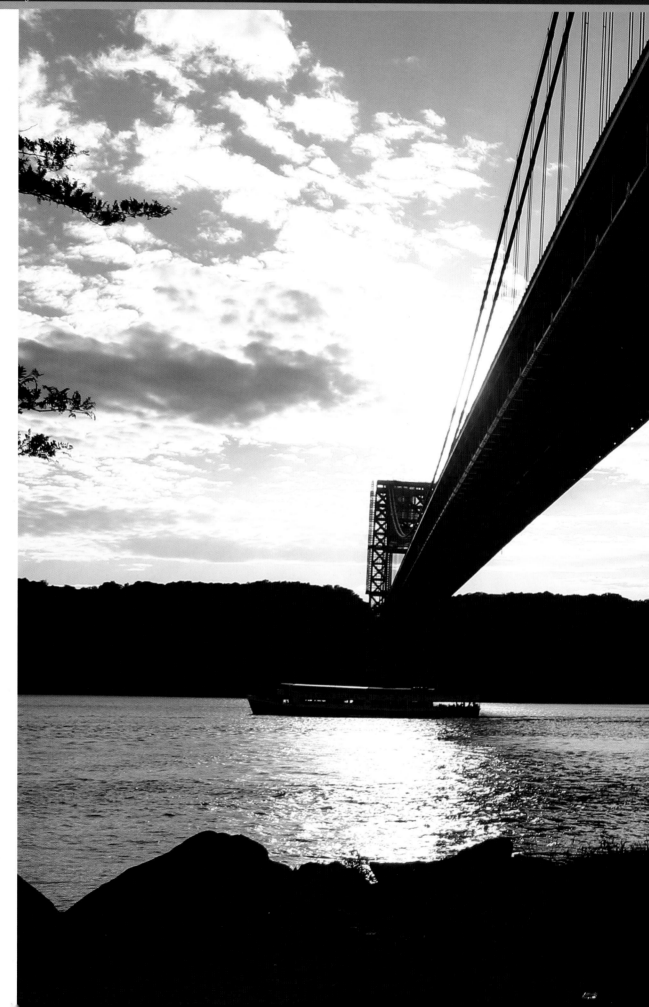

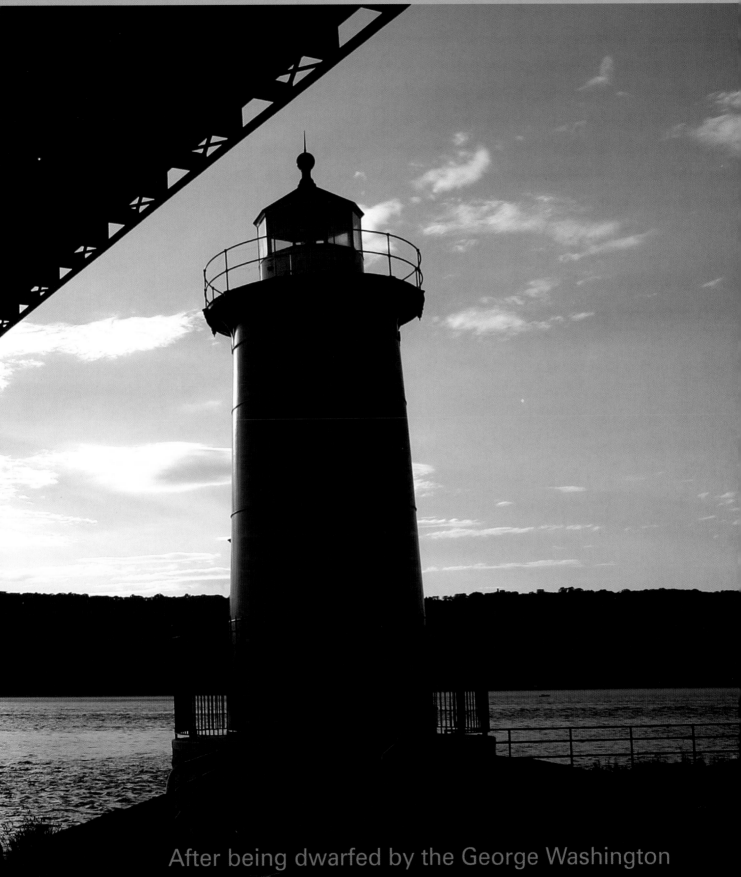

After being dwarfed by the George Washington Bridge and even being the subject of a children's book, Jeffrey's Hook Lighthouse has stood along the eastern side of the Hudson River since 1921.

New Jersey

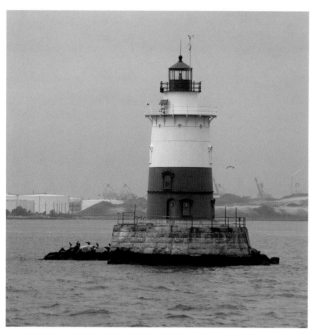

Left:
Located about two miles southwest of the Statue of Liberty in New York Harbor, Robbins Reef Lighthouse, built in 1883, is nicknamed Kate's Light in honor of legendary keeper Kate Walker.

Opposite page:
Sandy Hook Lighthouse, on the northern coast of New Jersey, is an American icon, still standing at 85 feet after more than 240 years in service.

Below:
Located on a reef about 2.5 miles north of Sandy Hook, Romer Shoal Lighthouse was built in 1898.

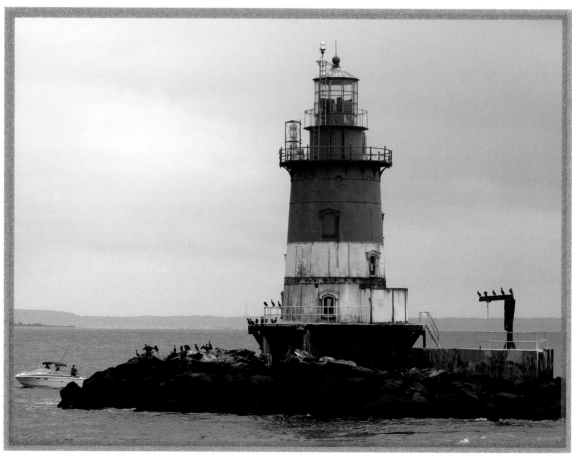

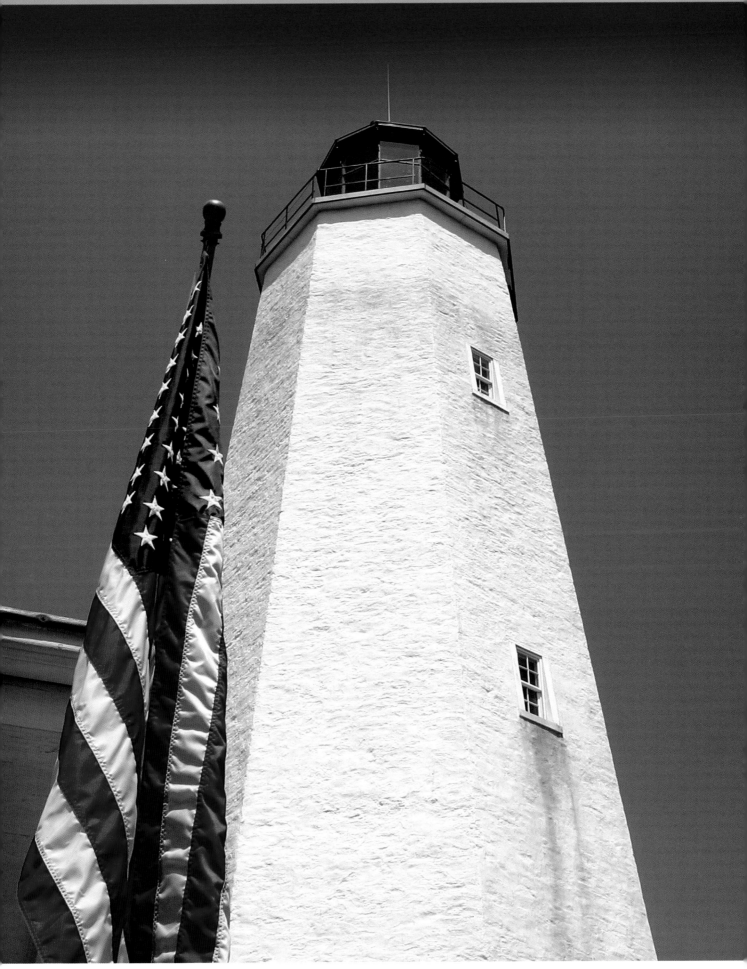

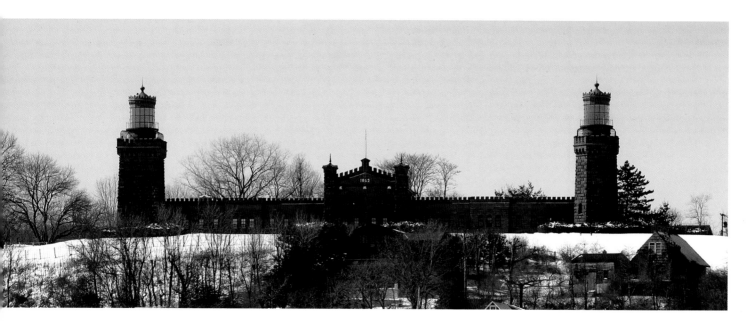

Built in 1862, the Twin Lights of Navesink is unique with its 73-foot octagonal (north side) and square (south side) towers and brownstone construction.

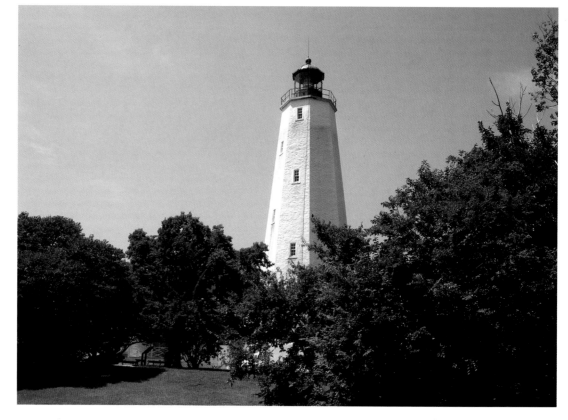

America's oldest original lighthouse, built in 1764, Sandy Hook has not only survived many storms at the north end of New Jersey's Atlantic Coast, but the Revolutionary War as well.

Opposite page:
With its lantern atop a brick, Victorian-style keeper's house, Sea Girt Lighthouse, which was built in 1896, has a charm unlike any other on New Jersey's Atlantic Coast.

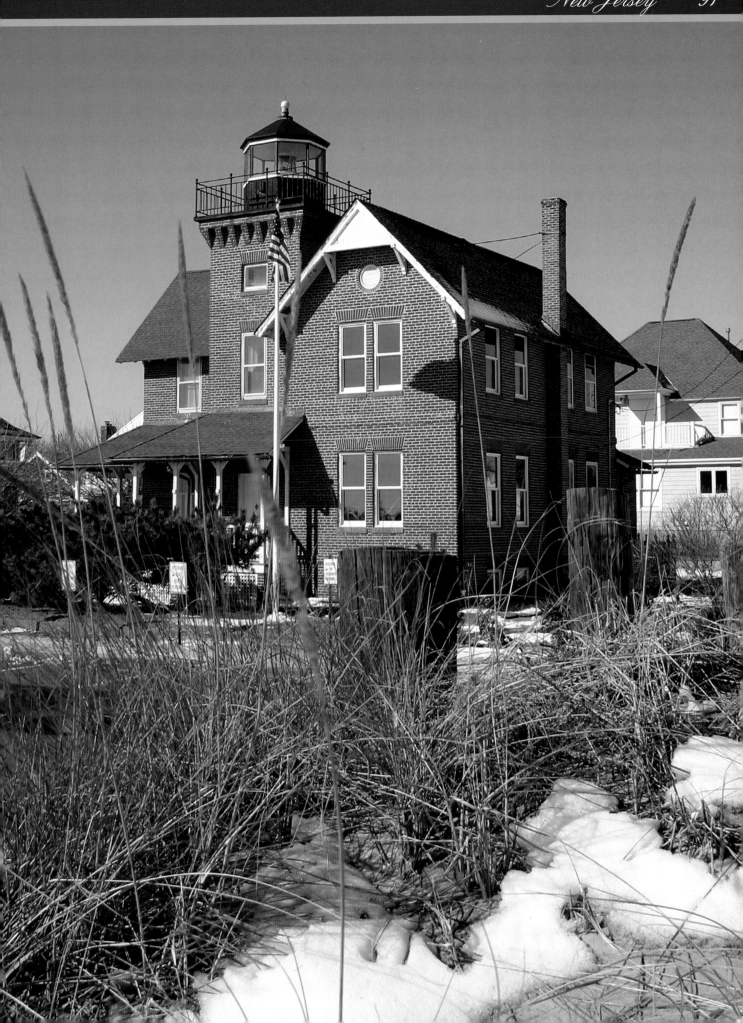

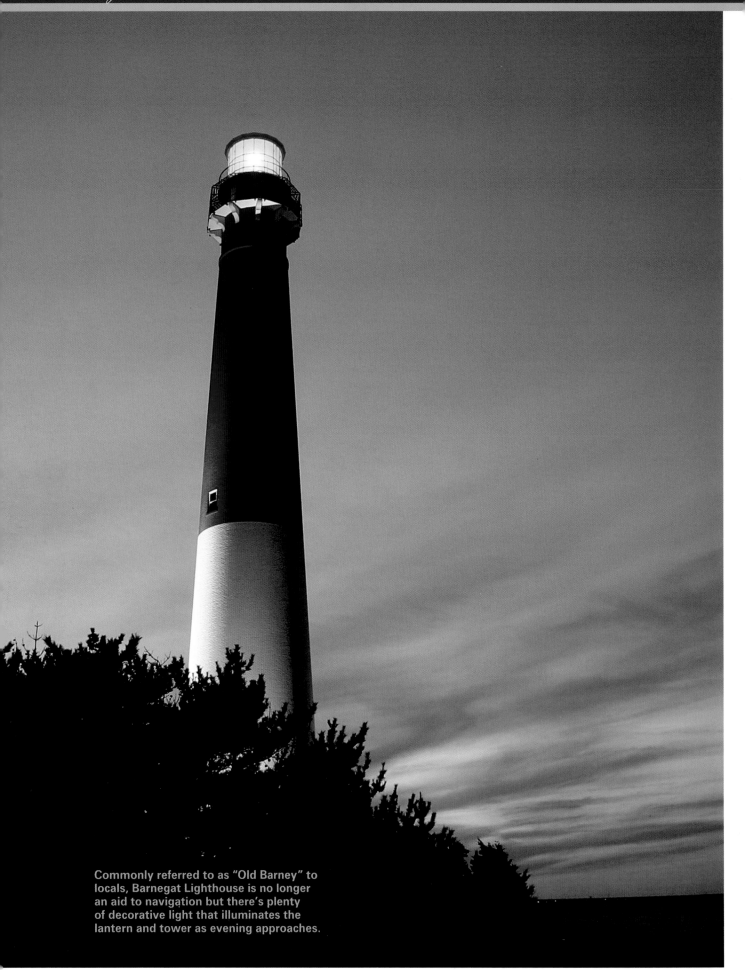

Commonly referred to as "Old Barney" to locals, Barnegat Lighthouse is no longer an aid to navigation but there's plenty of decorative light that illuminates the lantern and tower as evening approaches.

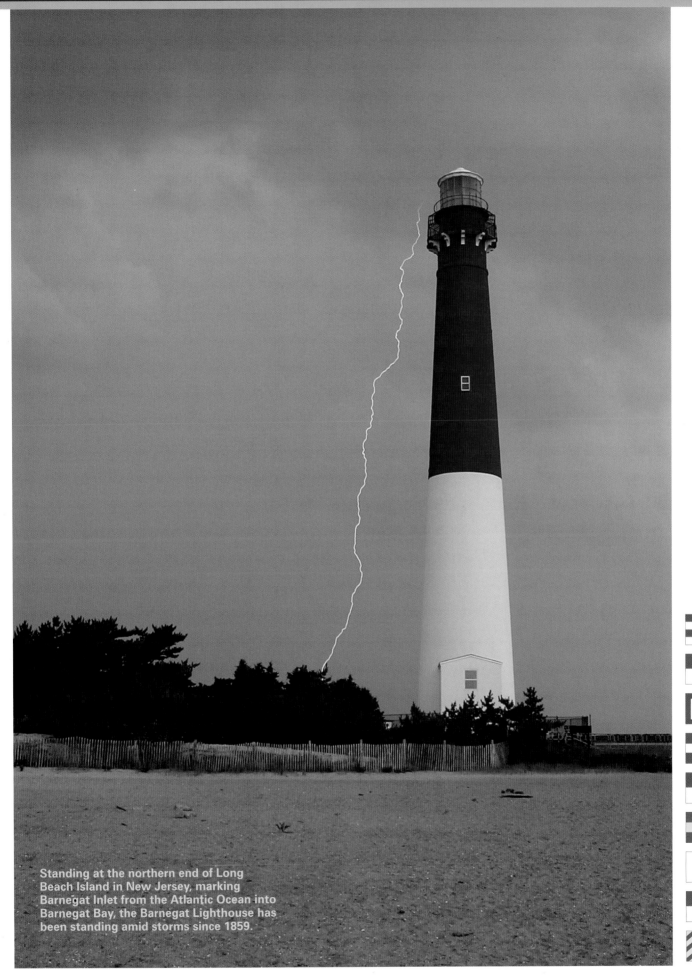

Standing at the northern end of Long Beach Island in New Jersey, marking Barnegat Inlet from the Atlantic Ocean into Barnegat Bay, the Barnegat Lighthouse has been standing amid storms since 1859.

With many
angles
to view
Barnegat
Lighthouse,
at some
times of the
year it's easy
to watch
a sunset
drop over
the western
horizon of
Barnegat
Bay.

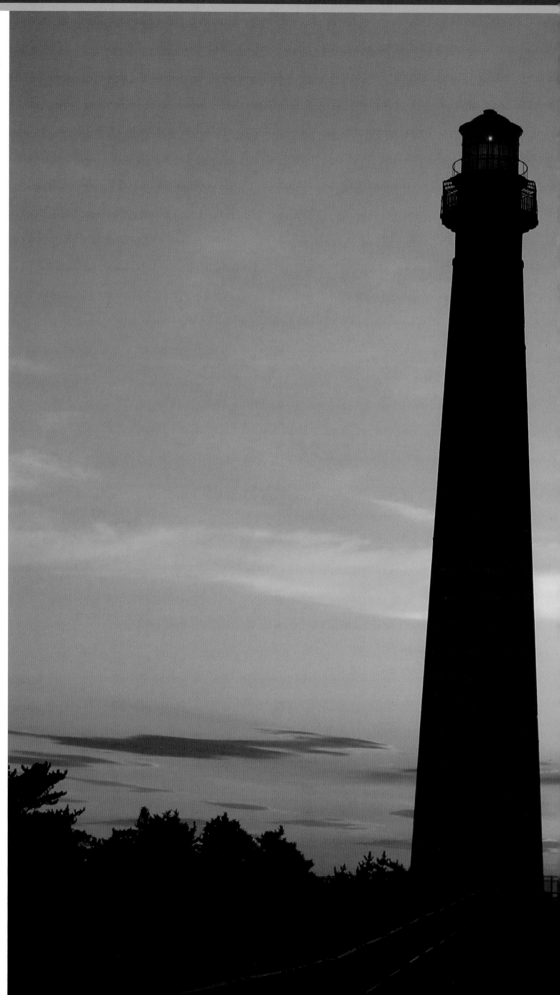

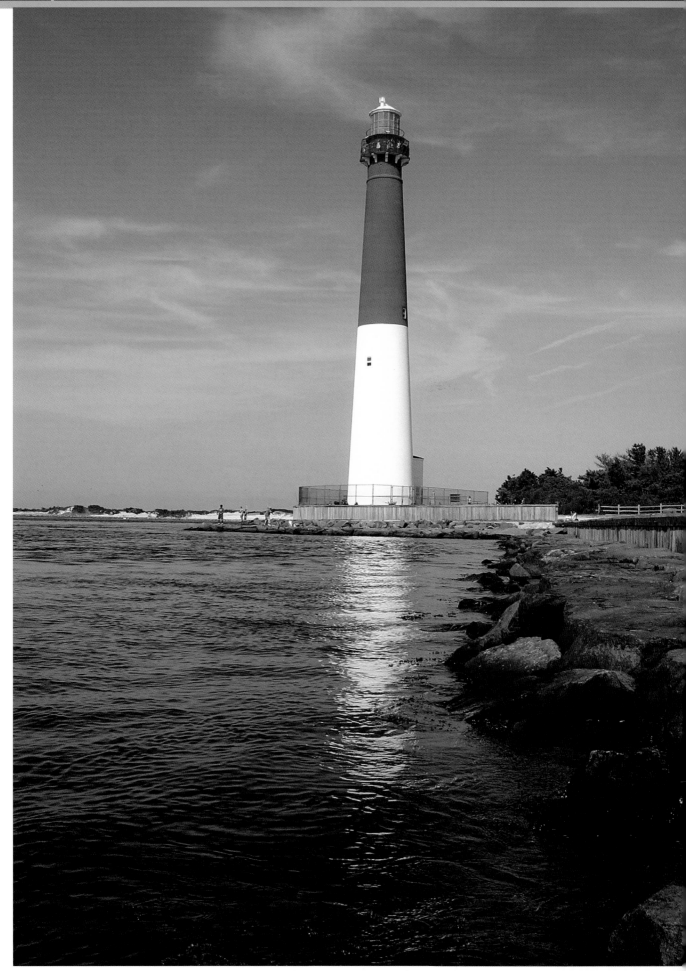

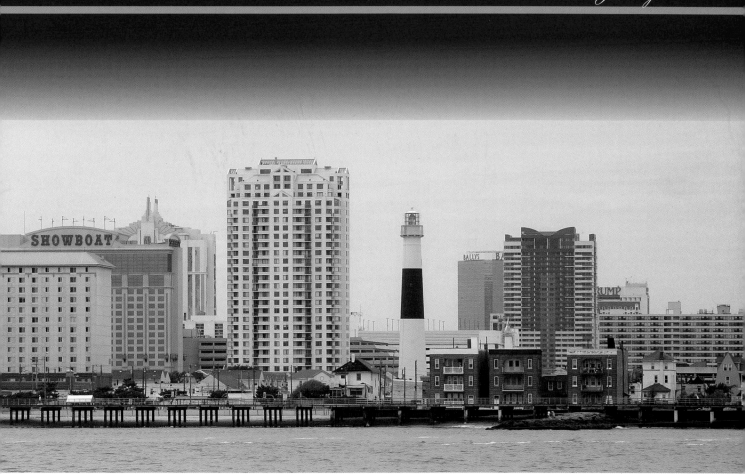

Above:
With Atlantic City's casino district as the backdrop facing south from Brigantine Inlet, Absecon Lighthouse is one of New Jersey's tallest lighthouses.

Right:
Standing 57 feet above sea level, Hereford Inlet Lighthouse was constructed in 1874 and has since had the color of its keeper's house changed from white to yellow.

Opposite page:
Definitely one of the most recognized lights along the New Jersey coast, Barnegat Lighthouse is unmistakable with its red-and-white daymark.

Many visitors who make a stop at
Hereford Inlet Lighthouse in North
Wildwood, just north of Cape May,
are just as enthralled by the gardens
surrounding the Swiss Gothic-style light
as they are with the lighthouse itself.

With so much viewing area surrounding its white, conical tower, Cape May Lighthouse remains as one of the best along New Jersey's coastline to capture in photographs.

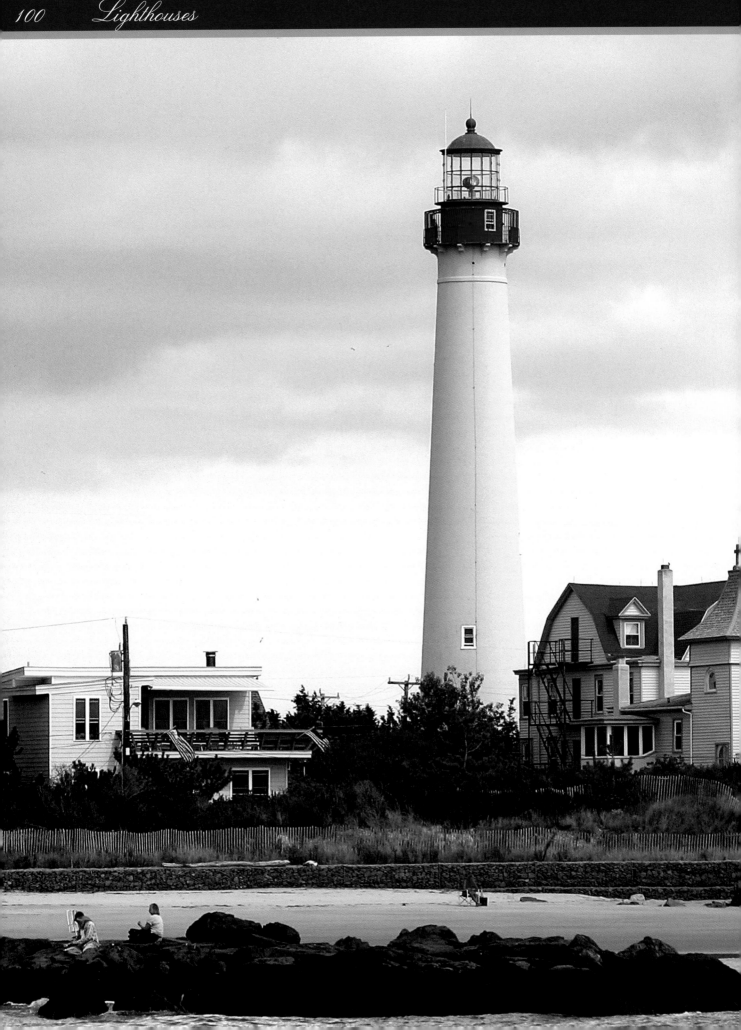

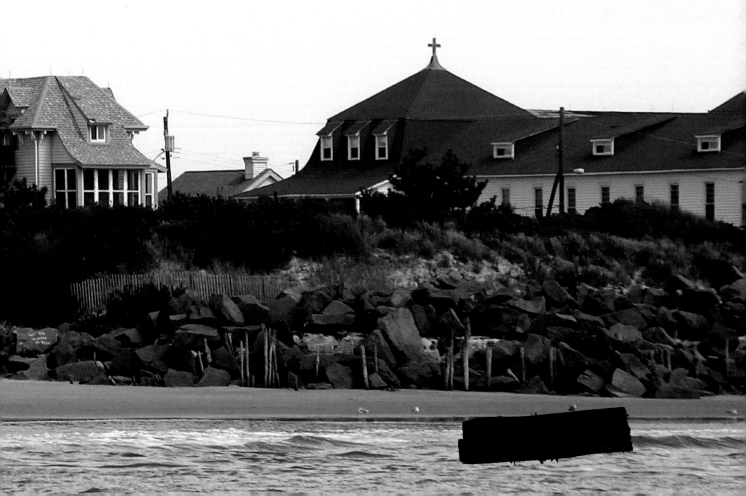

Built in 1859, Cape May Lighthouse stands 157 feet above the area where the Atlantic Ocean meets Delaware Bay at the southern-most tip of New Jersey.

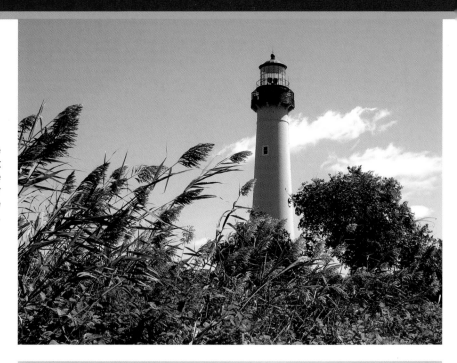

Not only is Cape May Lighthouse on New Jersey's Atlantic Coast very well maintained, but the grounds around it offer many interesting views of the white tower and red lantern.

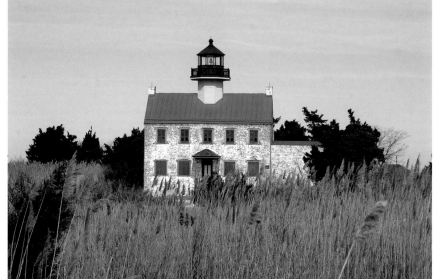

At the entrance of the Maurice River on the banks of Delaware Bay in New Jersey, East Point Lighthouse's unique design is quite eye-catching.

Built in 1849, New Jersey's East Point Lighthouse stands along the north side of Delaware Bay in a very scenic and peaceful area.

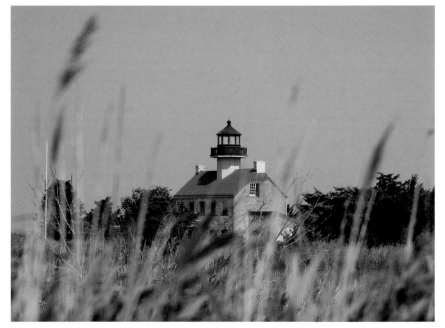

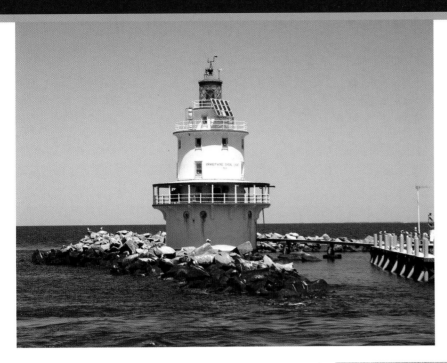

Marking the area of a dangerous shoal in Delaware Bay off the coast of New Jersey, Brandywine Shoal Lighthouse is 45 feet tall and was built in 1914.

Active since 1913, Miah Maull Shoal Lighthouse's tower is 45 feet tall and sits atop a cast-iron caisson near the center of Delaware Bay.

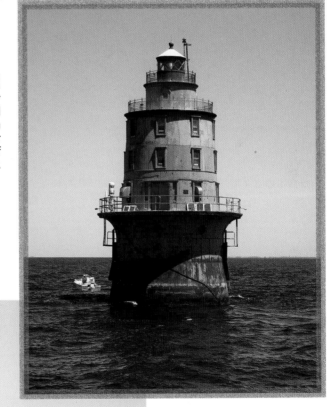

Built in 1877 and also 45 feet tall, Ship John Shoal Lighthouse is unique in structure for an iron caisson light.

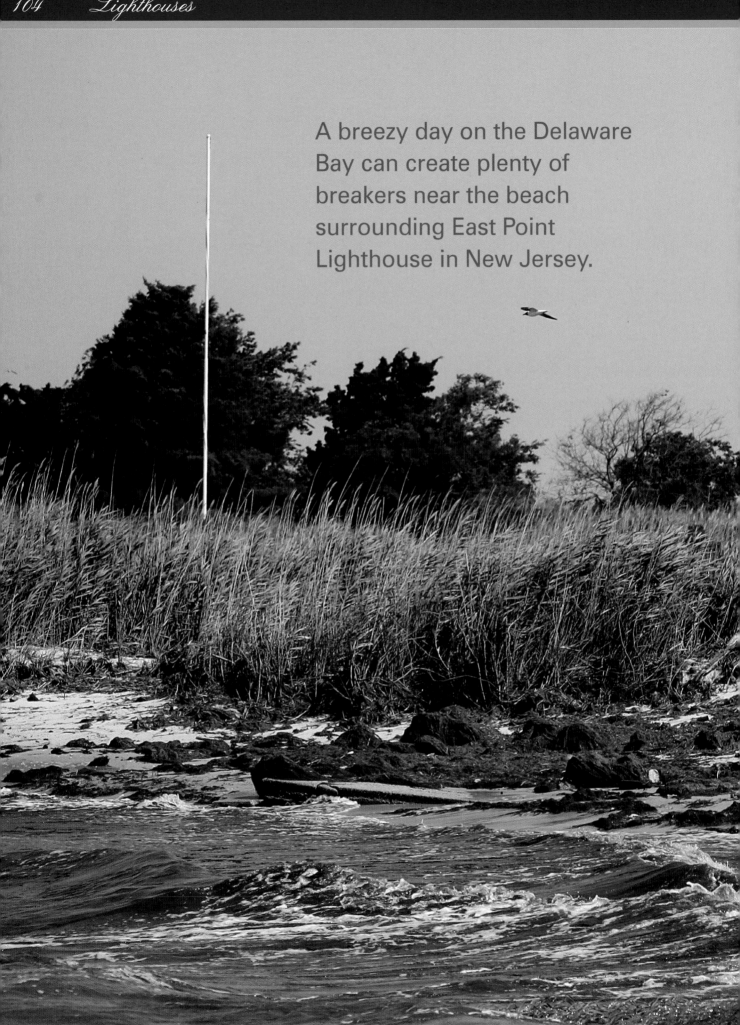

A breezy day on the Delaware Bay can create plenty of breakers near the beach surrounding East Point Lighthouse in New Jersey.

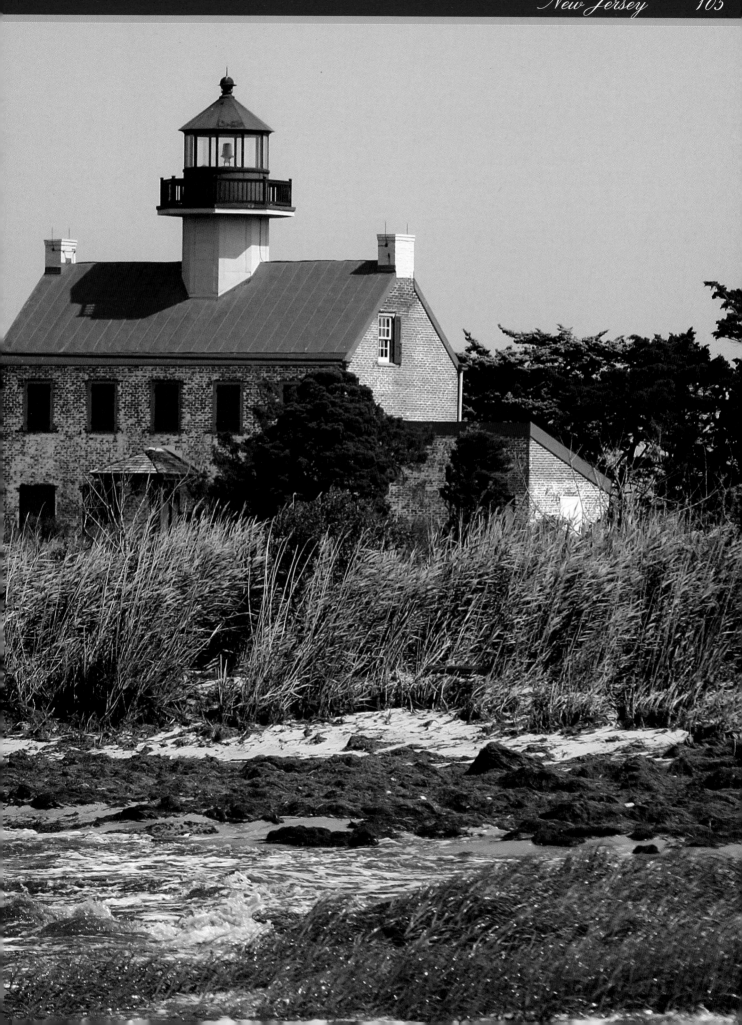

Delaware

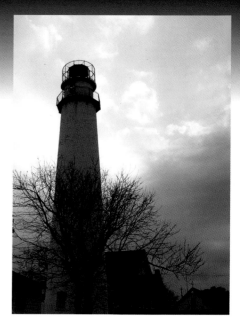

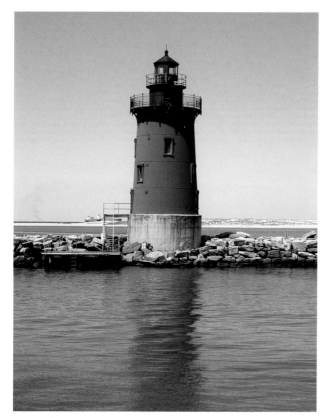

Just north of the Delaware-Maryland state line, Fenwick Island Lighthouse, which was built in 1859 and stands 84 feet, is the only lighthouse standing along Delaware's Atlantic Coast.

Where Cape Henlopen State Park in Delaware juts into Delaware Bay, the Harbor of Refuge and Breakwater East End lighthouses mark a safe harbor at the southern part of the bay. With its black-and-white tower atop an iron caisson, the Harbor of Refuge light was built in 1926, while the East End light, with a distinctive red tower, was put in place some 40 years earlier in 1885.

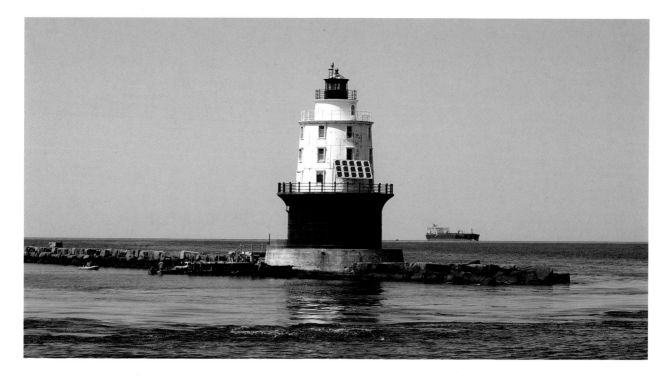

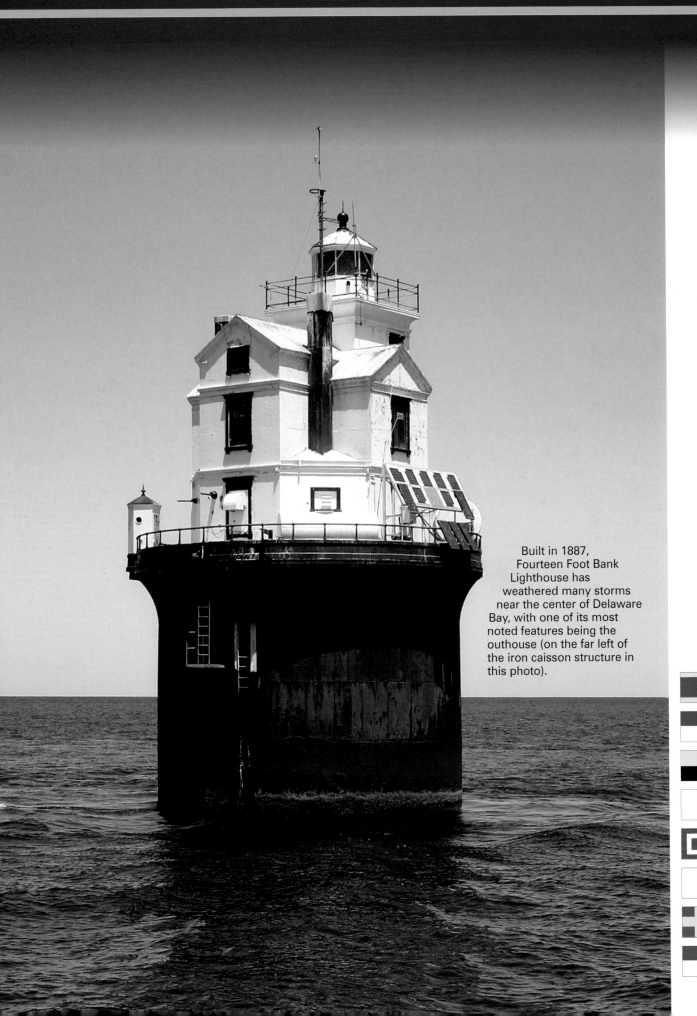

Built in 1887, Fourteen Foot Bank Lighthouse has weathered many storms near the center of Delaware Bay, with one of its most noted features being the outhouse (on the far left of the iron caisson structure in this photo).

Maryland

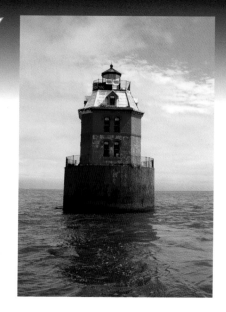

Sandy Point Shoal Lighthouse is one of several iron caissons in the Chesapeake Bay with an Empire-style keeper's house.

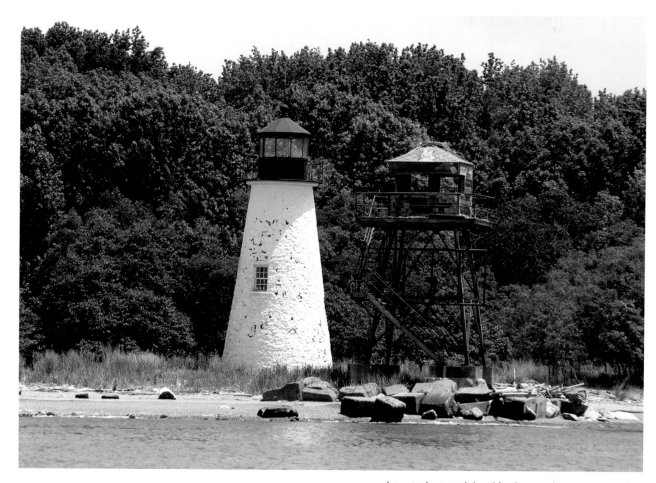

Located on an island in the northwestern portion of Maryland's Chesapeake Bay and built in 1825, Poole's Island also has stood through many storms and several wars.

Opposite page:
Built in 1827 at the western side of the mouth of the Susquehanna River, Concord Point Lighthouse is the northern-most lighthouse in Maryland's Chesapeake Bay.

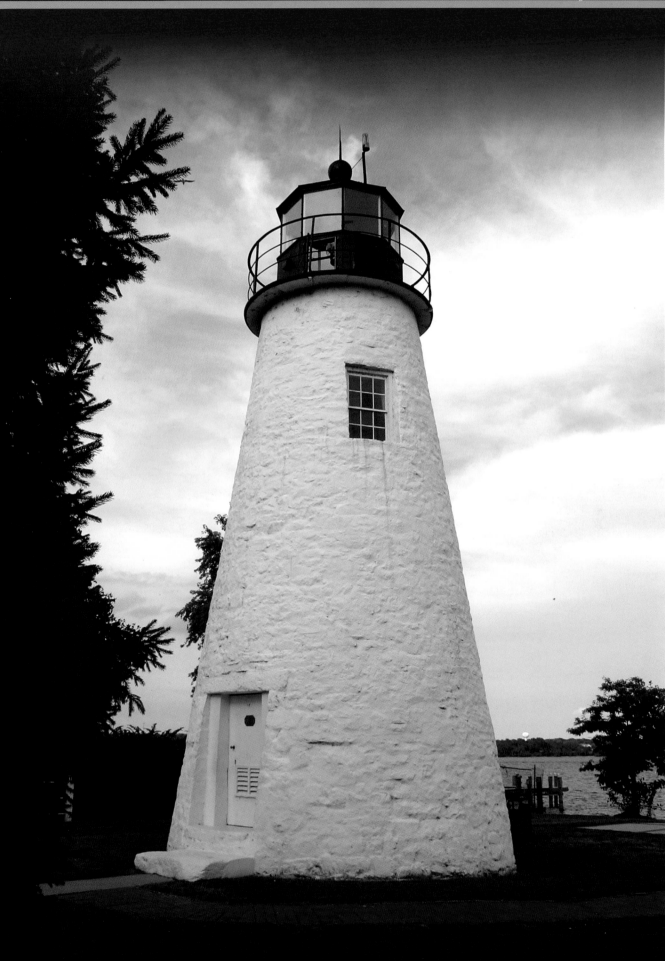

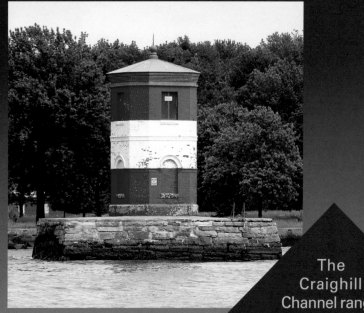

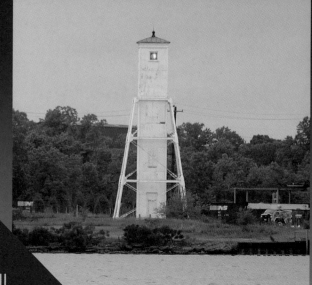

The Craighill Channel range lights, which mark the approach to the Patapsco River and Baltimore Harbor, were constructed in two phases in 1873 and 1886. The 18-foot, red-and-white tower and 90-foot white tower mark the Craighill Upper Range, while the 42-foot, all-red, sparkplug-style tower and the 105-foot, red-and-white tower mark the Craighill Lower Range.

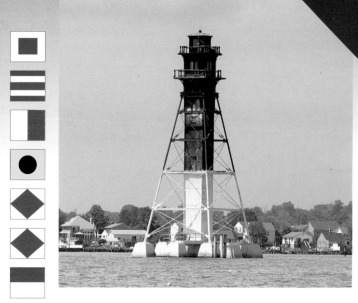

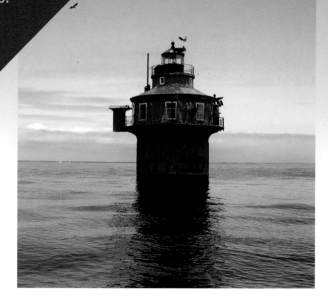

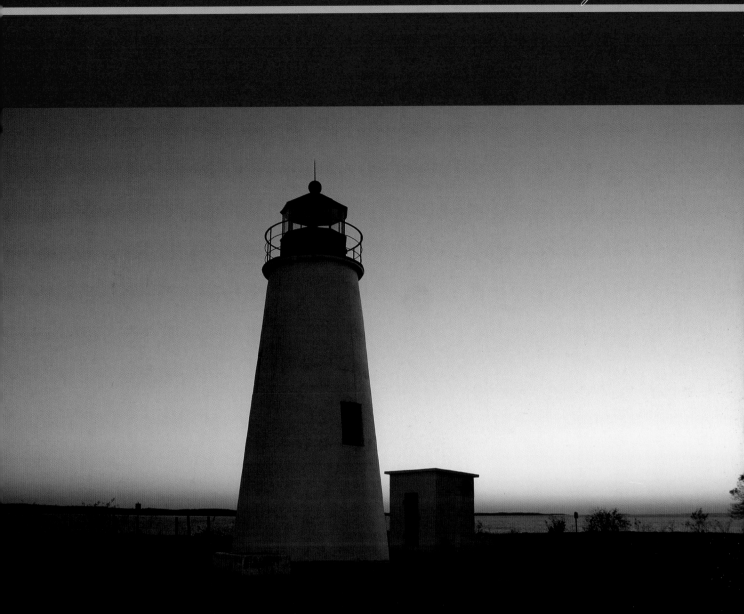

Above:
Located atop a 100-foot bluff in the northeastern part of Maryland's Chesapeake Bay, Turkey Point Lighthouse is 38 feet tall and was built in 1833.

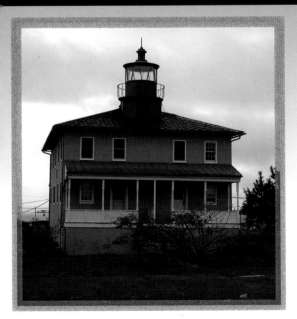

Left:
Located on a narrow strip of land where the Chesapeake Bay and Potomac River meet, Point Lookout Lighthouse, built in 1830, has a great deal of Civil War lore attached to it.

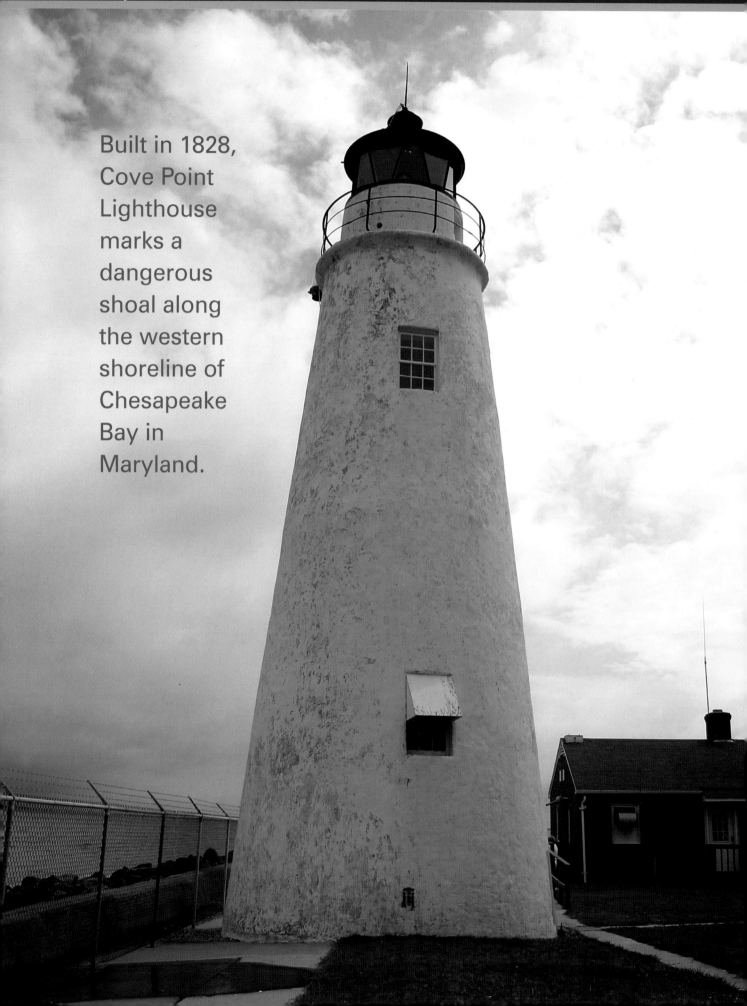

Built in 1828, Cove Point Lighthouse marks a dangerous shoal along the western shoreline of Chesapeake Bay in Maryland.

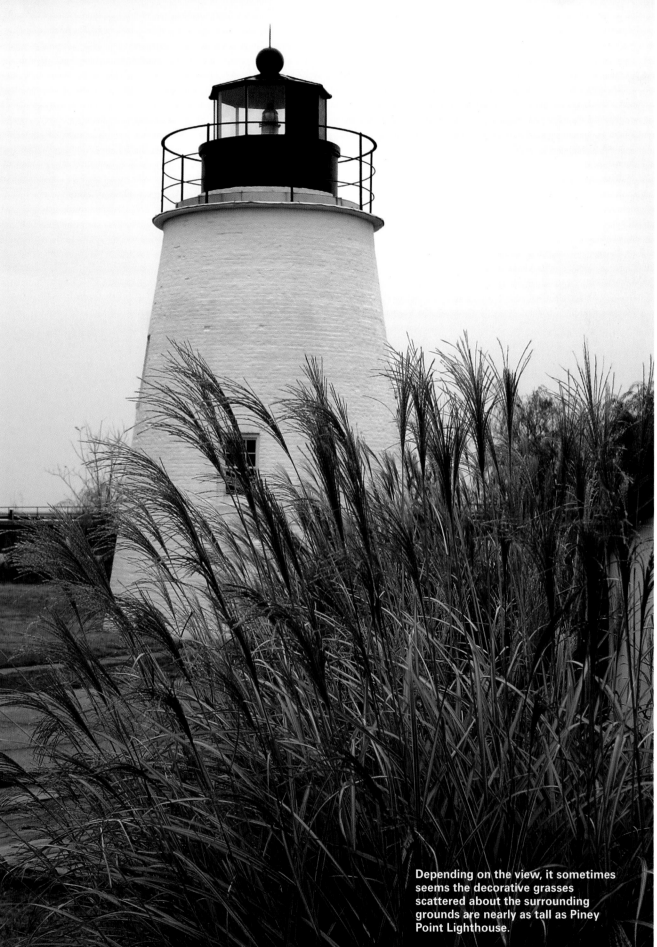

Depending on the view, it sometimes seems the decorative grasses scattered about the surrounding grounds are nearly as tall as Piney Point Lighthouse.

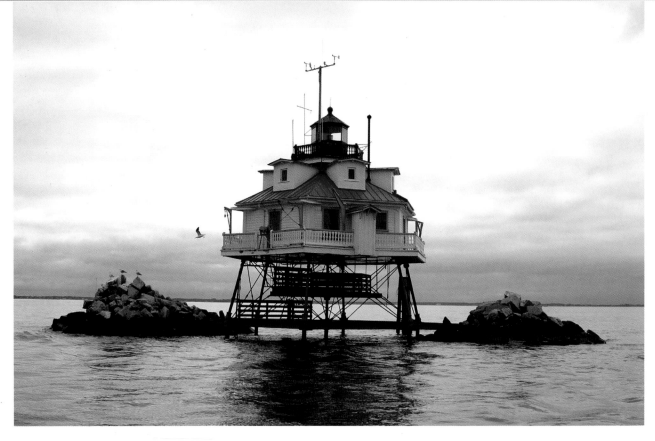

Above:
One of the Chesapeake Bay's most recognized
lighthouses, Maryland's Thomas Point Shoal
is one of the last screwpile lighthouses still
standing in its original location.

Below:
Built in 1883, Drum Point Lighthouse was one of many
screw pile lighthouses to mark dangerous spots within
Chesapeake Bay in Maryland until it was decommissioned
and later moved to Calvert Marine Museum in Solomons.

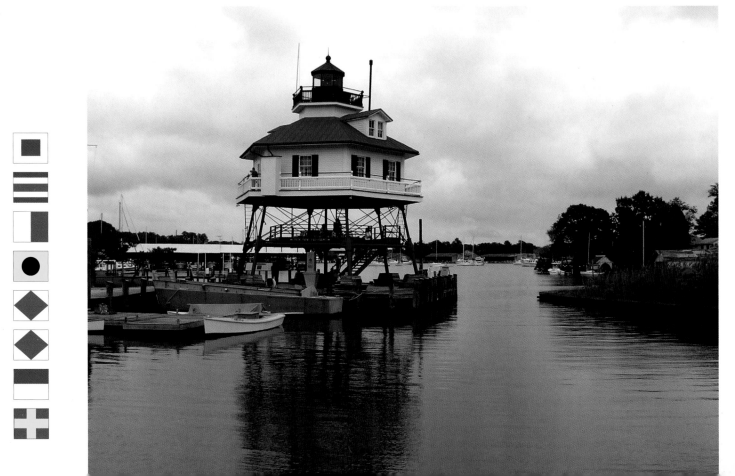

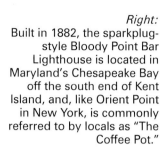

Right:
Built in 1882, the sparkplug-style Bloody Point Bar Lighthouse is located in Maryland's Chesapeake Bay off the south end of Kent Island, and, like Orient Point in New York, is commonly referred to by locals as "The Coffee Pot."

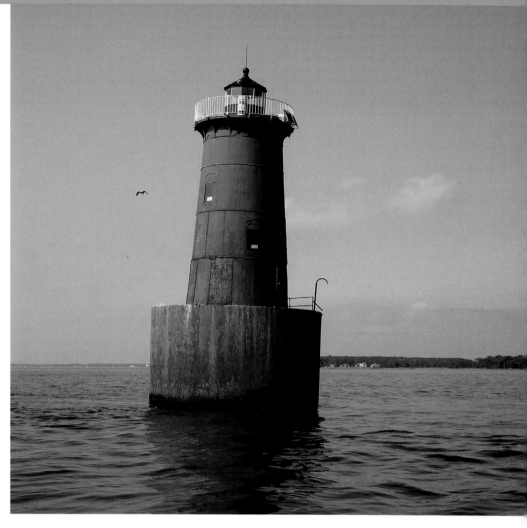

Below:
Ice floes in the Chesapeake Bay during past winters have resulted in the characteristic tilt of Sharps Island Lighthouse, which is located about four miles off the western shore of the Bay.

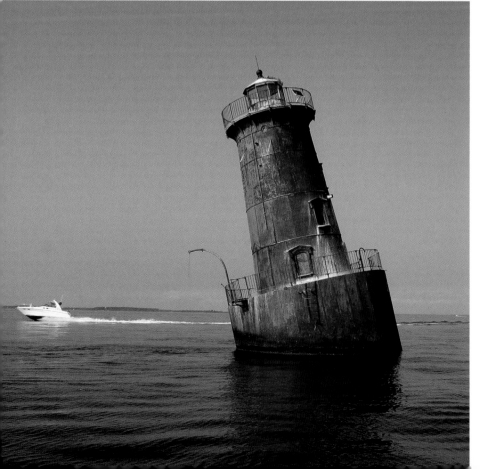

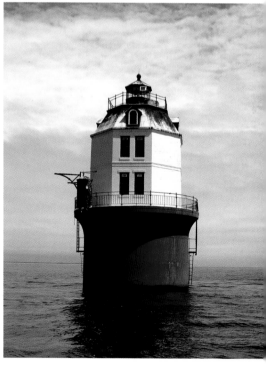

Located off Gibson Island in the Chesapeake Bay, to the southeast of Baltimore Harbor, the 38-foot-tall Baltimore Harbor Lighthouse was built in 1908.

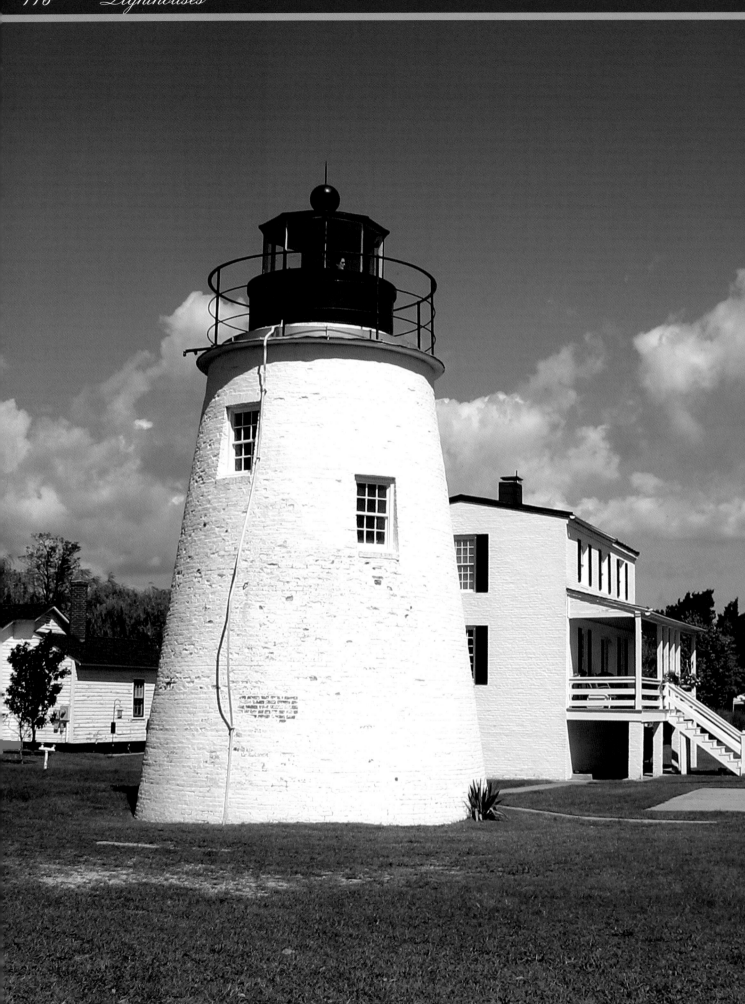

Often used as a summer retreat by a number of presidents during the 19th century, Piney Point Lighthouse in Maryland is a stout 35 feet tall.

Virginia

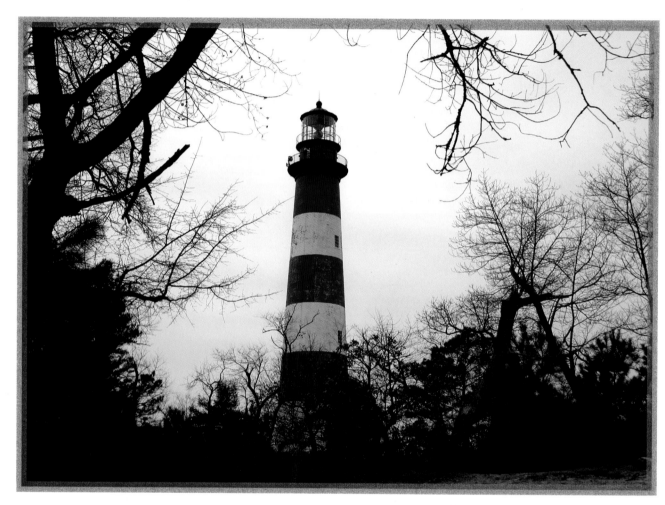

Above:
Beautiful Assateague Island, along the northern Atlantic Coast of Virginia, is home to the 142-foot-tall Assateague Lighthouse and its distinct red-and-white daymark.

Opposite page:
The original tower built in 1792, Old Cape Henry Lighthouse has been inactive since 1881 but remains in place as a tourist attraction at Fort Story in Virginia.

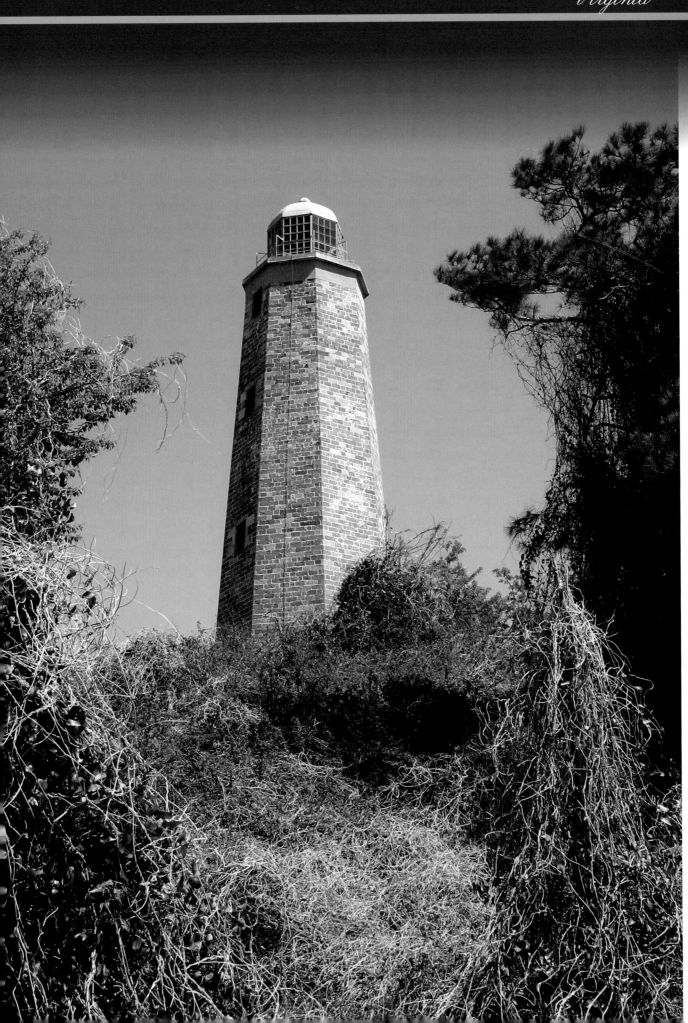

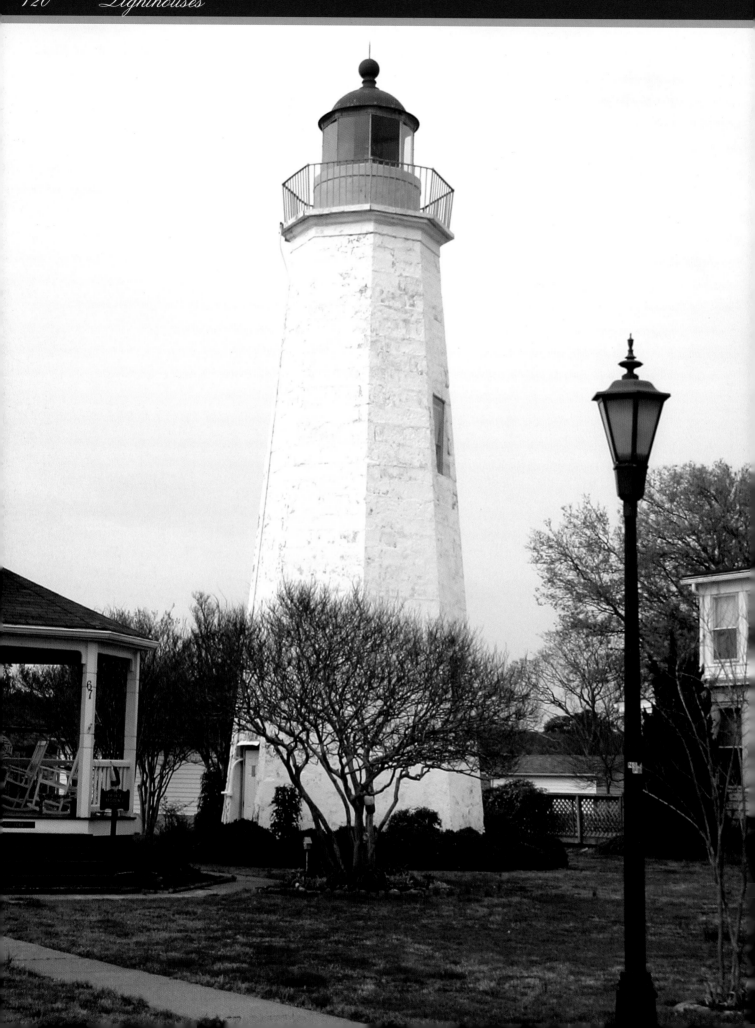

Built in 1881 as a replacement to Old Cape Henry Lighthouse, the New Cape Henry Lighthouse has one of the most unique daymarks of America's lighthouses.

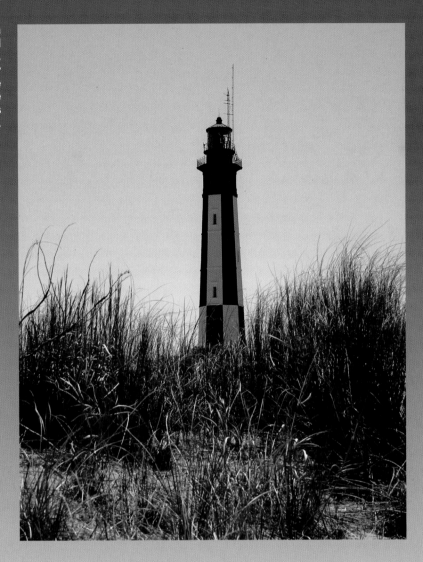

Located at Fort Monroe in Virginia and standing 58 feet tall, Old Point Comfort Lighthouse marks the entrance to the harbor near Hampton Roads.

North Carolina

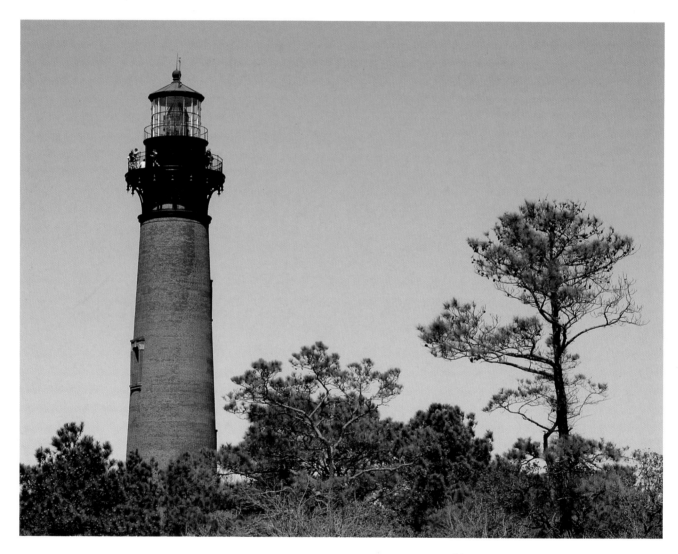

Above:
Currituck Beach Lighthouse is a popular place during the tourist season, and stands high above the trees along the northern Atlantic Coast on the Outer Banks.

Opposite page:
At 160 feet tall and with its distinctive daymark, Bodie Island Lighthouse on North Carolina's Outer Banks is a wonderful sight at any time of the day.

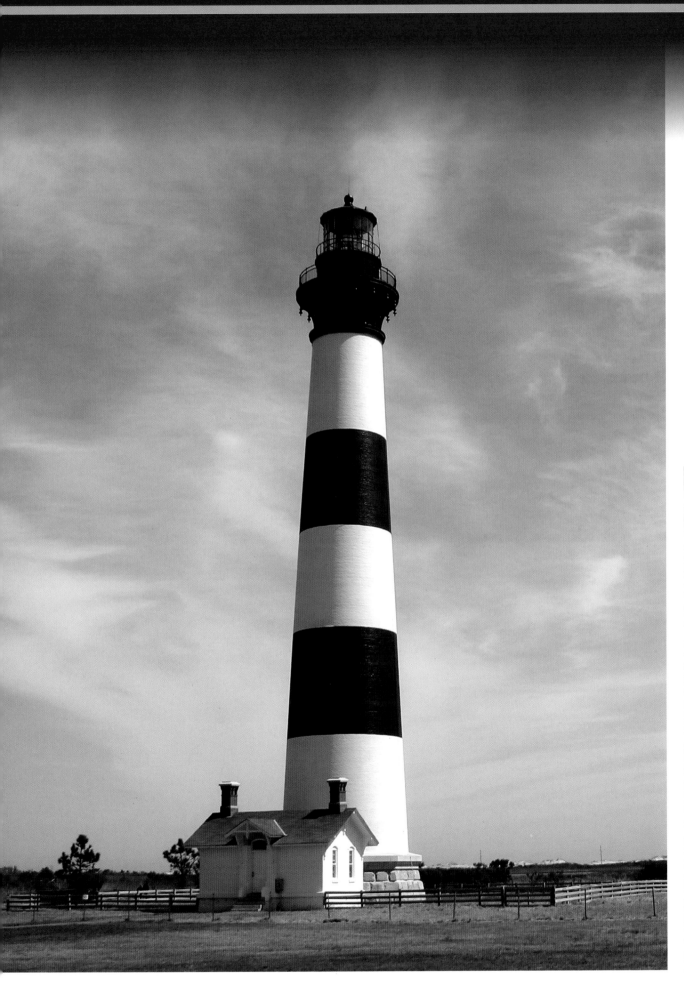

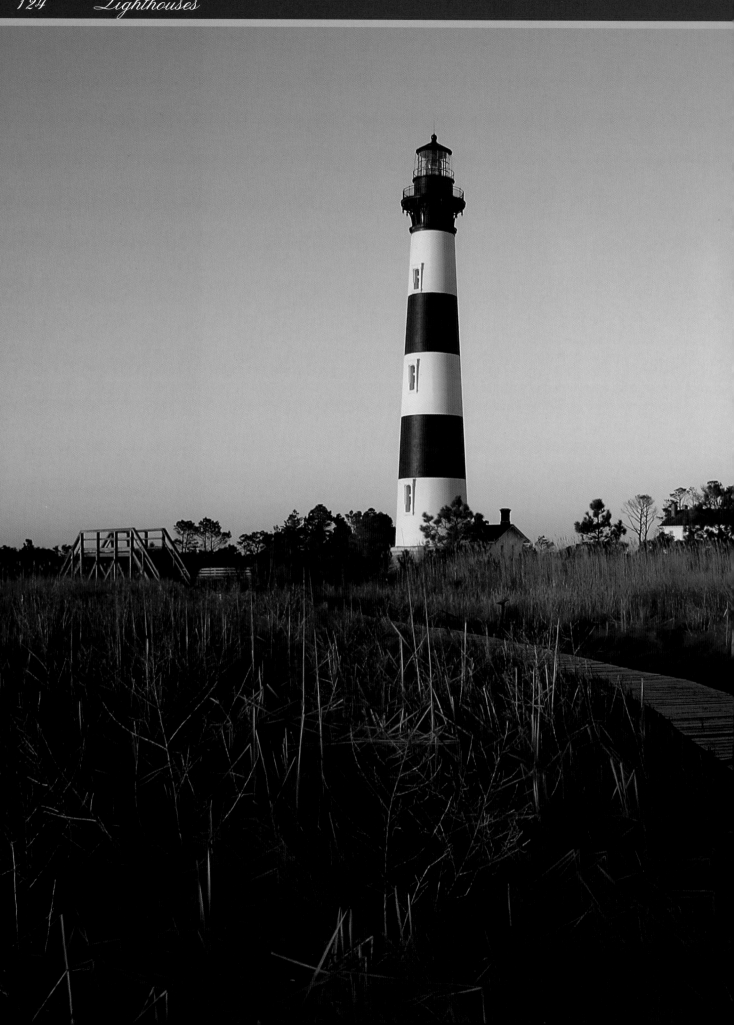

Early in the morning during certain times of the year, the wetlands surrounding Bodie Island Lighthouse on the Outer Banks of North Carolina light up with fiery color and make for an interesting contrast with Bodie's black-and-white bands.

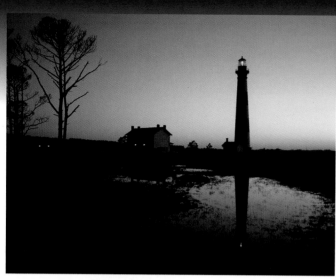

On some mornings following a rainy day, the view of Bodie Island Lighthouse, located on the Outer Banks of North Carolina, can be spectacular, especially just before sunrise.

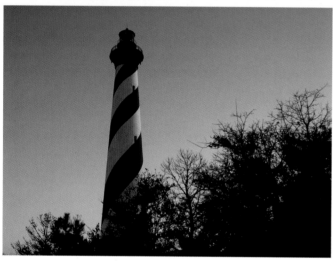

Cape Hatteras at one time stood on the beach of one of the most eroded spots along the Outer Banks of North Carolina, but now it stands safely away from the water.

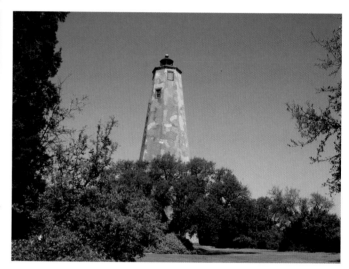

Often referred to as "Old Baldy," the 100-foot-tall Bald Head Island Lighthouse built in 1818 is quite unique in style with its mottled stucco veneer.

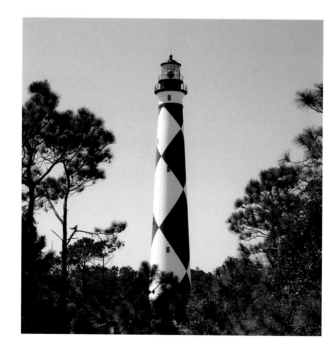

Built in 1859 amid some of the shiftiest waters along the Outer Banks of North Carolina, Cape Lookout Lighthouse still remains an active aid to navigation.

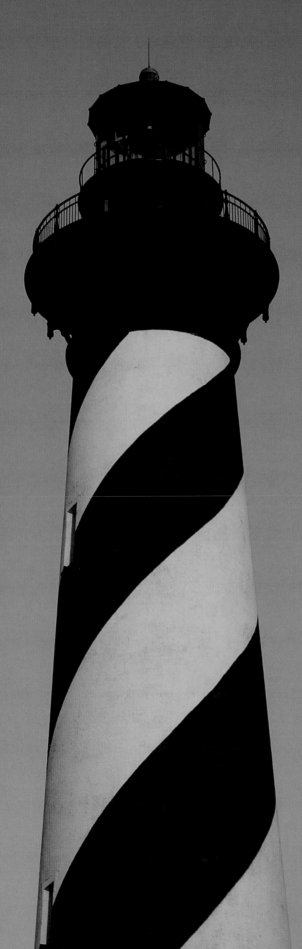

North Carolina's Cape Hatteras Lighthouse, which is the eastern-most lighthouse on the Outer Banks, is America's tallest lighthouse and one of the most recognized in the world.

At 200 feet tall,
Cape Hatteras
Lighthouse
on the Outer
Banks of North
Carolina towers
above the trees
that surround it
nowadays.

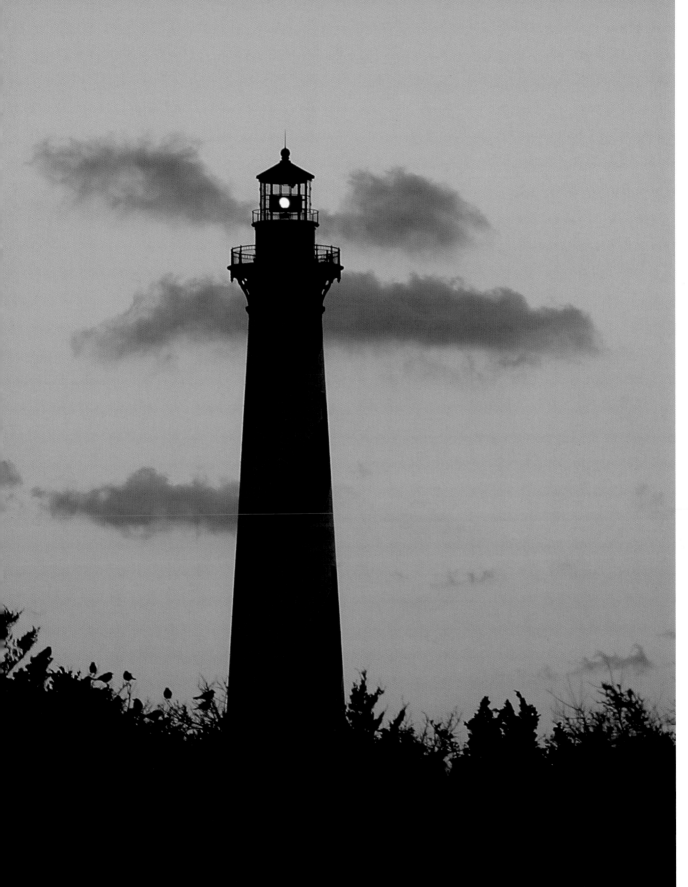

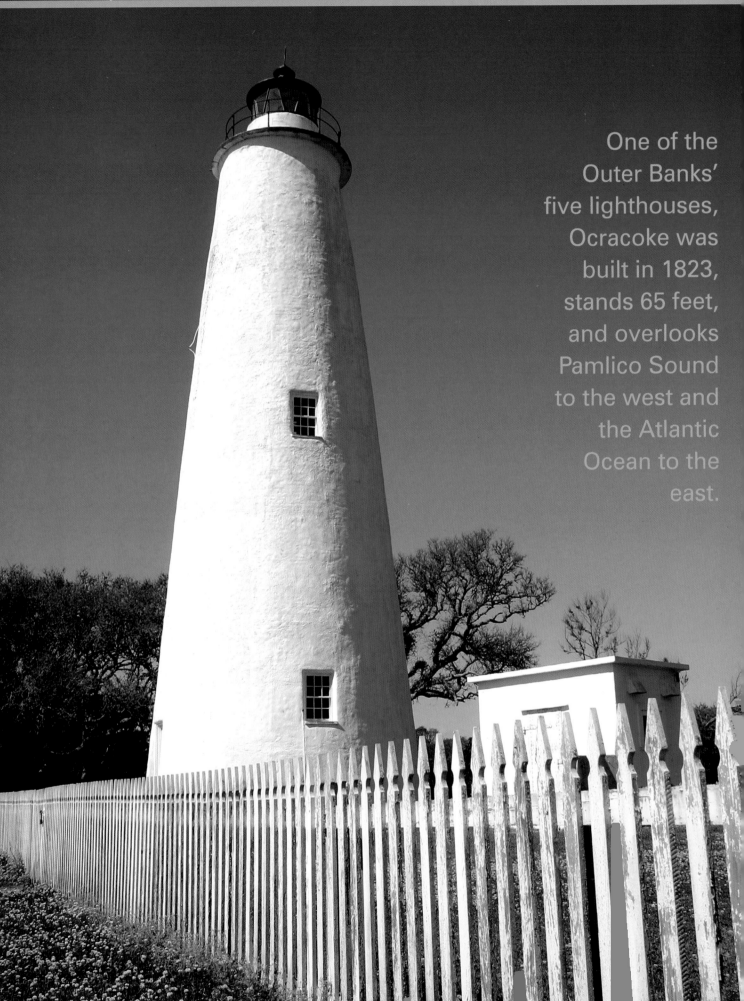

One of the Outer Banks' five lighthouses, Ocracoke was built in 1823, stands 65 feet, and overlooks Pamlico Sound to the west and the Atlantic Ocean to the east.

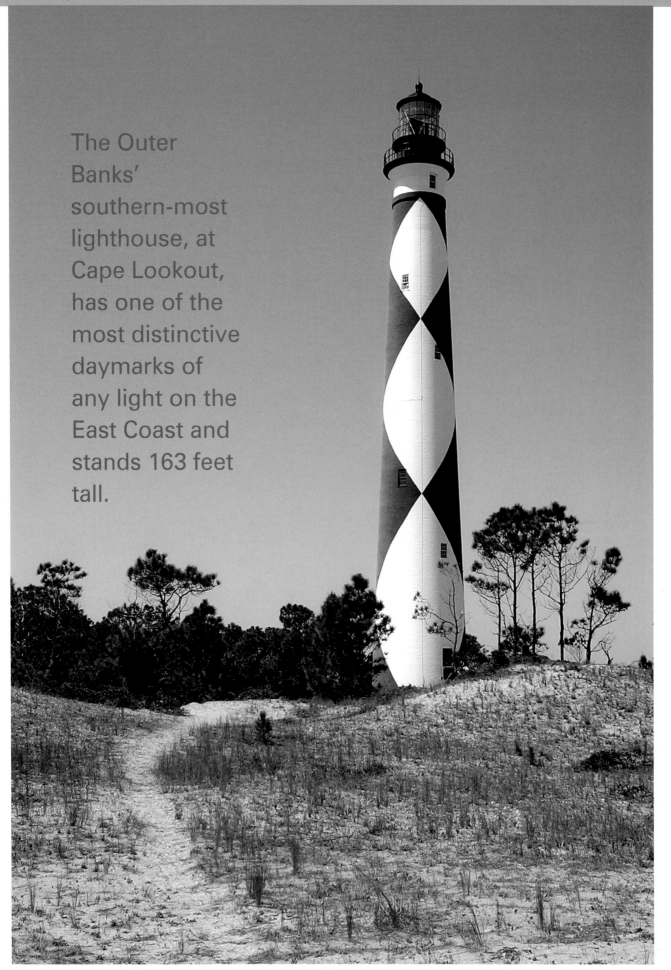

The Outer Banks' southern-most lighthouse, at Cape Lookout, has one of the most distinctive daymarks of any light on the East Coast and stands 163 feet tall.

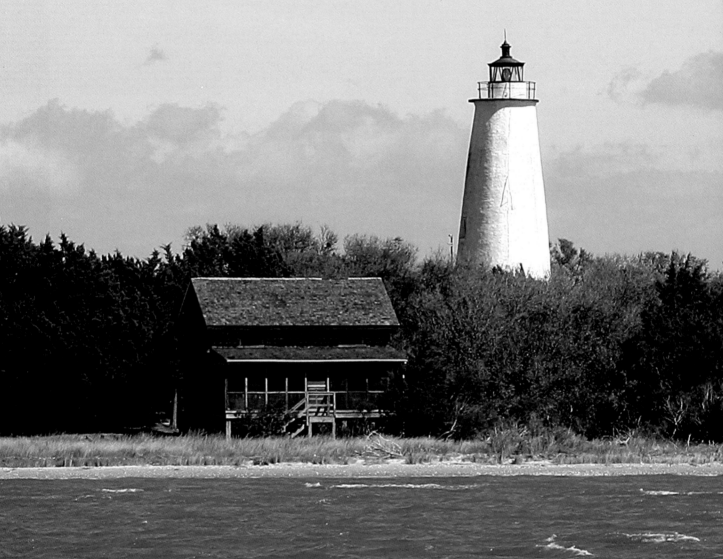

The ferry ride
from Cedar Island
to Ocracoke Island
is a pleasant
one, and the
view of Ocracoke
Lighthouse from
Pamlico Sound is
just as pleasant.

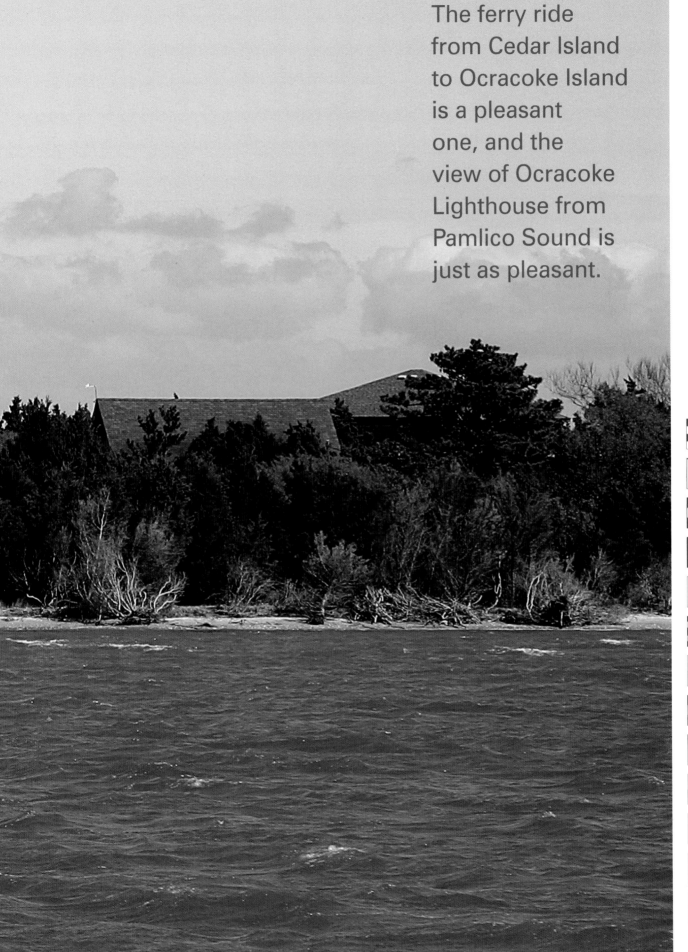

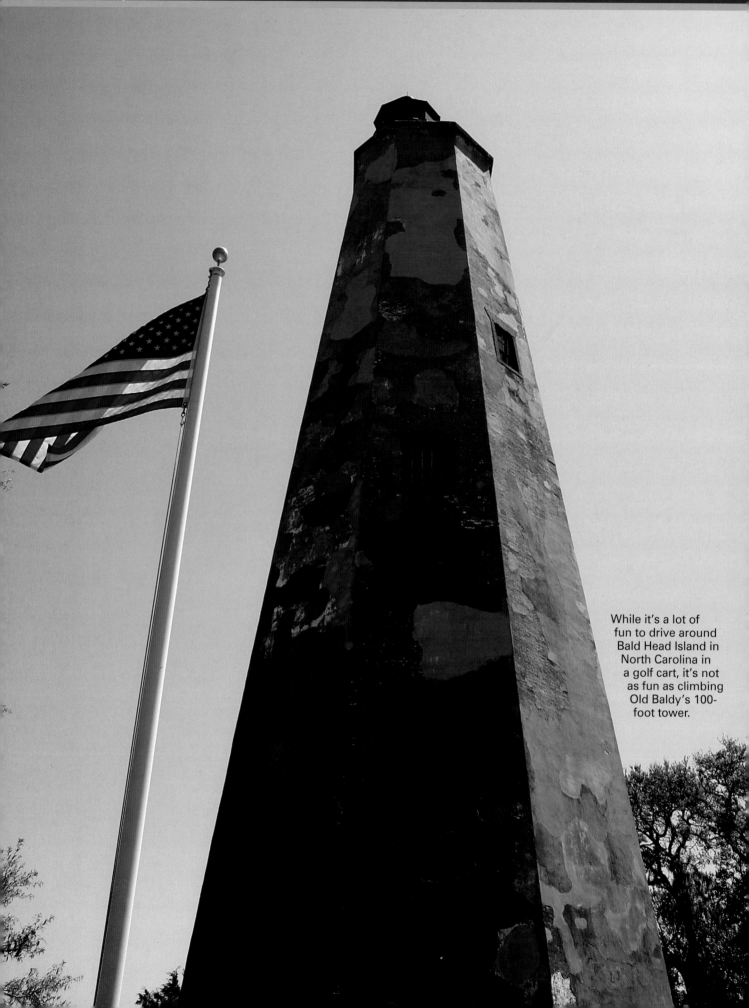

While it's a lot of fun to drive around Bald Head Island in North Carolina in a golf cart, it's not as fun as climbing Old Baldy's 100-foot tower.

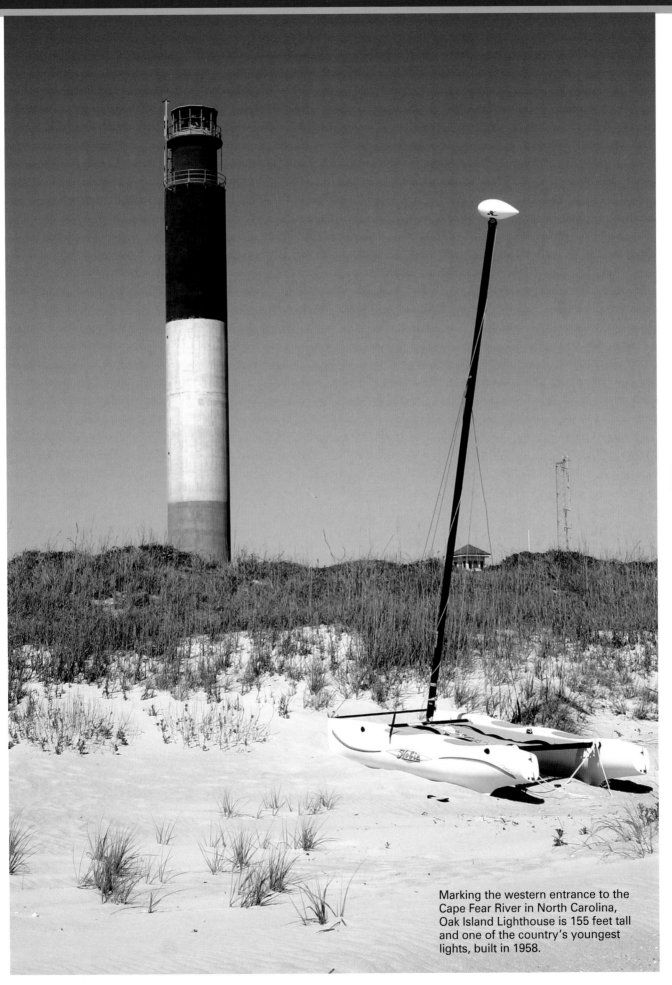

Marking the western entrance to the Cape Fear River in North Carolina, Oak Island Lighthouse is 155 feet tall and one of the country's youngest lights, built in 1958.

South Carolina

Beaten and battered by rough weather since 1876, Morris Island Lighthouse, which stands just off the coast of South Carolina near Folly Beach, was in serious danger of ruin before a local preservation group organized to save the tower.

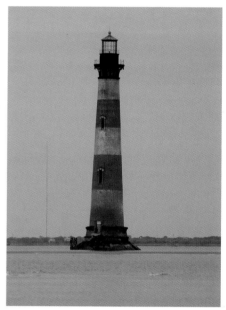

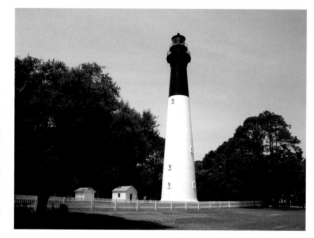

At 136 feet tall, the conical, cast-iron tower that makes up Hunting Island Lighthouse has been active along South Carolina's Atlantic Coast since 1875.

Standing along the Atlantic Coast on the eastern side of Charleston, S.C., Sullivan's Island Lighthouse gives the appearance of an airport control tower.

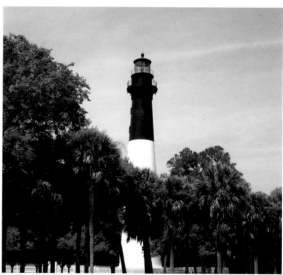

Hunting Island Lighthouse stands tall among many trees along the southeastern coast of South Carolina.

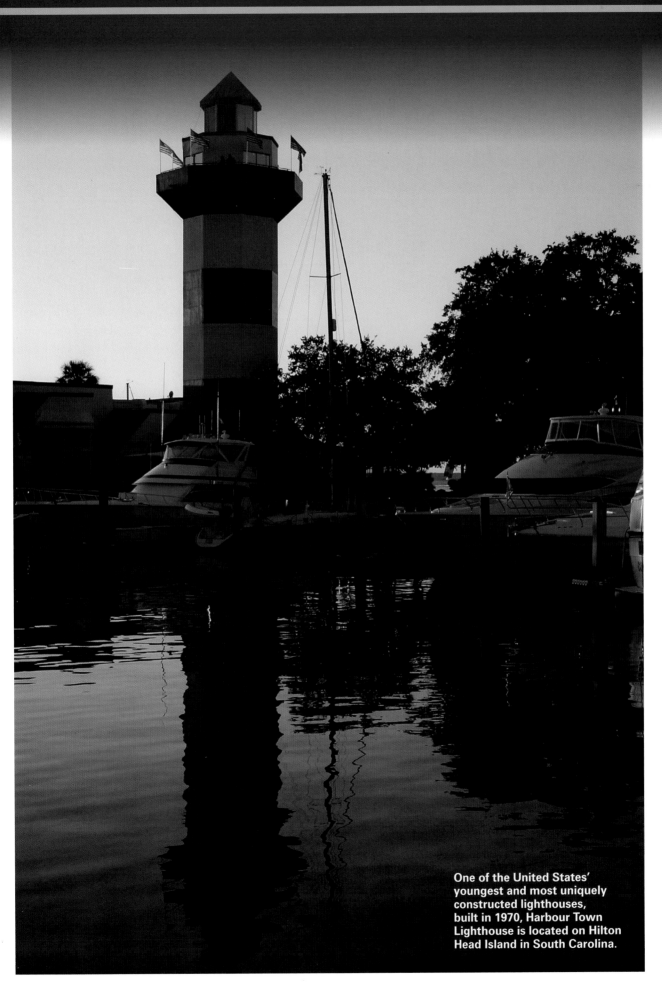

One of the United States'
youngest and most uniquely
constructed lighthouses,
built in 1970, Harbour Town
Lighthouse is located on Hilton
Head Island in South Carolina.

Georgia

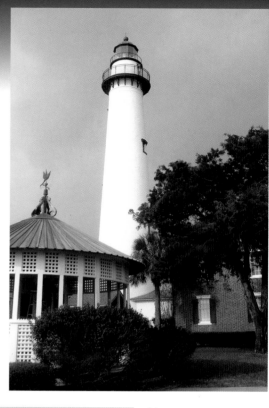

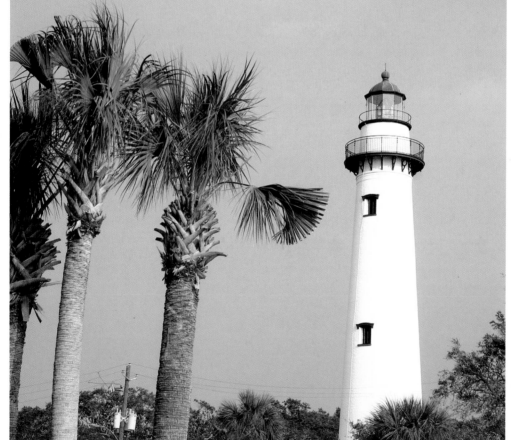

Above:
The grounds surrounding St. Simons Island Lighthouse on Georgia's southern Atlantic Coast are a wonderful place to relax and enjoy a peaceful, November afternoon.

Left:
The tallest of Georgia's conical towers along the Atlantic Coast, St. Simons Island Lighthouse was brought into service in 1872 and still acts as an aid to navigation with its original Fresnel lens.

Opposite page:
With its distinctive black-and-white daymark, Tybee Island Lighthouse has stood along Georgia's Atlantic Coast since 1867.

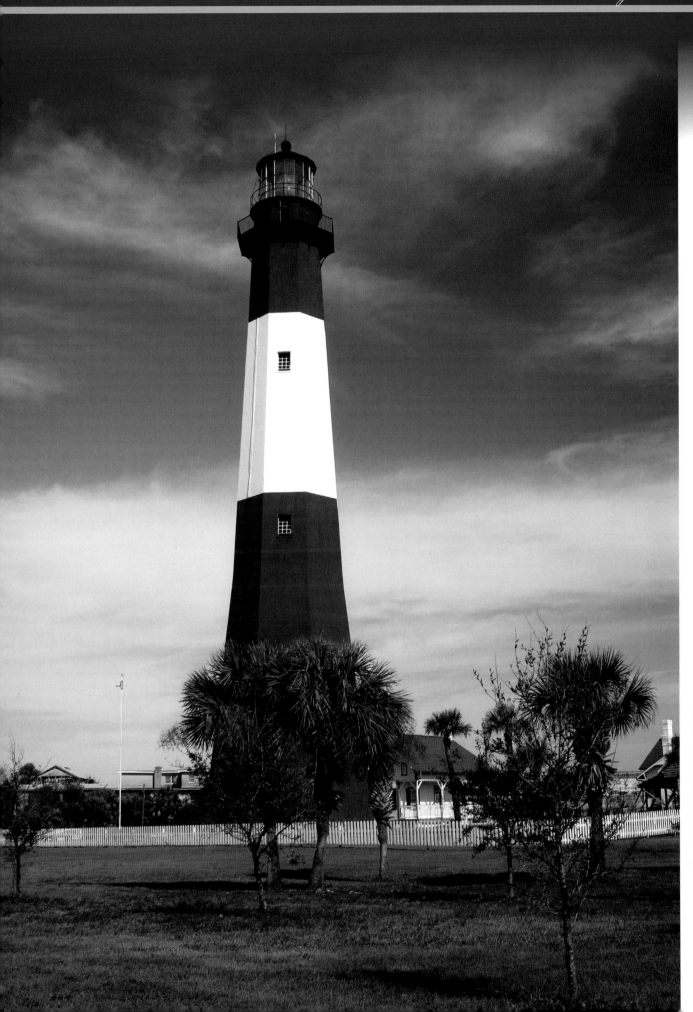

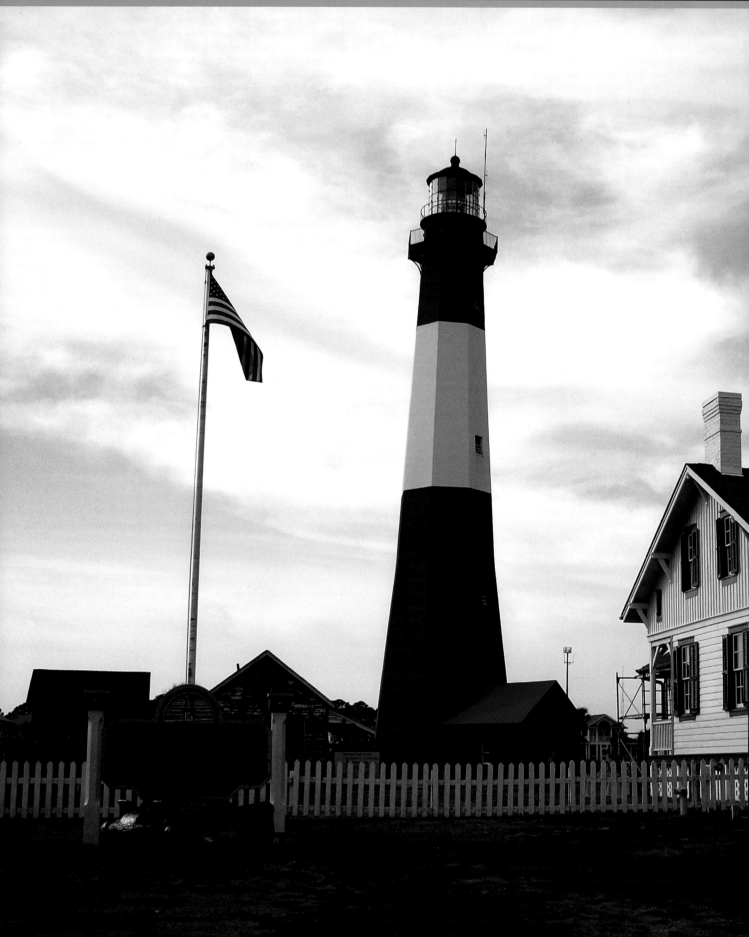

Standing 145 feet tall, Tybee Island Lighthouse not only has stood for more than 140 years on the Atlantic Coast near Savannah, Georgia, but its lantern room still holds its original Fresnel lens.

Florida

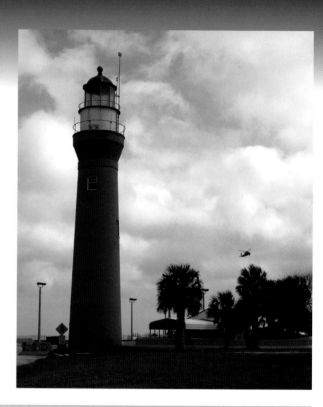

Left:
Located at Florida's
Mayport Naval Air Station
just east of Jacksonville,
the St. John's River
Lighthouse seems to have
as much air traffic going
by it as boat traffic.

Below:
The City of St. Augustine
in Florida is a major
tourist attraction on
the Atlantic Coast, as
is the black-and-white
lighthouse with the
red lantern.

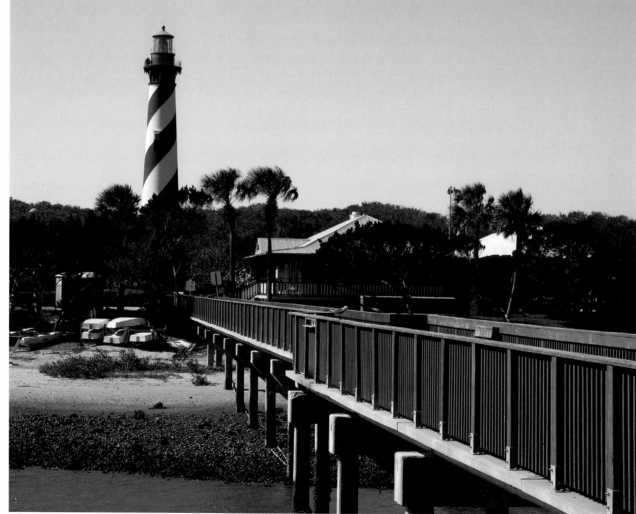

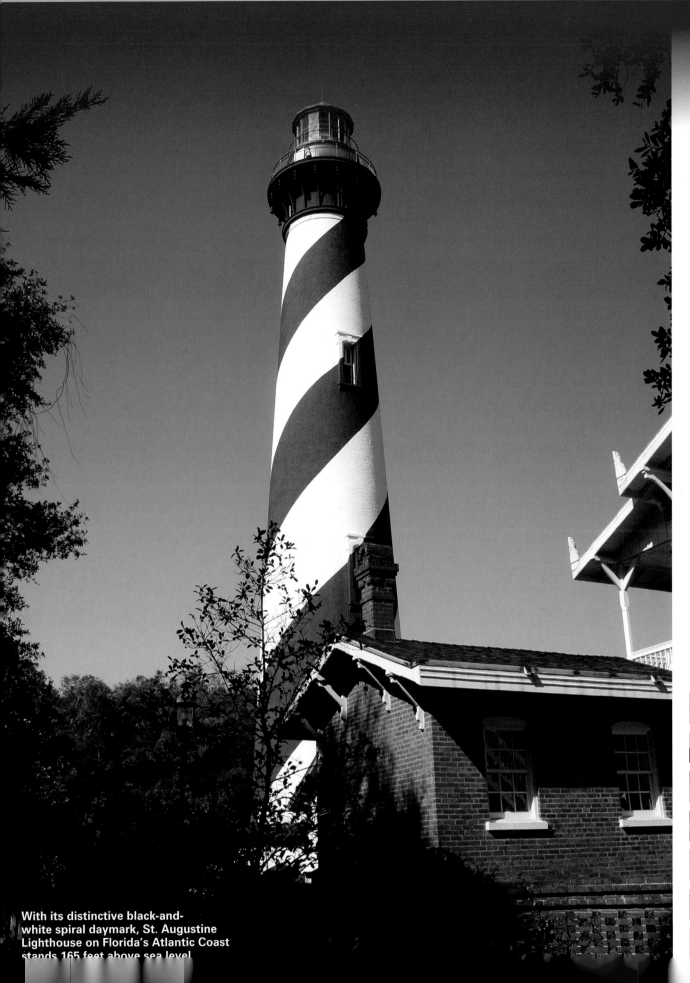

With its distinctive black-and-white spiral daymark, St. Augustine Lighthouse on Florida's Atlantic Coast stands 165 feet above sea level.

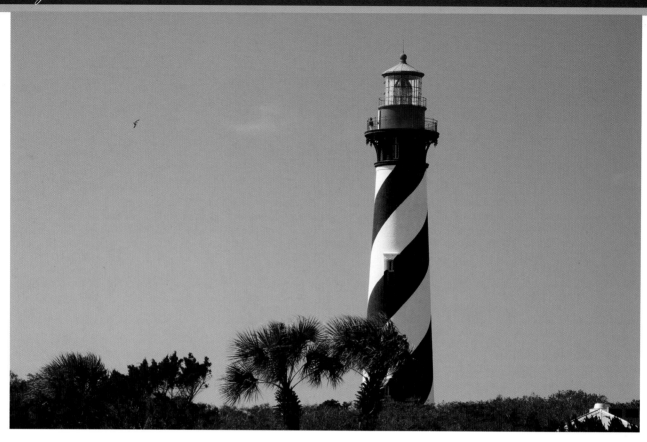

Above:
Many people mistake the shorter St. Augustine Lighthouse in Florida for North Carolina's Cape Hatteras, and while they are similar with their black-and-white, spiral daymark, St. Augustine's red lantern distinguishes the difference.

Below:
With lots of boat traffic cruising through Hillsboro Inlet to and from the Atlantic Ocean, Hillsboro Inlet Lighthouse in Florida serves a great purpose, even on bright and sunny days.

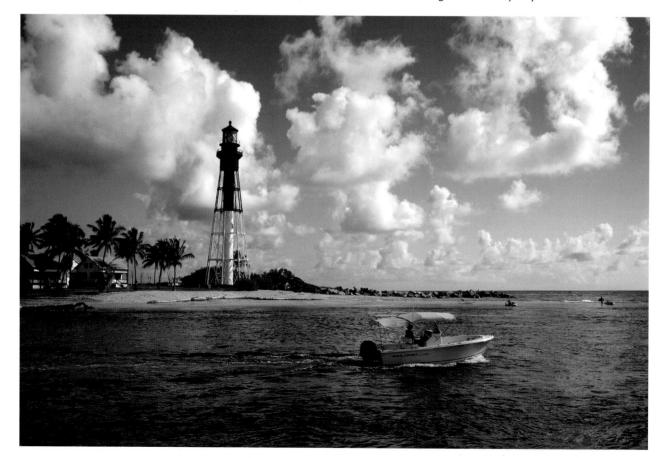

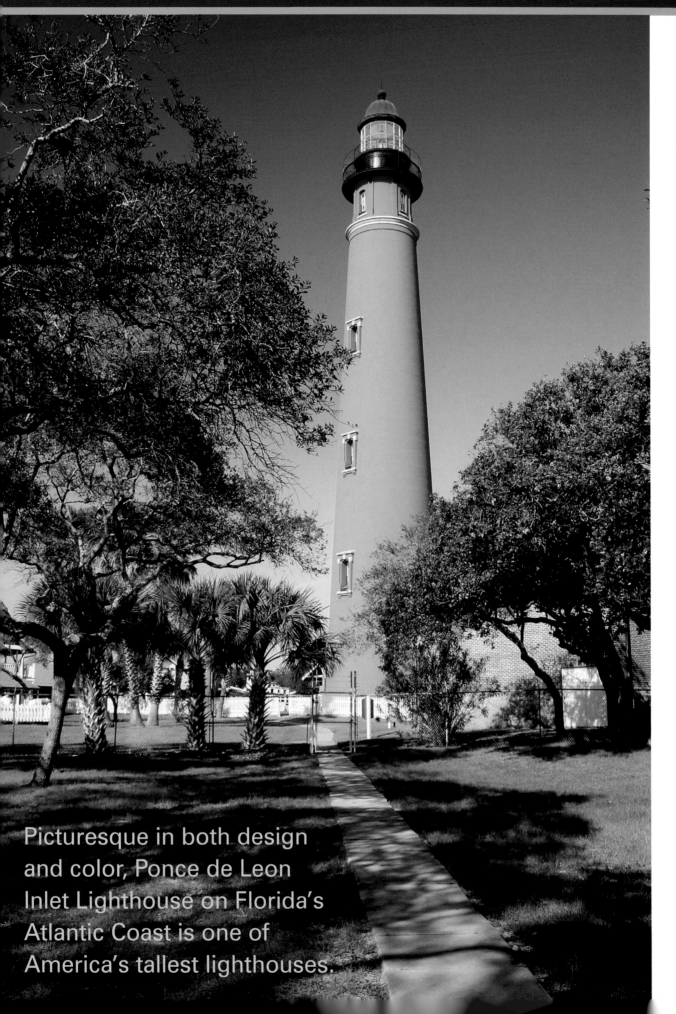

Picturesque in both design and color, Ponce de Leon Inlet Lighthouse on Florida's Atlantic Coast is one of America's tallest lighthouses.

At 175 feet tall, Ponce de Leon Inlet Lighthouse on Florida's Atlantic Coast was built in 1887 and remains active with its original Fresnel lens.

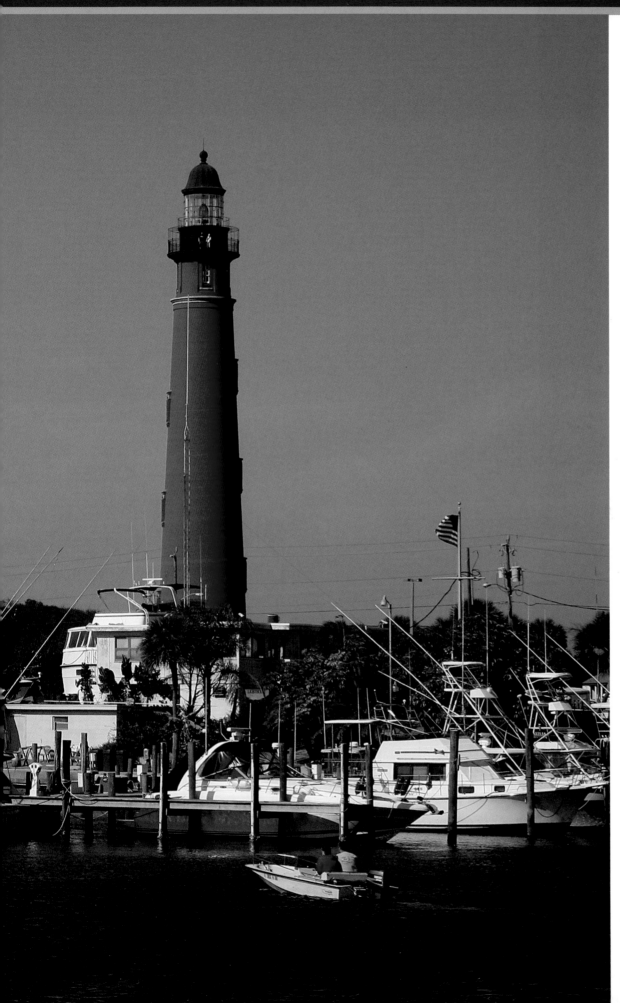

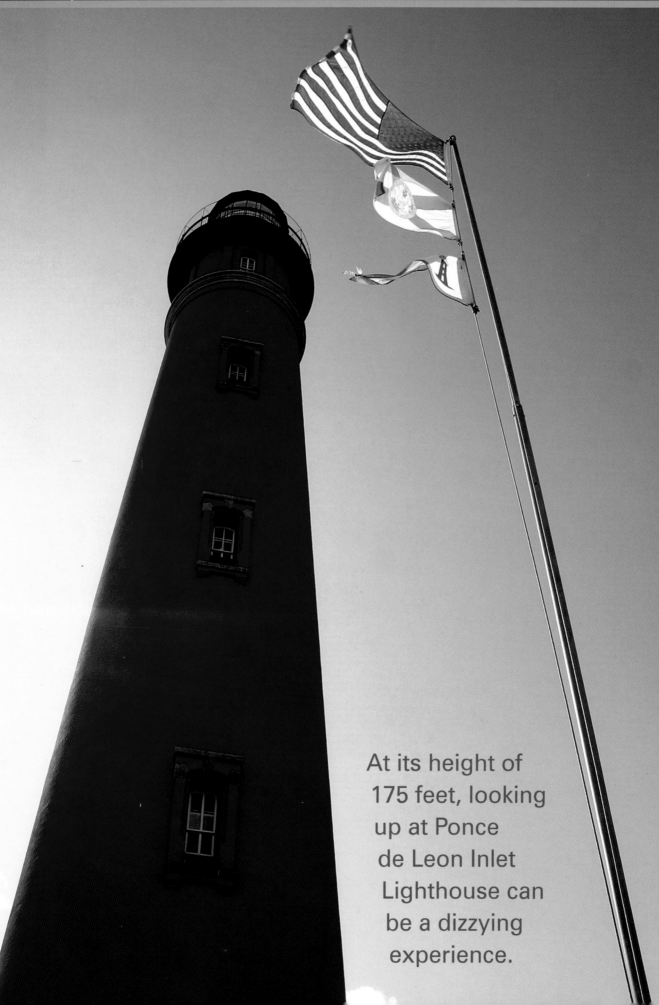

At its height of 175 feet, looking up at Ponce de Leon Inlet Lighthouse can be a dizzying experience.

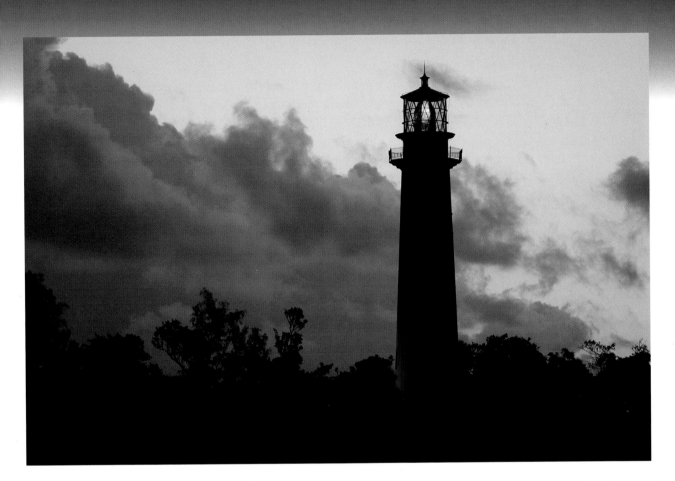

Above:
Built in 1860 and with its original Fresnel lens still in operation, Jupiter Inlet Lighthouse stands along the Atlantic Coast of Florida and occasionally takes a beating from a hurricane.

Right:
Before the sun comes up in Florida's Key West, you can find Key West Lighthouse lit up very nicely amid its tropic location.

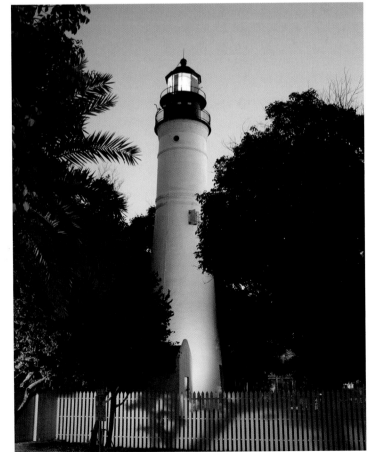

Hillsboro Inlet Lighthouse stands 142 feet above the sandy beaches of Pompano Beach in Florida, as well as the inlet into Hillsboro Bay from the Atlantic Ocean.

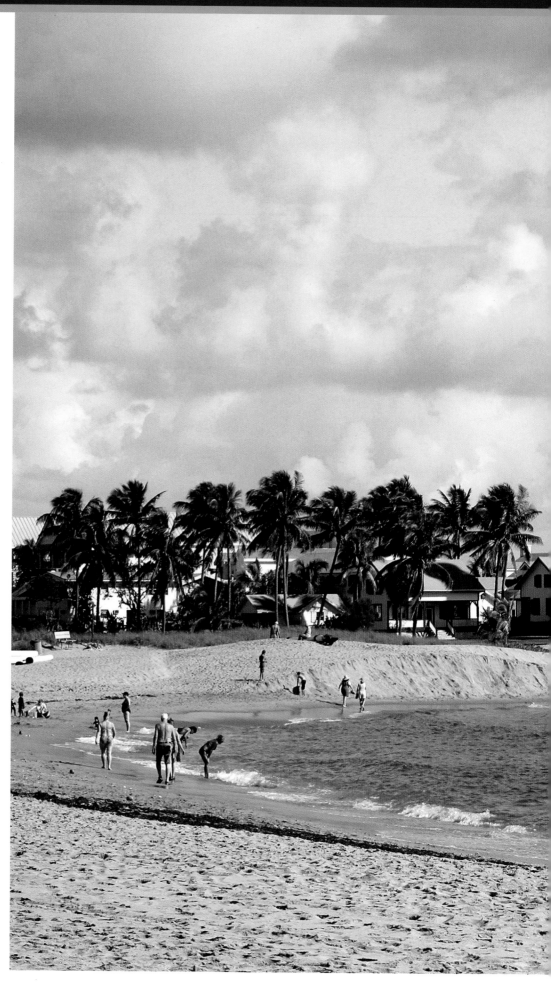

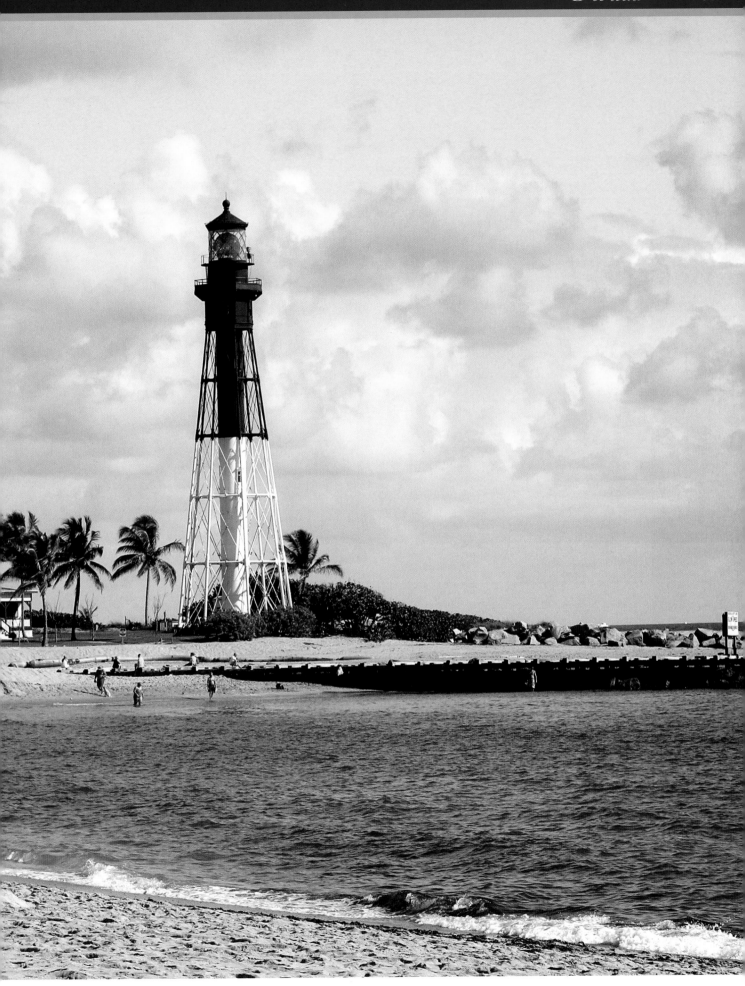

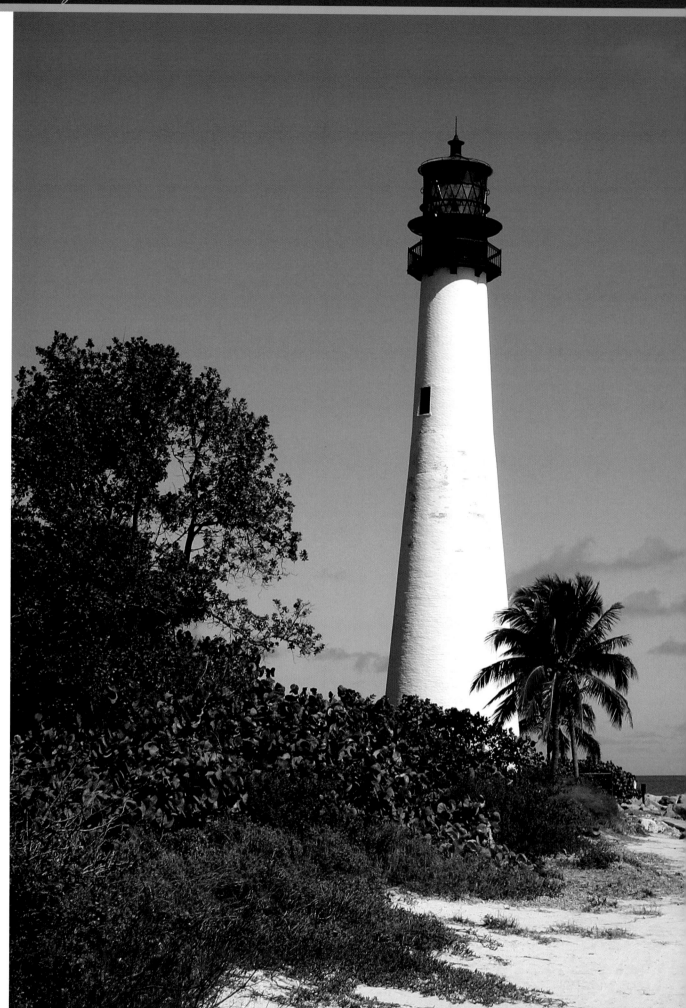

Most definitely
one of the
most beautiful
areas in Florida,
Key Biscayne
is home to
Cape Florida
Lighthouse,
which was built
in 1846.

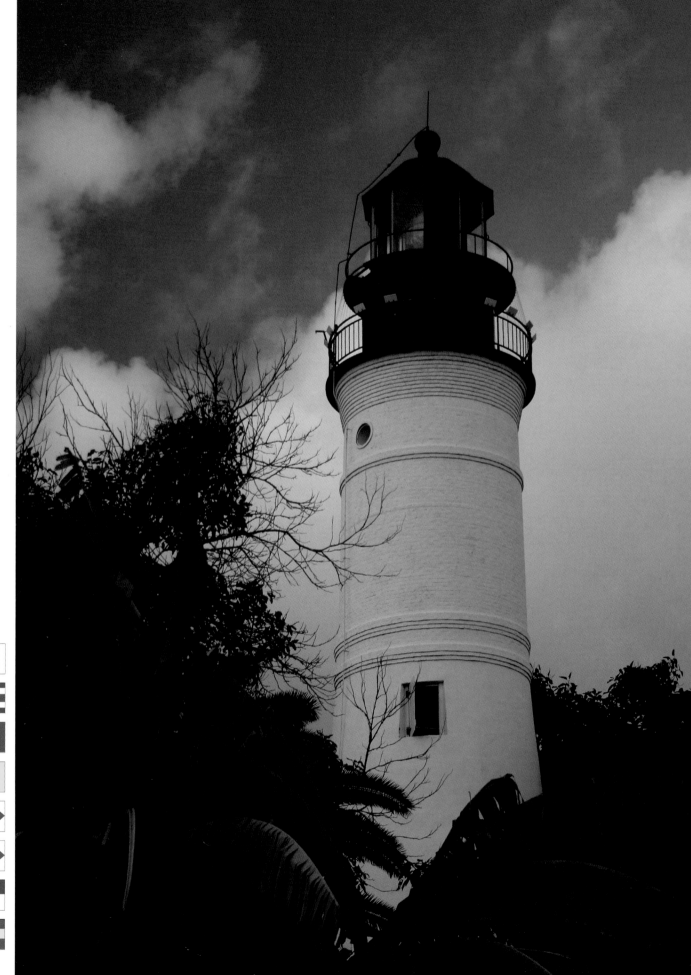

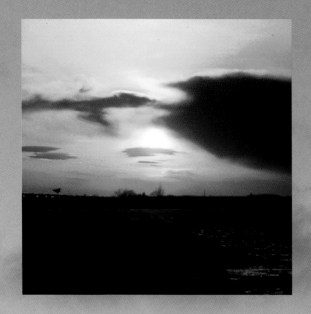

As the sun lowers in the sky every evening, the United States' southern-most beacon, Key West Lighthouse in Florida, eventually lights up at night, but no longer as an active aid to navigation.

Lighthouse Organizations

There are many local, state and regional organizations that care for specific lighthouses along the United States' East Coast. We urge you to support their preservation, protection, and restoration causes. The following organizations care for the lighthouses shown in this book.

Maine
American Lighthouse Foundation
P.O. Box 565
Rockland, ME 04841
(207) 594-4174
www.lighthousefoundation.org

Friends of Pemaquid Point Lighthouse
P.O. Box 353
Bristol, ME 04539-0353
(207) 563-2739

Friends of Perkins Island Lighthouse
P.O. Box 376
Georgetown, ME 04548

New Hampshire
Friends of Portsmouth Harbor Lighthouse
P.O. Box 8232
Portsmouth, NH 03802-5092
(603) 431-9155
www.portsmouthharborlighthouse.org

Massachusetts
Cape Cod Chapter of ALF
P.O. Box 570
Truro, MA 02652
(508) 487-9930
www.racepointlighthouse.net

Rhode Island
Friends of Pomham Rocks Lighthouse
P.O. Box 15121
Riverside, RI 02915
(508) 226-1185

New York
New England Lighthouse Lovers
38 Lime Kiln Rd
Tuckahoe, NY 10707
www.nell.cc

Hudson-Athens Lighthouse Preservation Society
P.O. Box 145
Athens, NY 12015
518-828-5294
www.hudsonathenslighthouse.org

Saugerties Lighthouse Conservancy
P.O. Box 654
Saugerties, NY 12477
(845)247-0656
www.saugertieslighthouse.com

Long Island Chapter, USLHS
29745 Main Road
Cutchogue, New York 11935
(631) 207-4331
www.lilighthousesociety.org

New Jersey
New Jersey Lighthouse Society
P.O. Box 332
Navesink, NJ 07752-0332
www.njlhs.org

Delaware
Delaware River & Bay Lighthouse Foundation
P.O. Box 708
Lewes, DE 19958
(302) 644-7046
www.delawarebaylights.org

Virginia
Chesapeake Chapter, USLHS
P.O. Box 1270
Annandale VA 22003-1270
www.cheslights.org

North Carolina
Outer Banks Lighthouse Society
P.O. Box 1005
Morehead City, NC 28557
(919) 787-6378
www.outerbankslighthousesociety.org

South Carolina
Save The Morris Island Light
P. O. Box 12490
Charleston, SC 29422
(843) 633-0099
www.savethelight.org

Georgia
Tybee Island Historical Society
P.O. Box 366
Tybee Island, GA 31328
(912) 786-5801
www.tybeelighthouse.org

Coastal Georgia Historical Society
St. Simons Island Lighthouse Museum
P.O. Box 21136
St. Simons Island, GA 31522
(912) 638-4666
www.saintsimonslighthouse.org

Florida
Florida Lighthouse Association
15275 Collier Blvd, #201, PMB 179
Naples, Florida 34120
www.floridalighthouses.org

St. Augustine Lighthouse & Museum
81 Lighthouse Avenue
St. Augustine, FL 32080
(904) 829-0745
www.staugustinelighthouse.com

Ponce de Leon Inlet Lighthouse
Preservation Association
4931 S. Peninsula Dr.
Ponce Inlet, FL 32127-7301
(386) 761-1821
www.ponceinlet.org

Washington
United States Lighthouse Society
9005 Point No Point Rd. NE
Hansville, WA 98340
(415) 362-7255
www.uslhs.org

Index